LOCATION LIGHTING
SOLUTIONS

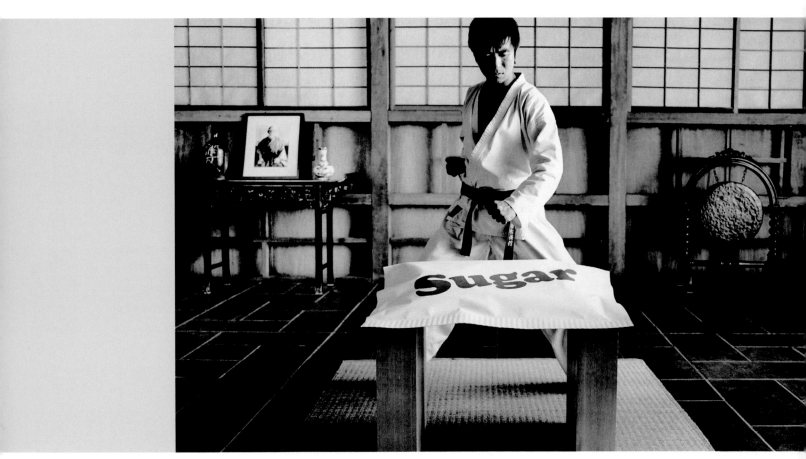

LOCATION LIGHTING
SOLUTIONS

EXPERT PROFESSIONAL TECHNIQUES FOR ARTISTIC AND COMMERCIAL SUCCESS

JACK NEUBART

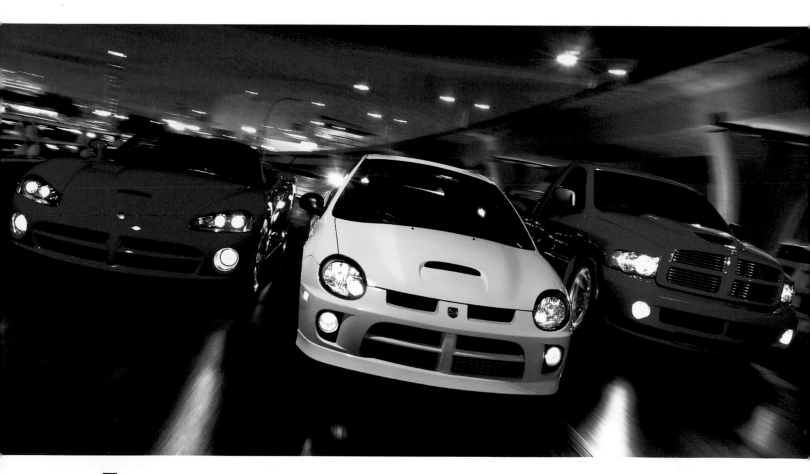

pdnPROS

PHOTO DISTRICT NEWS

AMPHOTO BOOKS an imprint of
WATSON-GUPTILL PUBLICATIONS | New York

Copyright © 2006 by Jack Neubart

First published in 2006 by Amphoto Books,
An imprint of Watson-Guptill Publications,
A division of VNU Business Media, Inc.
770 Broadway, New York, NY 10003

Library of Congress-in-Publication Data
Neubart, Jack.
 Location lighting solutions / Jack Neubart.
 p. cm.
 ISBN-13: 978-0-8174-5909-3
 ISBN-10: 0-8174-5909-X
 1. Photography-Lighting. I. Title.
 TR590.N38 2006
 778.7-dc22

 2006012452

Lighting diagrams by Jack Neubart unless otherwise noted

Printed in Singapore
1 2 3 4 5 6 7 8 9 10 / 14 13 12 11 10 09 08 07 06

Senior Acquisitions Editor: Victoria Craven
Editor: John A. Foster
Designer: Alexandra Maldonado
Senior Production Manager: Alyn Evans

Amphoto books are available for promotions, premiums,
textbook adoptions, and other special sales opportunities.
For details contact Amphoto Books Special Markets, 770
Broadway, New York, NY 10003, www.amphotobooks.com,
or call 1-800-451-1741.

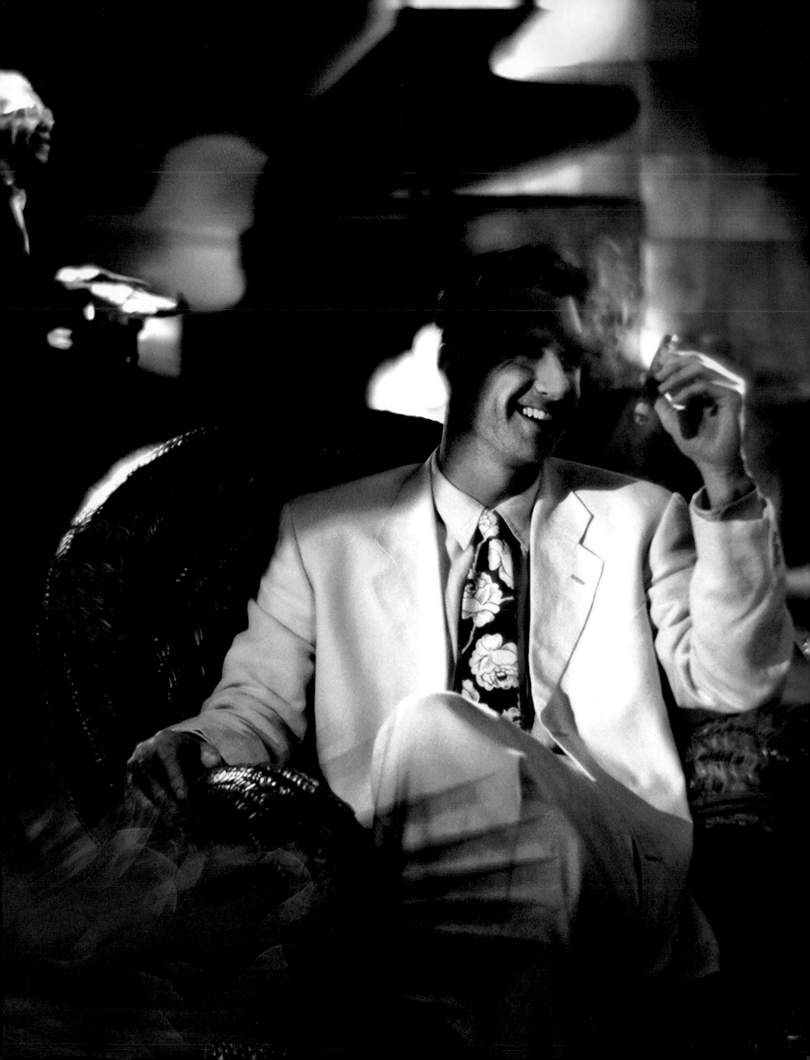

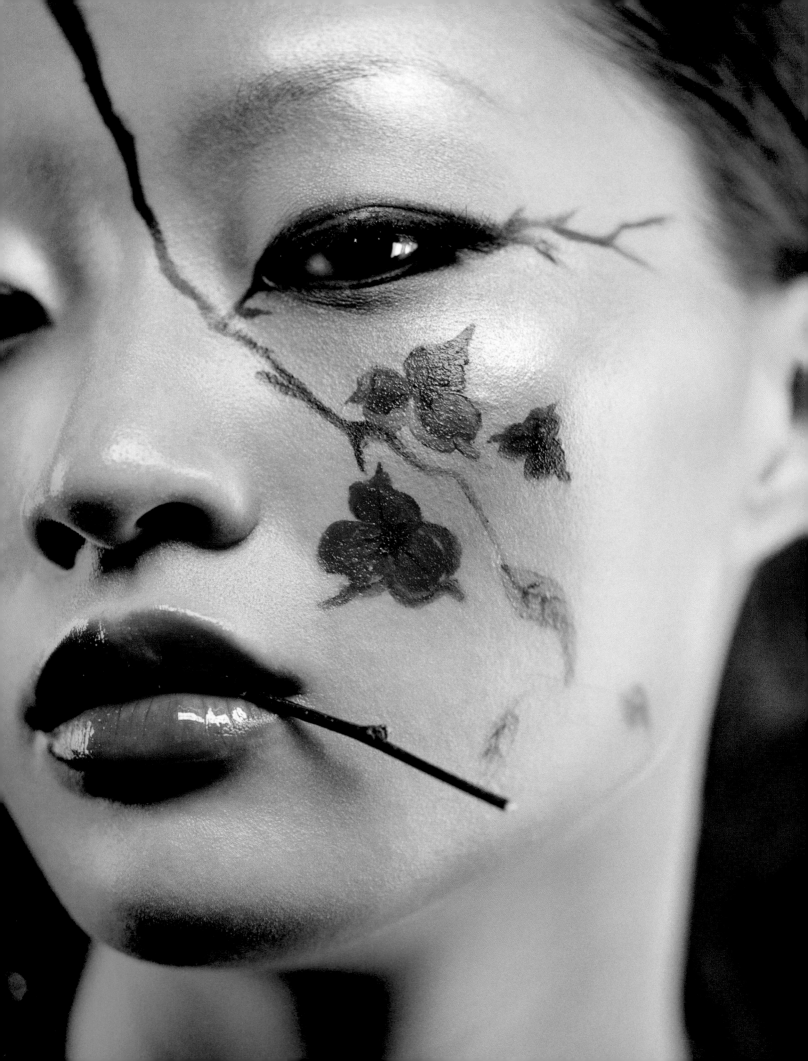

contents

PREFACE 8

CONTRIBUTING PHOTOGRAPHERS 10

FASHION AND BEAUTY 14

LIFESTYLE AND PORTRAITURE 36

NUANCE, NOIR, AND NOSTALGIA 66

ARCHITECTURE, INTERIORS, AND HOSPITALITY 96

CARS 124

CORPORATE AND INDUSTRIAL 140

GLOSSARY 170

INDEX 174

PREFACE

Location shots don't just happen. They are made—with meticulous attention to detail. They may require the services of a location scout. Time and distance permitting, you may tech-scout the location, alone or with client or crew, making note—in advance—of all your lighting needs and related demands of the job. Then you have to truck, or fly, in all the lighting gear, or rent it.

And finally you set up for the shoot and take the important picture. As Lou Jones once stated in my earlier book, *Industrial Photography* (Amphoto, 1989), "It's all about the picture." Nothing happens that does not center around the picture, and, by extension, the client's needs. And everything that affects the shot must be calculated in advance—even bad weather.

If, after reading *Studio Lighting Solutions* (Amphoto, 2005), my first book in the PDNpros series, you thought that studio photography was demanding, sit back and be prepared for a new set of challenges—some might call it a thrill ride in a different dimension. The location photographer may shoot exclusively outside the confines of the studio, or extend the studio, blending elements of one with the other. But no matter where the job takes you, certain elements remain: a client, and possibly an agency; one or more assistants; and a crew of talented individuals helping to bring the shot to fruition. You will have to decide: Do I hire my crew locally or bring them with me? You weigh the costs and benefits and calculate the dollar amounts into the estimate, and you have to live with the consequences.

Location shoots are filled with variables and paperwork, not least of which may be acquiring permits—a job a good location scout should have dealt with in advance. Each genre and specialty that comprises location photography is different. The architectural photographer shooting for an architect or designer looks at a site differently from a lifestyle photographer shooting a magazine cover. The automotive photographer looks at a car on the road with an eye toward highlighting performance for an ad; an industrial photographer looks at a tanker truck with an eye toward making it fit into an annual report. The fashion photographer must ensure the shoot not only fits the fashion but also meets the comfort and safety needs of the model.

Of course, not all location assignments require added lighting. So I've naturally chosen to focus on those that did require the photographer to finesse the situation with introduced lights, be they strobe, tungsten, HMI, or any combination of these light sources or others. In this book, we'll see how lights played a key role in supporting the ambience of the "set," and why they made a difference.

This book would not have been possible without the tireless efforts of all the photographers involved, to whom I am sincerely thankful. Their captivating photographs provide the cornerstone of this book. This work covers the gamut from fashion to fashionable cars, from industrial settings to industrious and clever ways to solve a myriad of challenges in a variety of locations.

What's more, a book of this nature would not be possible without the help and support of the Amphoto team, namely Victoria Craven, the captain of the ship, and John Foster, chief cook and bottle washer. As always, I am indebted to PDN for the magazine's continued support of my "Technically Speaking" column, on which this book is based (with numerous additions), and specifically to my editors Holly Hughes and Anthony LaSala and publisher Lauren Wendle.

But mostly, it comes back to the photographers. This book brings you a wealth of experience from twenty-six individuals. It's their words, pictures, and talent that we focus on, and it is from them that I trust you will glean many hours of enjoyment.

—Jack Neubart

CONTRIBUTING PHOTOGRAPHERS

Tony L. Arrasmith
Tony operates Arrasmith & Associates (www.tonyarrasmith.com) out of Cincinnati, Ohio, and has been in business for twenty years. He brings a definable exuberance to each shoot, portraying commonplace subjects in ways we would not ordinarily think to portray them. Examples showcasing his unusual and often quirky viewpoint can be found in *Studio Lighting Solutions* (Amphoto, 2005). He carries that vitality over to his location work in this book.

PHOTOGRAPH BY STACIE KINNEY

Paula (Friedland) Boggust Recently making the transition to digital, Paula shows off her unique ability to make the most of vintage gear and techniques. Together with Stacie Kinney, she operates Paula Friedland Studio (www.friedlandstudio.com) out of Omaha, NB. The studio has been in business for fifteen years. Paula describes her style as "whimsical and retro." She does, indeed, have an eye for offbeat, yet reverential, portrayals of people.

David Allan Brandt If anything can describe David's work, it is his uncanny ability to take the mundane and fashion it into a vital visual statement that is both respectful of his subject and teasingly playful. With his wife Elaine, he operates David Allan Brandt Studios out of Los Angeles, CA (www.davidallanbrandt.com). David has been in business since the early 1980s. His photographs, both monochrome and color, added a distinctive flavor and dimension to *Studio Lighting Solutions* (Amphoto, 2005). David's work never fails to grab the viewer's attention.

Don Dixon Based in Toronto, Canada, Don heads Don Dixon Film & Photography (www.dixonfilm.com) and has been in business for over twenty-five years. He specializes in advertising, automotive, and lifestyle. Don describes his studio by "if you can think it, we can create it," adding, "with two studios and a team of talented digital artists, we've positioned ourselves to produce unique conceptual photography." Don has a unique way of cleverly weaving a tale, which he also clearly displayed in *Studio Lighting Solutions* (Amphoto, 2005).

PHOTOGRAPH BY RODERICK MICKENS

Denis Finnin Denis has the enviable task of photographing practically anything and everything that planet Earth has to offer in his role as director and head photographer at the prestigious American Museum of Natural History in New York City (www.amnh.org). His photographs have been featured in *Windows On Nature: The Great Habitat Dioramas of The American Museum of Natural History; Pearls: A Natural History; Amber: Window to the Past, Discovering Fossil Fishes;* and *The Nature of Diamonds*. His work also has graced the pages of *Studio Lighting Solutions* (Amphoto, 2005).

PHOTOGRAPH BY JACK NEUBART

Rafael Fuchs Rafi brings a unique vision and sensibility to each shoot, imbuing his portrait and lifestyle imagery with humor, sensitivity, and a fascination for life.

He operates Rafael Fuchs Photography out of Brooklyn, NY (www.rafaelfuchs.com), and has been in business over twelve years. A PDN editor described his work with "the unexpected is (his) trademark." Rafi's photographs have appeared in various books and several gallery exhibits.

Lee Gordon In business over twenty years, Lee operates Lee Gordon Photography, Inc. (www.leegordonphotography.com) out of Boca Raton, FL. The consummate fine-art and commercial photographer that he is, Lee observes that "the magic happens when I can transport the viewer to sense the moment in time and feel the space depicted." He adds, "my creative intention is to share and communicate the beauty and significance of the earth's magnificence."

Jeffrey Green While Jeff's contribution to this book focuses on residential interiors, he showed a different side of his art in *Studio Lighting Solutions* (Amphoto, 2005), where his photographs of food and beverages left us wanting more. Based in Las Vegas, NV, he has been in business for twelve years (www.jgreenphoto.com). Jeff's work was featured in *Canyon Ranch Cooks* (Canyon Ranch Publications) and *The New Southwest Home* (Northland Publishing, 2004).

Marshall Harrington Marshall defines his work as "visual semiotics," adding, "I love making pictures that tell complex stories, but are reduced to simple, passionate images." His passion early in life was to become a photographer. The work reflected in this book proves he has achieved his goal, with a decided panache. Doing business out of San Diego, CA (www.harringtonstudio.com), he started shooting professionally in the 1970s. Marshall's favorite pastime is racing sailboats.

Charles Hopkins In business for nearly fifteen years, Charles operates Charles Hopkins Photography Inc. (www.charleshopkins.com) out of Los Angeles, CA. Specializing in automotive photography, he defines his lighting style as non-formulaic, flexible, and open to exploration. Charles was featured in *Studio Lighting Solutions* (Amphoto, 2005), where he showed off his adept use of Kino Flo lighting to define the lines and shapes in a vehicle.

Edward Jacoby Edward has been photographing architecture and interiors for over thirty years. Based in Boston, MA, he operates Jacoby Photography (www.archi-medias.com), focusing primarily on the northeastern region of the United States. Of his studio's approach, he notes, "we are defined by a complete dedication to the best possible location lighting in order to enhance the interiors that we shoot."

Don Johnston In business for over twenty-one years, Don operates Johnston Images Inc. (www.johnstonimages.com) out of Oxford, MI. These days we can find this avid outdoorsman on assignment shooting not only cars and trucks, but snowmobiles, jet skis, motorcycles, and race cars around the globe—as well as in the studio. He notes that his ability to understand the exhilaration and beauty of motion qualifies him to capture the excitement of the moment, resulting in outdoor performance-oriented automotive shots with a distinct vitality.

Lou Jones From Lou's contribution to Jack Neubart's *Industrial Photography* (Amphoto, 1989), one might mistakenly describe him simply as an industrial photographer. But that only defines one aspect of his work. Lou is also a travel photographer, producing telling portraits from around the globe, and numerous Olympics reflect his distinctive eye as a sports photographer. In his book *Final Exposure: Portraits from Death Row* (with Lorie Savel), he shows another side of his talents as photographer, making extremely poignant visual statements about prison inmates whose lives took a tragic turn. In business since 1972, he operates Jones Photography (www.fotojones.com) out of Boston, MA.

Jim Karageorge This award-winning photographer's early documentary films laid the groundwork for his lighting style, which he has shared at numerous workshops and seminars. Operating out of Nicasio, CA, he opened Karageorge Studio (www.karageorgestudio.com) in 1977. Jim defines his work as the "ability to communicate the essence of the story or product in a simple, direct, and dramatic way, making the mundane appear magical."

Brian Kuhlmann In business for twenty years, Brian operates Kuhlmann Studio (www.kuhlphoto.com) out of Chicago, IL, with a second studio in St. Louis, MO. He specializes in lifestyle, fashion, and fine-art photography, with a focus on "high-end advertising." Brian likes to imbue his images with energy and vibrant colors, as is apparent in the images he shares with us on these pages.

Tammy Magnatta Tammy has recently broadened the scope of her creative activities. Previously focusing solely on photographic portraiture, especially for the music industry, she now adds web design to the array of services she provides clients. Tammy operates out of New York City (www.artistcampaign.com).

PHOTOGRAPH BY VPOLA

Jock McDonald Jock (www.jockmcdonald.com) operates out of San Francisco, CA, and specializes in people photography "using wit, humor, pathos, and a sense of mystery." An acclaimed lecturer, Jock is a poet with the camera, transmuting each subject into its own haiku on film. His celebrity portraits and depictions of rural life around the globe have graced galleries and exhibits worldwide. We previously had the pleasure of experiencing Jock's work, with its innate humorous bent, in *Studio Lighting Solutions* (Amphoto, 2005).

Remi Rebillard Remi has been a professional photographer for over twenty years, working out of Paris, Milan, and New York (www.remirebillard.com). His passions in photography are beauty and fashion. When asked to define his style, he responded, "Eclectic perhaps best describes it. The only constant in my lighting is change. I am continually researching and experimenting with light." He truly has his own way of seeing beauty.

F. Scott Schafer Scott (www.fscottschafer.com) operates out of New York City, and specializes in celebrity portraiture, entertainment and music personalities, and conceptual advertising. He has been a

pro shooter for fifteen years, shooting on assignment from coast to coast. While he also enjoys adding a humorous twist when the situation calls for it, Scott's images in this book reflect how skilled he is at fabricating sets to deliver incisive stories and deeply insightful portraits. His travel images reveal yet another facet of his creativity.

Annie Schlechter Annie (www.annieschlechter.com) has been in business over five years, operating out of New York City. She specializes in still life, interiors, and architecture and defines her work as "graphic humor." Her work was featured in Jonathan Alder's *My Prescription for Anti-Depressive Living* (Melcher Media, 2005).

Bob Scott In business for over twelve years, Bob operates BobScottNYC (www.bobscottnyc.com) out of the Chelsea District in New York City. Often choosing unusual viewpoints that have become his trademark, he specializes in

PHOTOGRAPH BY RICK SEEDMAN

action, lifestyle, and environmental portraits. Bob defines his style as "ever evolving" to meet the challenges of the day and to reflect his growing visual sensibility. His photographs were featured in *The Shaolin Workout* (Rodale Press, 2006).

Jeff Smith Jeff lent his expertise to Jack Neubart's *Industrial Photography* (Amphoto, 1989). Back then we could find him shooting with a ton of gear at industrial and corporate settings worldwide. These days, he has shifted gears, modifying his approach

PHOTOGRAPH BY EMILY M. SMITH

and focusing more on architectural themes. Jeff runs Jeff Smith Photography (www.jeffsmithimages.com) out of New Jersey and brings nearly forty years of experience to this book. Of his photography, Jeff writes: "I bring a strong ability to light a photo in a way that adds to the composition as well as the underlying meaning of the shot." His latest passion is boating.

Melvin Sokolsky Melvin's trademark style and fashion sense have often been mimicked but never duplicated. His career began at age 21, and every major fashion magazine worldwide has since carried his work. Photographer, teacher, and commercial TV director/cameraman, Melvin has garnered numerous awards. His photographs have been exhibited in the United States and Europe, and one of his photographs resides in the Louvre. Melvin (www.sokolsky.com) operates out of Beverly Hills and New York City.

Pierre Tremblay Montreal, Canada, is home to Pierre Tremblay (www.pierretremblay.com), although his clients range along the United States' east coast. He makes the following maxim his business philosophy: "Please the client, please yourself, have fun while making money." Pierre's flavorful food photography was featured in *Studio Lighting Solutions* (Amphoto, 2005).

Vickers & Beechler The dynamic partnership of Camille Vickers and Greg Beechler has produced volumes of work for their industrial, corporate, and institutional clients since 1988. Their work reflects a studied hand in lighting and an eye for design. They operate Vickers & Beechler Photography (www.cvgb.com) out of New York. Previously featured in Jack Neubart's *Industrial Photography*, when their work was entirely analog, they have redefined themselves for the digital age, performing work around the globe.

Andrew Vracin Andrew operates Andrew Vracin Photography (www.vracin.com) out of Dallas, TX. In business for over twenty-five years, Andrew notes that he focuses on people, kids, lifestyle, and location home furnishings. A specialty of his is film-noir styling and lighting, which brings a vintage flavor and a measurable degree of intrigue to his lifestyle portraits. He defines his studio as a "tight-knit, hardworking crew who really enjoy what we do."

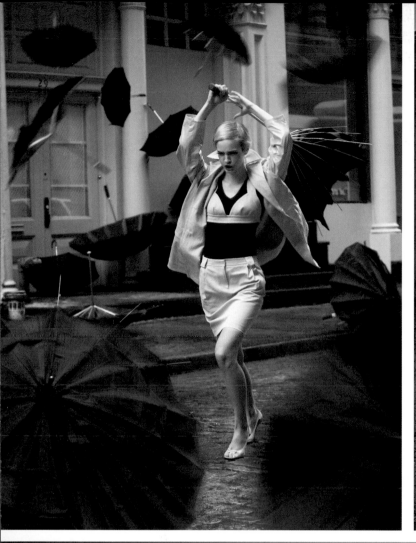
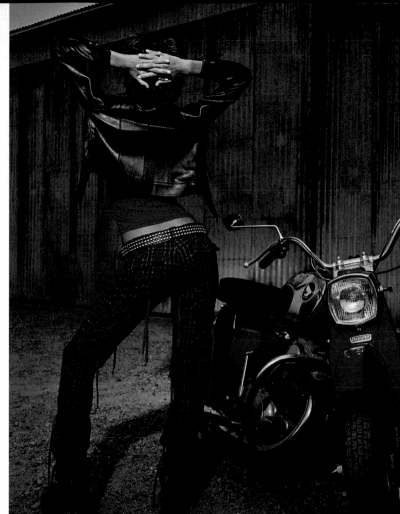
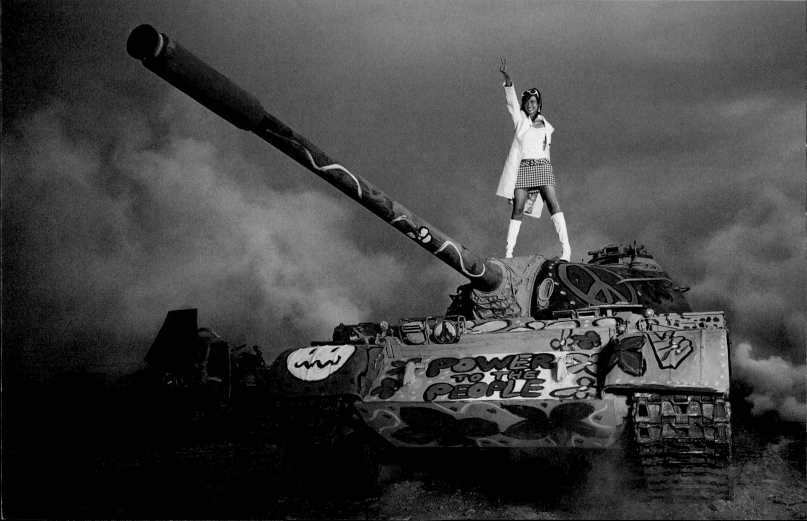

fashion and beauty

There are no formulas for a fashion or beauty shot. Each client has a look to convey, and each photographer strives to achieve that goal, adding little twists that make the picture as much a unique statement of his or her own vision as that of the client.

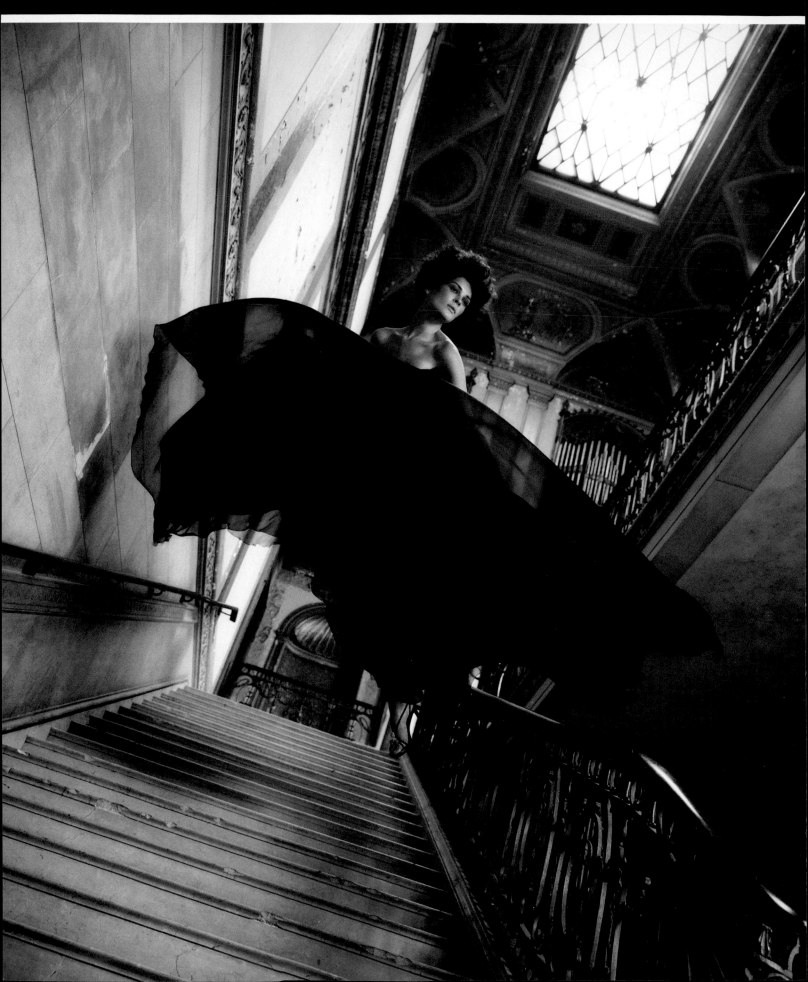

JOB SHEET

CLIENT: *Harper's Bazaar* **magazine**

USAGE: **Editorial**

EDITOR IN CHIEF: **Glenda Bailey**

PROJECT COORDINATOR: **Brana Wolf, editor-at-large**

ART DIRECTOR: **Stephan Gan**

LIGHTING: **Strobe**

CAPTURE: **Analog**

PHOTOGRAPH COPYRIGHT © **Melvin Sokolsky**

PRO TIP You're not going to get the shot or the dramatic effect you want simply by telling the model to be sexy. You have to give her some tangible direction that she can wrap her thoughts, emotions, and actions around.

Some fashion shots are meant simply to show the couture. But rarely do they encompass such imagination as we encounter here. The lighting itself is through the roof!

Harper's Bazaar wanted me to do something that would be different for them—to showcase models floating on air. Granted, this wasn't something new for me. It's a technique for which I'd won world acclaim back in 1965 (though those were fine-art pieces shot in black-and-white). This time we were shooting the couture gowns in color. It was left to me to design the shot and choose the location, which in this instance was somewhere in Mount Kisco, New York.

Why take this gravity-defying approach? Because the dress was voluminous, and I knew, given the right conditions, it would flare upward like a parachute and carry the shot. As the model "flew" down, suspended from our rig, the upward cushion of air caused the skirt to flare out. I also used several high-powered fans to augment and ensure a good upsweep. We shot this on a Mamiya RZ, with 90mm lens and Kodak Ektachrome E100S. Exposure was f/11 or thereabouts. This shot required three assistants. I had two days to fill twelve pages.

The lighting, all rented, had to cover not only our model but the interior as well. We shot at noon, but ambient levels were not a concern. I used a griflon (a large tarpaulin stretched across a 20 x 20-foot frame, with one side silver, the other side black), thereby cutting out all the ambient light from the skylight. The griflon enabled me to have better control over the light and not worry about shifting rays of light and shadows. The shiny side faced the sun so as to not generate heat downward.

We began on the roof, up at that skylight, which was easily 70 feet above the model. As our main light we used four strobes—one above each corner, aimed straight downward through a silk. Having the light come through the skylight added texture to the walls. There was originally a lot of detail in the skylight, which I felt would work against the atmosphere I sought to create, so I modified the skylight digitally, both in terms of contrast and tone. In the end, I applied some additional retouching selectively, where needed.

In my lighting, I like to create textures by layering the light, as painters do when applying underpainting to a canvas. When you layer the light, it gives you a certain dimensionality that

The lighting for this gravity-defying fashion shot began at the top—literally above the skylight—and extended downward. It takes a special flair to do a shot such as this.

brings out more detail without unnecessarily calling attention to itself. So my next step was to set up a V-flat (consisting of 4x8-foot foamcore panels), way back past the foot of the stairs, with one strobe bounced into it. To prevent spill out the top, there was a card topping off the V.

There was also a baffle in front of the V-flat. I directed one of my assistants to give me a little more light from the V-flat, so he cut several slits in the baffle to allow light to spill through in a controlled manner. If the light looked like too much, we simply taped selected slits closed until we got just the right amount of light coming through.

Also, I often use flags and nets to paint the light where I want it. In this case, if the model's hair was getting a little flat, I could ask an assistant for a half net with a soft bottom and then cut it off the top of the model's hair. Near her waistline, where the banister is, I allowed the light to go through, but where her feet were, I used a big cutter so I wouldn't see the light coming through. (The highlight on the banister was coming from the V-flat, because that part of the light wasn't being cut.)

Under the stairwell, there were two strobes bounced into two contiguous V-flats. These provided the sidelighting on the model, particularly her shoulder and face, while filling in under the ceiling to add dimension to the shot. Like the first V-flat, these two others also had baffles.

One more very important thing: every strobe head had next to it an HMI or a blue-gelled tungsten light, so I could better visualize the shot. I don't like shooting blind, and modeling lights don't do it for me.

PRO TIP I'd designed special harnesses that work off a single supporting wire. The filament was extremely difficult to discern by the naked eye, but we retouched it out where needed. The wire was ⅛-inch steel aircraft cable, capable of lifting a model securely and easily. Still, not every model is comfortable "flying," so we always do tests and ensure a comfort level that allows us to work unimpeded.

The budget did not allow for a crane to lift the model. So, I took 3-inch-diameter aluminum tubing, from which I welded a tripod, securing it to a base for a solid support. The spread was about 36 inches. Then I formed a U-shape out of the metal at the top, with a 1.5-inch bolt running through it. Finally I made a telescoping fishing pole (consisting of two sliding tubes) that went into the U. At the back end was a winch that we could turn to lift the model off the ground. Two men sat at the opposite end of our "fishing pole" to counterbalance the model. This setup gave us the ability to move her freely. One more thing: we took a piece of monofilament and tied it to the heel on one of the model's shoes so that we could rotate her as needed. The fishing pole was toward the front of the picture, out of frame.

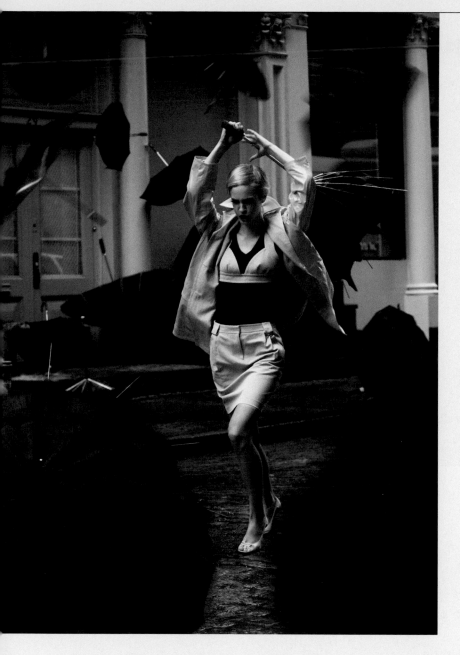

JOB SHEET

CLIENT: *Wallpaper* **magazine**
USAGE: **Editorial**
CREATIVE DIRECTOR: **Tony Chambers**
FIRST ASSISTANT: **Ben Treuhaft**
LIGHTING: **HMI (plus existing daylight)**
CAPTURE: **Digital**
PHOTOGRAPH COPYRIGHT © **Melvin Sokolsky**

Here, again, I was called upon to emulate a shot I'd done years back: in this instance it happened to be a TV commercial for the Egg Bureau. This request came from **Wallpaper** magazine, and when I sent them my reel, they were eager to get started. It was a 12-page spread, with six or eight fashions to be shot in one day.

This was shot in SoHo, in New York City. Shooting digitally this time, I used a Canon 1Ds with 24-70mm lens, at between 35 and 40mm, for an ISO 200 exposure of f/5.6 or f/8.

We began by setting up the umbrellas in the background, which were secured to the street by wire and sandbagged at various angles or connected to overhanging structures. The two front umbrellas were sandbagged so they would stay in place. Then, when we turned the giant wind machine on, everything started rattling and blowing all over the place. The wires needed to be retouched out in very selective instances, where they caught a glint of the light. For better contrast between cobblestones and umbrellas, I'd decided to wet down the street. But we couldn't use a water truck. Instead, we ended up using five-gallon jugs of water that we'd bought.

The model was not standing still. Instead, she was gesturing while taking a couple of steps back and forth. And to get some emotion out of her, I would tell her, "Get more angry, don't worry about your face; there's a dragon in your way, confronting you. She is Don Quixote fighting windmills, or the wind."

As you'll see, there were a considerable number of lights here—all HMI, powered by a huge generator. Why all these lights? Given that it was late in the day and overcast, we wanted this to have some kind of an edge to it. So we began our lighting with a 10K, up high and aimed through a silk. This light came in on the set from camera left, near the front of the set. What was happening was that we were overpowering the ambient light hitting the scene.

We had two 5Ks off to the left side and a little toward the back, bounced off a griflon—as overall fill but also to add some sheen to the street. Then, way in back on the opposite side, we had a 2K bounced off a reflector that was positioned at an angle to the set. We also added reflectors on set where we felt they might be needed. We kept moving these, depending on whether or not we moved an umbrella. In fact, none of my lighting just sits there—it's constantly moving. There's always somebody on it. It's a habit I picked up from doing television commercials.

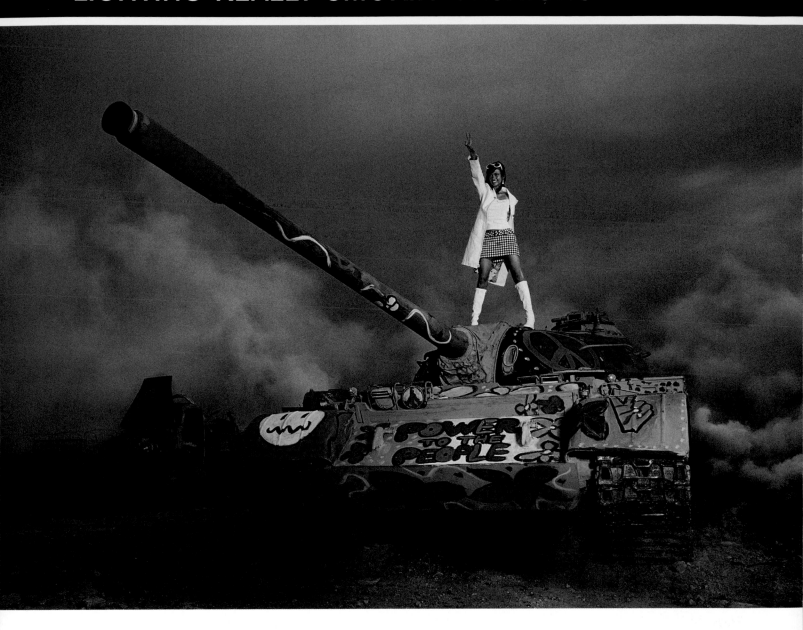

This highly inventive treatment pits fashion against the machinery of war, and fashion wins. The lighting helps accentuate the smoke-filled battlefield but pays equal attention to our fashion-forward heroine.

A combination of strobe and smoke machines contributed to this portentous scenario—an unusual, clever, and timely fashion concept.

With this shot from an ad campaign aimed at the European and Asian markets, the client wanted to make not only a fashion statement but also an unsubtle statement about war. The clothing was retro, a throwback to the 1960s. The tank, too, was a throwback to a bygone era, as were the symbols painted on the vehicle—in water-based paints so they could be cleaned off easily. All this was based on a rough layout the client had provided. It was then left to me and my crew to improvise the details. The creative director was there to oversee our

JOB SHEET

CLIENT: **Peace Angel London**

USAGE: **Advertising**

AGENCY: **China Live**

CREATIVE DIRECTOR: **Kinson Chan**

PRODUCER: **Elaine Kwan Brandt**

FIRST ASSISTANT: **Pete Breza**

SET PAINTER/STYLIST: **Gary Randall**

WARDROBE STYLIST: **Mike Sam**

HAIR & MAKEUP: **Maya Murakami**

LIGHTING: **Strobe**

CAPTURE: **Analog**

PHOTOGRAPHS COPYRIGHT ©**David Allan Brandt**

PRO TIP I shoot a lot of print film now, because it has gotten so much better. I don't see much difference between negative and transparency emulsions if you're shooting 2¼ or larger. And you get better latitude in print film, enabling you to manipulate the image more easily after scanning it into the computer.

progress and approve our final concept. The client furnished the entire wardrobe, including the glasses.

We did an exhaustive search for the right location in Southern California. The facility we found provided everything we needed: a location where we could stage our mock battle, as well as props, since all the old war machinery could be rented from the landowner. Most important was the tank, which was fully operational—driven by the owner, who moved it into position. We also brought a jeep and truck into the shot.

Knowing the shot would ultimately be cropped down to a horizontal, I opted to shoot on a Hasselblad 500C (tripod-mounted) with 50mm lens. Though I shot on Kodak Portra 160 Portrait print film—preferring the greater control this emulsion affords—I delivered images on disk to the client, with match prints. Camera-to-tank distance was maybe 15 or 20 feet. I used an incident meter and Polaroided, resulting in an exposure of f/8 at 1/125.

Creating a smoky, dust-laden battlefield atmosphere required us to bring in four smoke machines, placed strategically around the set. We had two large machines, one behind the tank and another off to the right. A medium-sized smoke machine stood between the truck and jeep. There was also a smaller one in the right foreground to add that wispy bit of smoke. The wind helped matters considerably, blowing the smoke from left to right, adding a dynamic element of smoke trailing over the battlefield as the tank was coming toward camera (although, in reality, it was standing still). Smoke machines in back were gasoline-powered, whereas the foreground machine was AC-powered. We didn't need generators, even for the lights, because we were able to run cables to various electrical outlets located around the site. Since we were on the outskirts of a regional airport, generating all that smoke required us to alert the tower and fire department, especially to ensure that the smoke didn't interfere with air traffic.

Painting the tank was the most time-consuming aspect of the shoot, commencing the day before we started shooting. The shoot day itself stretched from 6 AM until 9 PM. While the tank was being painted, we focused on other shots for this job—we did five or six in all. By noon, we were ready to start working on the tank shot, but it wasn't until late afternoon that we actually starting running film through the camera. It was summer, and we didn't want strong sunlight ruining the battlefield mood. As luck would have it, the sky clouded over, which allowed me to effectively use our strobes to give the shot an ominous feeling.

All our strobes were Normans. Our first light, a 10-inch Fresnel, was aimed at the talent, but with barndoors open wide enough to hit the tank. The Fresnel was adjusted to a medium spot, and was positioned 20 feet up and 20 feet to the right.

In a fashion shoot you might anticipate a beauty dish, and one did come into play here—but not for the reasons you'd expect. To the left of the Fresnel stood the beauty dish, 5 feet up and 10 feet from the tank—and aimed primarily at the front of the tank. This light also reached the talent, but barely. Another head stood to the right, far back, hitting the rear of the tank, but was there mostly for the smoke.

We had three lights on the left side of the tank. To the rear of the truck, from the right, was one head (for the smoke), with another (specifically for the truck) stationed a few more feet forward.

PRO TIP One of the key things that I wanted to do was to give the battlefield shot an ominous feeling, even though it was kind of a campy idea. I wanted to keep the campiness within the talent and the tank but give the background a portentous feeling, as if it were genuinely part of a battlefield. To support all this, it was important to get the smoke lit and, at the same time, to balance the daylight with the strobe.

Positioned about midway along the length of the tank was the third light—to illuminate the general area in front of the truck. We employed five packs to distribute power to all our heads on this shot. There were warming gels on all the lights.

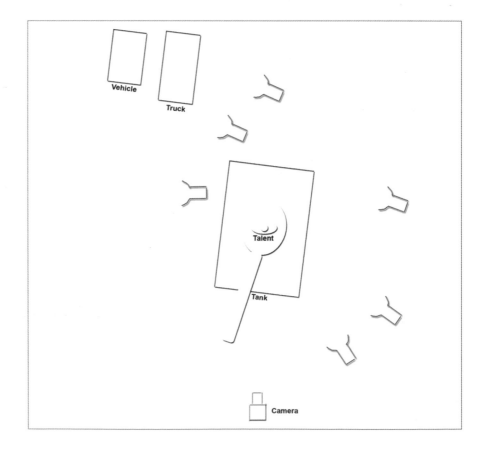

The lighting had to focus attention not only on the model and her wardrobe, but, just as importantly, it had to imbue the set with the feel of a true battlefield.

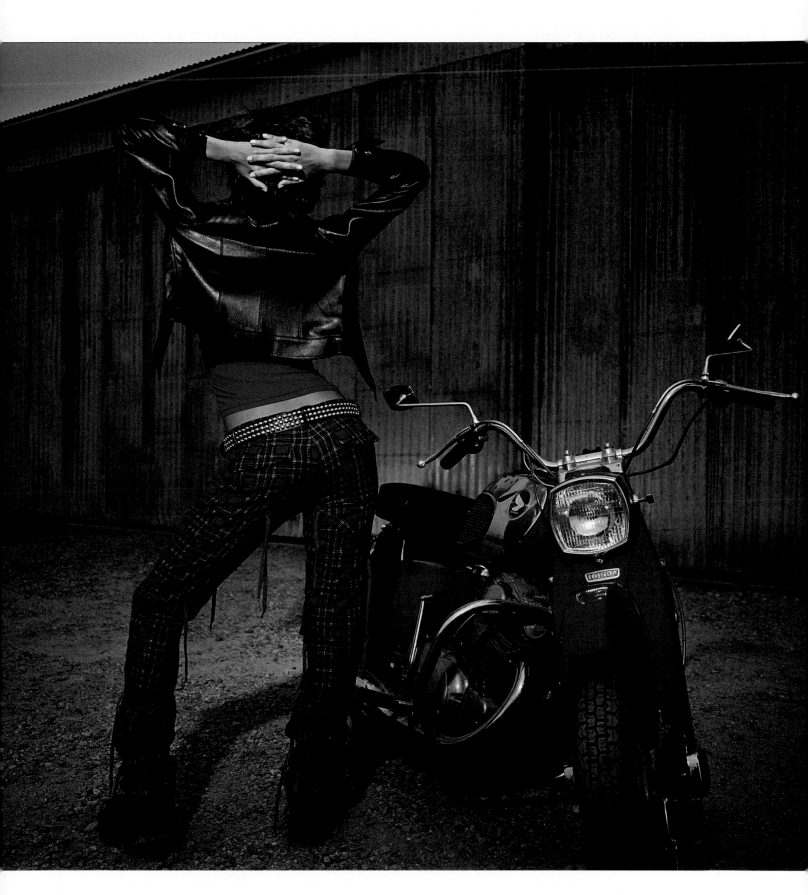

This was an extensive shoot, making use of a variety of props to illustrate the various fashions.

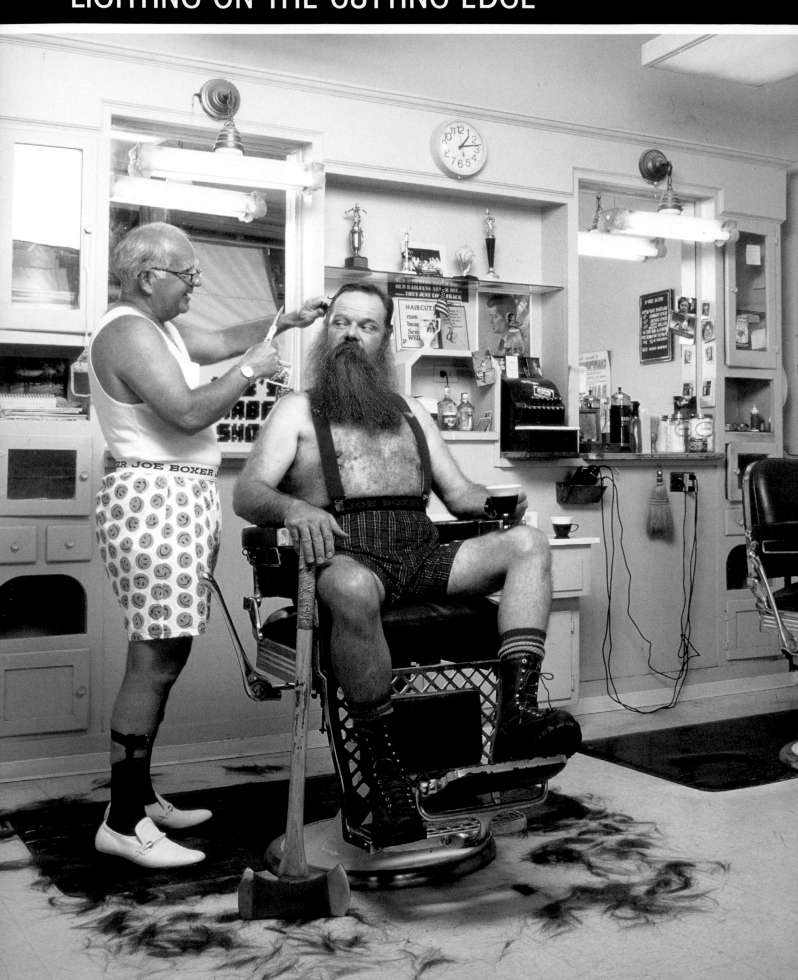

JOB SHEET

CLIENT: **Joe Boxer**

USAGE: **Advertising**

AGENCY: **Odiorne Wilde and Narraway & Partners**

ART DIRECTOR: **Erich Pfeifer**

PRODUCER: **Andrea Potts**

PROP STYLIST: **Michael V**

HAIR & MAKEUP: **Jon Lucca**

CASTING: **Scott Globus**

LIGHTING: **Strobe (plus existing light)**

CAPTURE: **Analog**

PHOTOGRAPH COPYRIGHT ©**Jock McDonald**

PRO TIP When space is tight, try to go wider. In this shot, I gave the 40mm lens the old college try from inside the shop, but it introduced too much distortion. The solution was to step outside and shoot through the store window with a slightly longer lens.

H umor is at the heart of this fashion statement. The barbershop may not be a fashion salon, yet it seems to make a good fit. Lighting in such tight quarters, though, does prove a challenge.

There were three different pieces for this national magazine ad campaign aimed at men leading contemporary lifestyles. For each piece, the art director provided a rough layout and specified that he was looking for a trendy, hip twist on a Norman Rockwell-like scene—a certain slice-of-life, down-home quality, yet quirky and offbeat. If it's not obvious, both the barber and his customer are wearing the client's boxer shorts.

We scouted locations, looking at 15 to 20 different barbershops in Northern California. What drew me to this particular site was its symmetry and the fact that it had been around—unchanged—since the early 1930s, with the authentic furnishings that would lend this shot a period feel. However, we did make some changes on set. To accommodate the proportions of the shot, we had to move the barber chairs closer together.

Our stylist brought in selected props for the walls. The trick to getting the right feel was "less is more,"

so we propped it lightly to avoid compromising the credibility of the shot. Something the stylist did to bring in a bag of hair for the floor, as well as boots and suspenders for the customer and garters, white shoes, and a wristwatch for the barber. The models were professional talent. We were looking for what would be a "stereotypical" barber, of a certain age, and as his customer, a burly character, with a heavy beard à la Norman Rockwell.

I set up a Hasselblad 500ELX with 50mm lens outside the shop, because space inside was tight. Owing to lens and wardrobe changes, we ended up shooting more than 100 rolls on Kodak EPP 120, for a final exposure of 1/250th second at f/4.5.

The barbershop was on a busy street, with its main window open to daylight and peering crowds, so we had to prevent interruptions by curiosity seekers and, even more important, block out ambient light. We worked from morning until late afternoon. My assistants set up a black cloth, suspended from a

This is a cutting-edge approach to promoting men's underwear, using a real barbershop, gelled fluorescent fixtures, and strobe as fill.

cross-arm on high-rollers, positioning it at the front lip of the extended awning. The curtain extended behind camera position, perhaps four or five feet from the storefront. The camera was pressed up against the glass, with a polarizer on the lens to prevent any potentially intrusive reflections.

When tech-scouting the location, I noted that the existing power was inadequate for my lights, so I rented a voltage-stabilized generator suitable to the needs of my Broncolor Flashman 2 packs. Beyond that, we worked with the existing fluorescent light fixtures over the mirrors and in the ceiling, gelling them with magenta to bring them to neutral.

Next, we started setting up our own lights, all of which would serve as fill. Strobe lighting was—for the most part—based on incident meter readings keyed to the existing light, to a degree-but mostly on Polaroids. The first light added was a 2x4-foot bank (running off its own pack), positioned vertically and jammed into the corner of the shop, to my left. This light stood about eight feet from the models and six feet up, and aimed right between them, so that it hit the two men evenly. Also, there was a gobo between the camera and this strobe.

Next came a light all the way to the right, nearly midway into the set, aimed into the far wall and top corner, on the same side of the set as the models. This light stood six feet up and provided a very subtle fill, after being powered down considerably, with neutral density added to lower its output even further. The standard P2 reflector was attached to this head, as well as to the next two lights.

Grouped together on the right side of the set were two additional lights, running off a third pack, adding additional fill by being bounced. One was pointed straight up, the other toward the back corner of the room. This second light was gelled down with neutral density so that I could get the gradation from right to left. These lights were up high, about 18 inches from the ceiling. The relative distance of these two lights from the models was about 10 feet. It's worth mentioning that these two "ceiling" lights were actually suspended from the ceiling, hooked to conduits with clamps, to keep them out of frame.

PRO TIP When mixing store fluorescents with strobe lighting, gel the existing lights for a neutral color balance. Here, we had to take each tube out and roll the gel material carefully around the light, and then tape it so the seam didn't show.

PERSONAL VISION

PHOTOGRAPH COPYRIGHT © JOCK MCDONALD

Throw out your notions about what a shoe shot should look like and observe how an unconventional treatment makes this shoe shine. And it's done largely with small, portable strobes.

The agency defined what they were looking for as funky, young, and very colorful. Beyond that, they were fully open to my ideas for this photograph promoting a new product line and the fall campaign for a retail shoe outlet. The picture would be used on bus-stop ads, postcards, billboards, and point-of-purchase displays.

At the outset, they asked me to do tests and to give them as many different looks as possible. So I tested on many different films and with varied lighting, using just any shoes, since we didn't know which shoes we were going to shoot. My films included Kodak infrared slide film, and that was the look they went for. It's not an easy film to use, but it does produce some rather unique and unusual results. Because we were shooting infrared, the colors we see

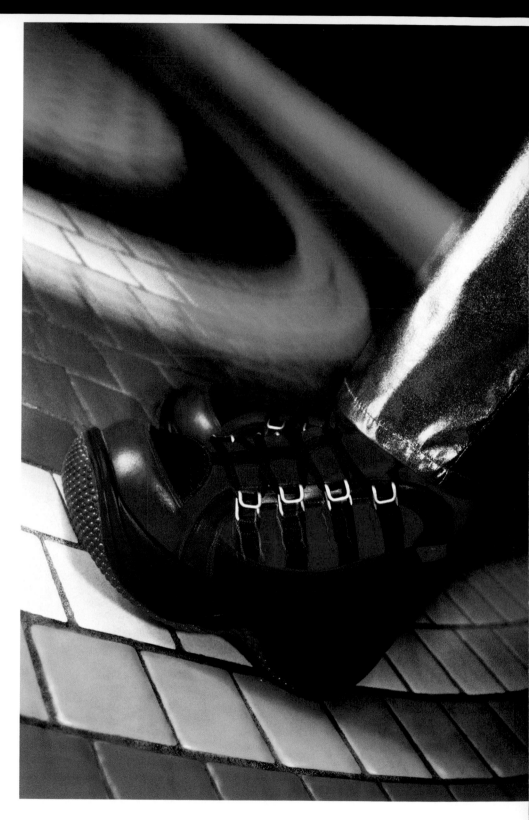

Finding the right film—in this case infrared—and a supporting backdrop only begin to tell this story. There was also a little shakin' goin' on.

JOB SHEET

CLIENT: **Stone Ridge/Aldo Shoes, Montreal**

USAGE: **Advertising and collateral**

AGENCY: **Wheatley & Rosenberg**

ART DIRECTOR: **Clodagh Wheatley**

FIRST ASSISTANT: **Elizabeth Knox**

LIGHTING: **Strobe (plus existing light)**

CAPTURE: **Analog**

PHOTOGRAPH COPYRIGHT **©Pierre Tremblay**

PRO TIP Shooting tests on location can prove to be a major time-saver. Since this was where all testing was done, setup on this shot was fairly quick.

are distorted. The actual color of the pants the model wore was a silver vinyl, whereas the vinyl-and-leather shoes were blue and black.

We'd already hired our model when the store came to us with their choice of shoe style—the day before the shoot. The pair they provided was the only pair available in that style but was the wrong size for our model. And the box contained two left shoes. We would have to make do, by hiding the right foot.

I shot this on a subway platform in Montreal, because I liked the spiral pattern in the floor tiles. As clean as the area was, some tidying up was required—more needed to be digitally cleaned after final film was shot, especially around the shoe. I also digitally burned in the foreground a little bit. The black area in back was where the subway tracks lay. People passing by were wondering what we were doing, mainly because I was lying on my stomach shooting.

The actual shoot took maybe a half-hour, during which time we exposed four rolls of film. The camera was a Nikon, with 35–70mm zoom, set at about 50mm. Since I didn't want to shoot too wide open

because of the infrared focusing, I set the aperture at f/8, guided by the ambient light, and adjusted further based on the shutter. Shutter-speed was bracketed at between one and five seconds, with this handheld exposure at one or two seconds, enabling me to introduce blur by shaking the camera. The camera was three feet from the subject.

To light the shot I began with two Nikon strobes in TTL mode. The main light was an SB26, on a TTL sync cord. It was positioned on axis, from the left, two feet up and three feet from the shoe—with a yellow gel to intensify the infrared effect. My assistant held this light, which enabled him to move out of the way of pedestrian traffic—the area was not closed off to the public. As fill, I used an SB24 on-camera flash, with diffuser in place, set at minus 2 stops, also gelled yellow.

I then added a Morris Ultra Slave, positioned on the floor. This remotely triggered light simply provided a neutral white color accent on a small area of the tiles, toward the back. The blue tone in the background came from the overhead fluorescent lights. I intended to use it as a blurred element when introducing camera shake.

Shooting fashion for a retail outlet requires a different tack from shooting for fashion houses. This creative treatment plays on a storybook theme. The lighting helps weave the tale.

The art director provided me with three layouts for a fashion campaign addressing the California market, with each ad focusing on a fairytale theme. This particular one was entitled "Cinderella Goes Clubbing," and the copy read, "Coming soon to a theatre near you: The magical tale of a young maiden, a charming prince, and one stunning platform shoe." The layout showed a young woman running from a club and losing her shoe outside the entrance. It seemed simple enough. But things would change as the picture began to take shape,

PRO TIP This job started out targeting a test market in California for six months. We quoted them a reasonable price for this initial purpose, but I had the feeling it would go beyond that. Then we quoted an additional fee when the client came back asking to use this campaign on a larger scale, in print—including posters and ads—though still in California.

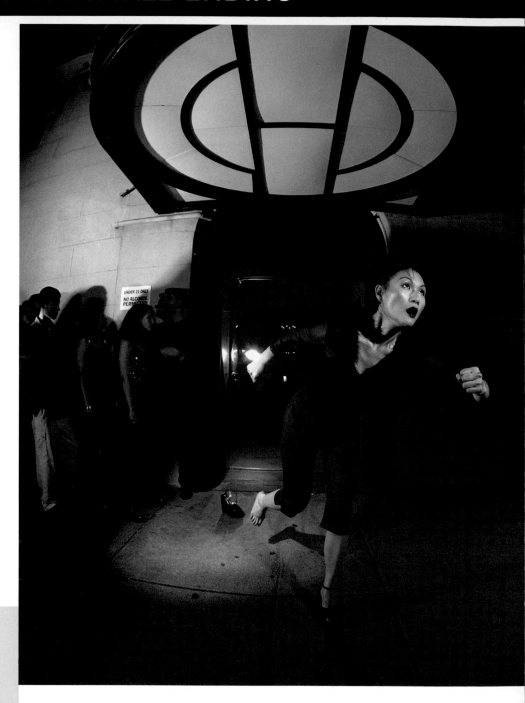

Cinderella loses her "slipper" for a promotional poster, in a set involving several gelled lights.

especially since we hadn't yet chosen a location. That location turned out to be the entrance to Miles Standish Hall at Boston University—not a real club by any means. That meant we'd have to take it and create a club-like atmosphere—mostly from the outside.

When I arrived at the location, I decided to go with a 37mm lens on a Mamiya RZ, to provide a

JOB SHEET

CLIENT: **Marshalls**

USAGE: **Advertising**

AGENCY: **Hill Holiday**

ART DIRECTOR: **Caroline Lawrence**

LIGHTING: **Strobe**

CAPTURE: **Analog**

PHOTOGRAPH COPYRIGHT ©**Rafael Fuchs**

PRO TIP Always be prepared for the unexpected. In this instance, the location scout had gotten all the necessary permits, but after we'd arrived we discovered there was a problem: we couldn't block the entrance, since students needed to use it. In the end, we sorted it all out to everyone's satisfaction.

certain perspective that would transform the scene. Besides, I didn't have much room to move back, and we needed space to include a line of people waiting to get in—another element that changed from the layout. The film was Fuji RDP 220. We'd end up shooting six rolls.

The only prepping we had to do was to drape some fabric over the entrance, to give it a more club-like appearance. Originally, the art director asked the prop stylist to add a step in front of the entrance and to put the shoe on top of the step, but once we started shooting, we realized that wasn't working—it didn't look real, so we removed it.

We set up an hour before dawn and shot for about 45 minutes. The key model came from an agency, while the others were acquaintances of people involved in the shoot and who happened to live in the area. We had enough people to form a long line, but couldn't get them all in the picture.

We started lighting inside the entrance. On a radio slave we had a Norman 400 gelled magenta, aimed toward the camera but downward, only barely hitting a turnstile just inside the doorway. The turnstile didn't need to be highlighted, so I left it fairly dark, along with most of the entranceway, to give the impression that this was indeed a club and not a school entrance. All the other lights were existing.

Dyna-Lites provided illumination for the rest of the shot, running off 1000 W/S packs, with some lights sharing packs. The next light was a yellow-gelled light, coming in from the left, about head height, just slightly to camera left, hitting the model. I was about four to six feet from her. The area overhead, which in the photo looks like a light source, was actually reflecting this same yellow light.

For the line of people I had two lights, one gelled yellow, the other blue, about 6 feet apart, both to the extreme left of the frame. These lights were waist-level and aimed upward so they cast very noticeable shadows. Each served as a complementary fill color for the shadows cast by the other light. I allowed the blue light to spill out a little bit.

I added a grid light on the key model—coming down on her from a little above head height, slightly to the right of camera. Then, because the floor and wall to the right and behind her were too dark, I added a red light, which was aimed mostly at the floor but spilled onto the wall behind. The area of wall above that still needed something, so I had one more light gelled blue. I wanted it dark, but not pitch black.

The light from inside the entrance was hitting the shoe. Still, I needed fill to bring out the shoe just a little more, which I achieved with one more grid on low power.

We tried a few shots with the model running, but they didn't work, so we directed her to hold her position. The problem with having her moving was that it was important to capture her bare foot clearly, along with the shoe that presumably fell off her foot. The stationary position proved to be the best solution.

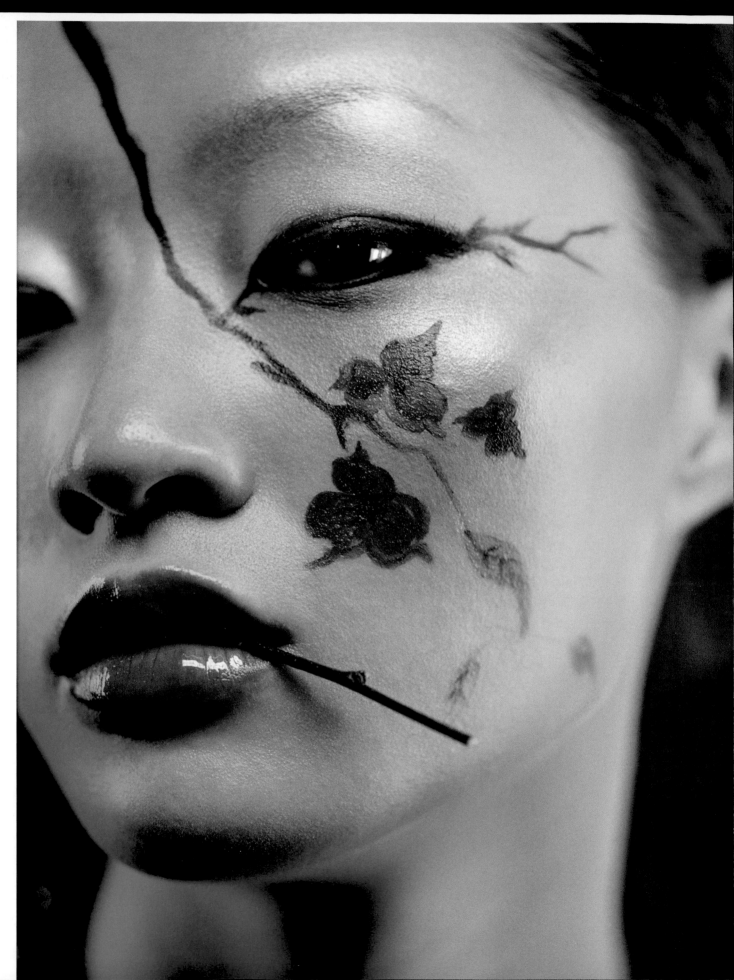

JOB SHEET

CLIENT: *Zink* magazine

USAGE: **Editorial**

PUBLISHER: **Sheriff Ishak**

MAKEUP ARTIST: **Paul Innis**

LIGHTING: **Kino Flo and flashlight (plus existing light)**

CAPTURE: **Analog**

PHOTOGRAPH COPYRIGHT ©**Remi Rebillard**

PRO TIP The benefit of personal work is that it lets you experiment with lighting. Using Kino Flos in this instance allowed me to define and shape the model's face and give it a nice glow.

Beauty is more than skin deep, as this photographer shows. The lighting had to support the three-dimensional quality of this stunning face, while allowing us to wade in the deep pools of thought behind those captivating eyes.

Every once in a while we have the opportunity to put our best foot forward—when clients ask for work that is "edgy." A new fashion and beauty publication out of New York was one such client. The magazine wanted a photo spread for a story titled "Asian Botanical," with emphasis on exotic makeup. This situation was one of those instances when I could sell images already in my portfolio but could also pave the way for a continuing working relationship, with future assignments that would allow me to push the proverbial envelope further.

In my lighting, I follow the dictum once passed on to me by a fellow photographer and mentor, Francis Giacobetti, who said, "Écrire avec la lumière (write with the light)." In much of my beauty work, I start with natural light—in this instance, a north-facing skylight in a 20-foot-high vaulted ceiling in my apartment. On a sunny day, this gives me a very soft light while still creating strong shadows that sculpt the model's facial features. Every model's face is different, so the shadow on each face is unique.

Credit goes to the makeup artist for the concept behind this image: painting a floral pattern on the young woman's face. Something I saw a while back

provided a means to enhance the image by adding a twig, which the model would hold in her mouth, thus giving the shot more depth. The final element would be the lighting, a combination of the aforementioned skylight alongside various light sources to add dimension and texture to the shot.

The model stood 10 to 12 feet away, facing the skylight, which produced that neutral band of illumination and those crisp shadows under nose and lower lip. In order not to dilute the shadows, it was necessary to practically surround the model in black velvet, with a curtain draped in front of her and to her right. To block another window, I suspended a large black gobo above the set, to the model's right. And I spread black velvet on the floor to further prevent unwanted reflections. The background, four feet behind the subject, is a dark gray seamless paper fading nearly to black.

After shooting Polaroids with the skylight alone, I saw where we needed additional lighting, so I began with two 4x4-foot Kino Flo banks, on C-stands. There was one on either side of the model—gelled green, in keeping with the foliage theme, three to four feet away. These lights were positioned behind

A combination of skylight, Kino Flos, and Maglites blend to form the perfect complement to this unusual floral makeup motif.

the subject, at about a 30-degree angle, one stop under the skylight illumination levels. One bank appears more intense in the photo because the model is turned toward that light. To prevent flare in the camera, I added two 2x4-foot flags, one on either side, supported on C-stands.

I then brought in two Maglites, supported on C-stands, placing each 15 to 20 inches behind the model. The one further back was gelled red and trained on her ponytail, while an orange-gelled light was aimed just below her chin, for a sliver of defin-

ing light. This aspect of the shot was actually the most difficult. Whenever the model moved her head, these lights had to be repositioned.

I prefer warm skin tones from my film. In this instance, I loaded my Hasselblad with Kodak Portra 400NC, which meant I wouldn't have to add any warming filters onto the 120mm lens. The exposure was based on a reading of the skylight, which gave me 1/125 at f/5.6. Camera-to-subject distance was three feet.

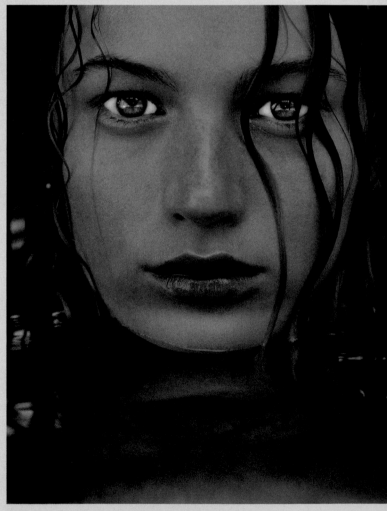

PERSONAL VISION

PHOTOGRAPH COPYRIGHT © REMI REBILLARD

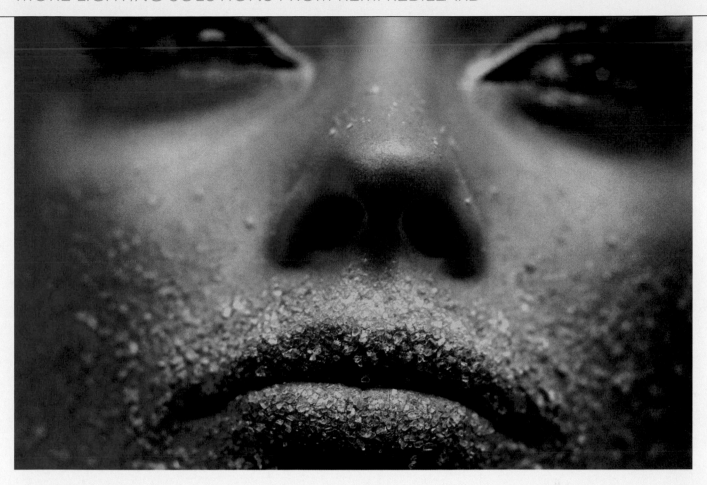

JOB SHEET

CLIENT: **ZooZoom.com**

USAGE: **Editorial**

CREATIVE DIRECTOR: **David MacIntyre**

LIGHTING: **Kino Flo (plus existing light)**

CAPTURE: **Analog**

PHOTOGRAPH COPYRIGHT ©**Remi Rebillard**

An online fashion and lifestyle magazine asked me whether I had stock pictures to illustrate a story on the role sugar could play as an exfoliant. I said no but that I'd be happy to shoot it—and was given the assignment to photograph what I call "Candy Girl." I had carte blanche to design the shot, the only directive being that the model's face would be covered in sugar. I felt that it would be especially interesting to see how the lighting would play with the crystals bedecking this model's face. We produced four images for this assignment.

I began with the skylight in my homemade studio and a black velvet surround, along with flags to prevent flare. As in a previous shot, I again employed my Kino Flo banks. However, in this project the banks were almost touching the model's face—that's how close they came, one on each side—and were parallel to each other, at eye level, with each one gelled blue. The brighter skylight opened up an area on the face with neutral light.

To get this tight (1 ½ feet from the face), I had to use an extension ring on a 120mm lens on my Hasselblad, for an f/8 exposure at 1/60, on Portra NC.

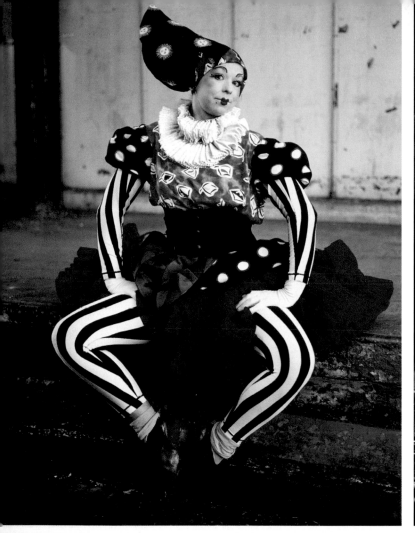

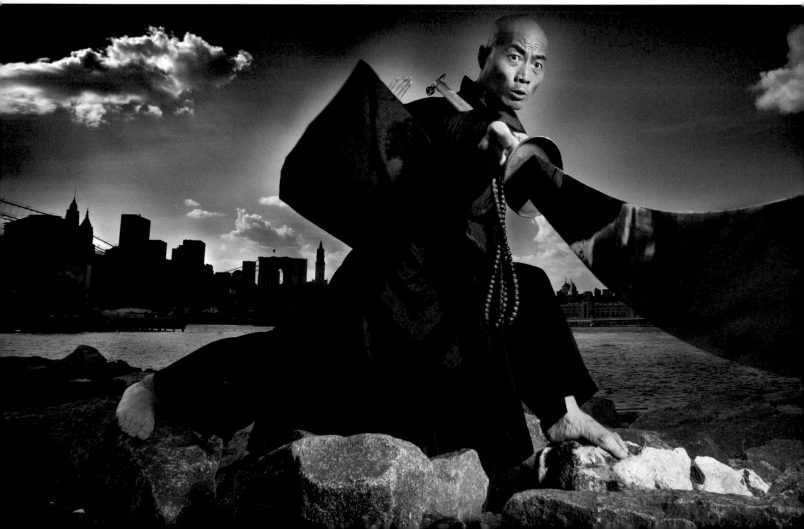

lifestyle and portraiture

There are different ways to approach a portrait. But whether posed or candid, stylized or slice-of-life, the lighting imbues the shot with a certain definable character and mood.

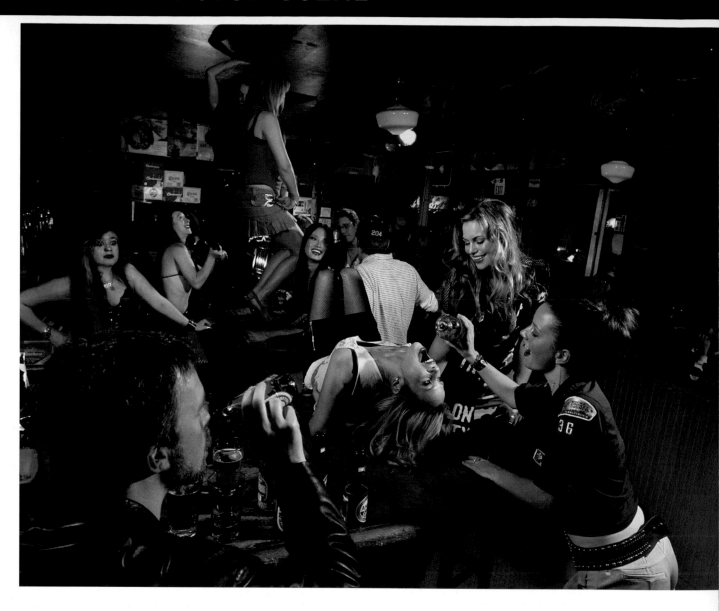

apturing the vitality of the club scene requires a keen eye. Without overplaying its hand, the lighting has to both support the ambience of the setting and highlight the key players. Not an easy task, as you'll see.

Strobe lighting supports the playful mood in the bar, enhanced with warming gels to imbue the shot with a more inviting atmosphere.

Dive bars these days are no longer the misbegotten drinking establishments we recall from the days of vintage Hollywood cinema. Today they are trendy, with a mix of clientele that adds a unique flavor and texture to the place—but still with a hint of tantalizing mystery, fun, and excitement.

As part of an annual roundup, *Stuff* magazine was featuring popular dive bars around the country. Most involved straight shots. In this instance, however, the magazine's creative director wanted to produce a distinctive and lively atmosphere, with the scene at this New York City tavern populated by young people enjoying life. That was the basic premise. With no layout to guide me, I was free to go with the flow, pretty much just telling our cast of characters—a select number of them models,

JOB SHEET

CLIENT: *Stuff* magazine

USAGE: **Editorial**

CREATIVE DIRECTOR: **Sam Syed**

ART DIRECTOR: **Ian Robinson**

PHOTO EDITOR: **Fabiana Santana**

FIRST ASSISTANT: **Paul Ambrose**

LIGHTING: **Strobe (plus existing light)**

CAPTURE: **Analog**

PHOTOGRAPH COPYRIGHT ©**Rafael Fuchs**

PRO TIP When going into a shoot that involves a lot of people, my basic approach is to let everyone at first be themselves—let them mingle so I can see how they work together naturally. Then I make adjustments and give direction where needed, making sure supporting players don't obscure key people or, in this instance, telling the model to bend over backward playfully on the bar. Then I establish the mood. In this case I told them that it's a dive bar, one of the best in the country, and that they're having fun in this social context. Then I turn the music on and let it all happen.

the rest magazine staff members and bartenders—just to have fun with it. From shot to shot, we changed characters and modified the activities somewhat.

With so many people, so much lighting, and the frenzied shooting pace, I needed three assistants on this job. The camera was a Mamiya RZ67 with 50mm lens, handheld and loaded with Fuji RVP 100-F Velvia. We rented Profoto lighting locally, from Foto Care. All our strobe packs were 2400 W/S.

The biggest challenge was lighting in a way that supported the original atmosphere and mood and, at the same time, accentuated selected faces that were vitally important to the shot. For our key players at the bar (foreground), I positioned a key light in the bottom-left corner, up high. This head had a ½ CTO to warm it up so it balanced with the ambient light, giving us that cozy bar feeling, and toughspun to soften it enough so as not to be too hot on their faces. This light is also hitting the Asian woman by the dancer atop the bar.

Right inside the front door we had a 40-degree grid spot with toughspun, on a boom and practically touching the ceiling, pointing downward. This light is hitting the people on the far right. It was toned down so that the peripheral areas of the shot would remain supportive and not conflict with the key light. A few feet to the left of this light (about midway to the bar), I had one light sharing a pack with another head that was adjacent to it and even closer to the bar. That first head came from a high angle, with a 40-degree grid, and was aimed at the near corner of the bar, primarily at the dark-haired and blonde models to the right of center. The next light was a 30-degree grid with Cinefoil to contain the light in a more defined pattern, and positioned on the floor, with a flag above it. This light helped to bring out the red carpeting behind those models.

We also needed to light the women dancing on the bar. So we stuck one head practically underneath the bar, with a snoot, Cinefoil, and thin red gel, and aimed it straight up. That also gave us the ceiling highlight and shadow.

The area in the very back was still too dark, so I added two heads (off one pack), rigging them to the side of the table, each with a half-orange gel. One was aimed at the back wall, the other just behind the seating area, at a pool table.

We had several more lights. One 40-degree grid was high against the ceiling, facing the bar, with yellow and half-orange gels. I wanted to make it warm, but not overly so. This light was positioned just behind the young lady on the bar, adding some highlights to her features. I stuck another light in the glass, inside the cover of the pool table, with another head on a table facing the wall on the right. Finally, we had a 20-degree grid for the guy in the foreground, coming from the side.

We started setting up at 9 AM, were shooting at noon, and were gone by 6 PM. We had to be out before the bar opened.

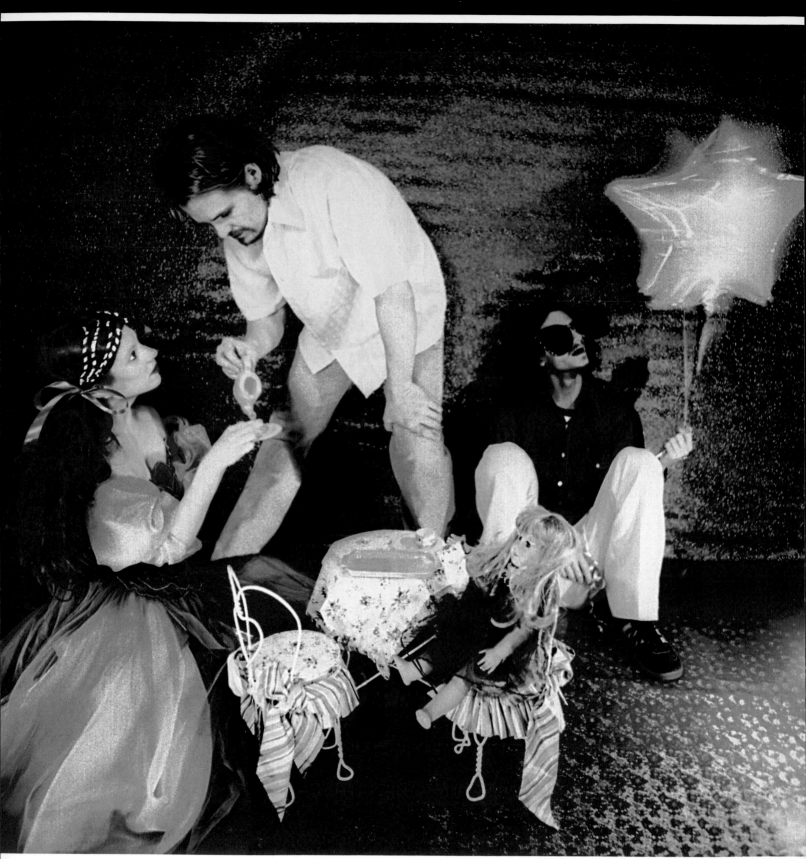

JOB SHEET

CLIENT: **Void Lucy**

USAGE: **Collateral**

LIGHTING: **Incandescent**

CAPTURE: **Analog**

PHOTOGRAPHS COPYRIGHT ©**Tammy Magnatta**

This photographer shows us an unusual way to light a set. Metal and Mylar mix to grab the lights as she presents a colorful fantasy tale.

Rock band Void Lucy was about to release their debut CD, *Seems So Charming*. Lead singer Jill Bowden said they wanted the pictures for the cover and liner notes to reflect a Cinderella-like story, in keeping with the storyline of the album, and of course featuring the band members. After I listened to the music, I came up with this idea for a fantasy scenario, with a set representing a dollhouse. These pictures were also used on the band's website and in promotions.

We shot this series in a loft in Manhattan's East Village, which meant there were restrictions on the amount of electricity I could draw on for my lighting. To be safe, I opted for low wattage (60-watt) clamp lights, purchased at a local hardware store and plugged into power strips. These lights made it easy to throw splashes of color around the set. Each head was fitted with a commercially purchased reflector, with some diffusion to soften the light.

Doing my own propping and wardrobe, I picked up the doll set at Toys"R"Us and an old prom dress-

at a thrift shop. I customized the gown to make it more fairytale-like for our purposes. Additional elements included the balloon and the glasses brought in by one of the musicians. The wardrobe chosen for the male band members was a mutual decision, and they arrived on the set ready to go.

For our fantasy set, we needed an atypical wall and floor. These came from Canal Plastics (also in New York City). The wall, our backdrop, was a shiny metallic, crunchy-textured paper suspended from a horizontal pole. The floor material was Mylar.

I scrunched down a bit, to be roughly at eye level with the main characters, with a rented Pentax 67 (with normal lens) on a tripod. Film was Fuji Provia RDP3, cross-processed to achieve this unusual palette of colors. The final exposure was five seconds at $f/5.6$ or $f/8$, based on a light meter reading and Polaroids.

The lighting for the scene involving our small cast of characters began with the floor and backdrop, shifting over to our story characters as they

An imaginative CD called for imaginative illustration, with lighting to match. All the lights are simple clamp lights fashioned to help weave our tale.

entered the picture, and ending with kicker lights where needed. Much of the light on the floor was spill from the other lights, as well as reflected light off the backdrop.

I positioned the background light upward about five feet and to the right of the set, behind camera, coming in at an angle and aimed toward the center of the magenta backdrop. It was gelled pink. The floor light was more of a kicker, creating that hot spot off to the right, with a yellow gel. This light was practically on the floor.

With the first two lights established, I focused my attention on our main players and the props. For the character against the wall, I used a yellow-gelled light to bring out the color in his trousers. This light came in from a relatively high position, to the left and outside frame. Next was the band member pouring tea—a parody of classic storybook fashion. I brought out the yellow in the clothing with a yellow light from a high angle, several feet away to the left.

The next light was on our fairytale princess. To create a subtle blend of colors in her purple-over-pink dress and purple hair, I began by gelling one light pink. This light came at her from the opposite side of the set, camera right, slightly above axis. I added one more light on her, this one gelled yellow—from a slightly higher elevation but otherwise at the same relative position—to mix gently with the pink, complementing the contours and subtle tones on her face, neck, and arm. Some of the pink and yellow light was allowed to spill onto the doll set.

The only element still lost in shadow was the magenta balloon. Knowing that cross-processing and the mix of gels would boost saturation of the dark colors and wash out the light tones, I wanted just a hint of contrasting color. So I added a blue-gelled light high and off to the right, aimed at the balloon. The long exposure caught the balloon's gentle swaying as a soft blur, as if capturing the ethereal passage of time in this fantasyland.

Here too, gelled lighting plays a key role in highlighting our central figure.

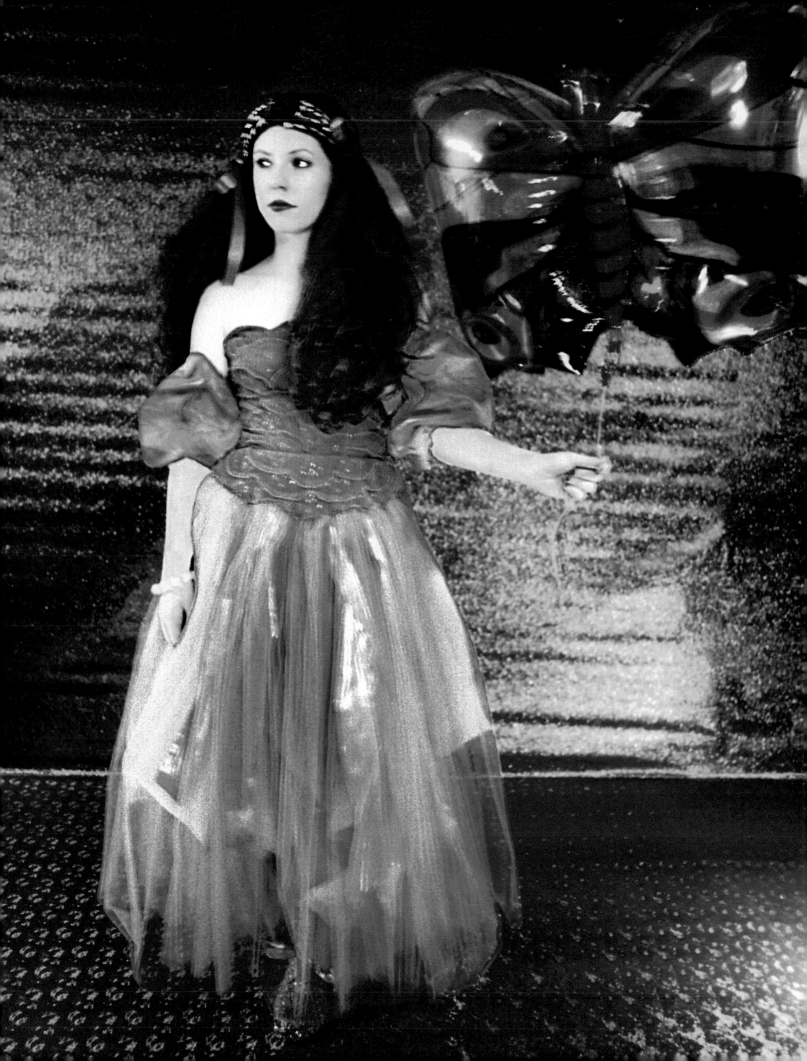

LIGHTING AN ACTION PORTRAIT

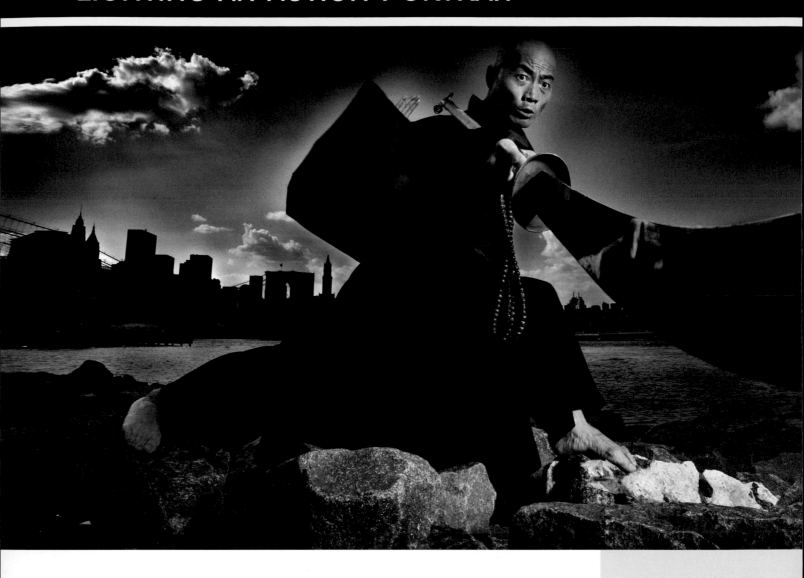

Forget what you've seen on TV—this Shaolin monk is the real thing. Creating a forceful portrait such as this requires a deft choice of location coupled with an equally adept use of lighting.

Sifu Shi Yan Ming, a thirty-fourth generation Shaolin temple fighting monk, had written a book entitled *The Shaolin Workout*, based on the martial arts that he practices and teaches. Now it was time to illustrate this tome.

In addition to showing Shi Yan Ming's technique, the book contained a dramatic shot of the martial artist in each of its four sections—it was here that we had the freedom to devise each shot as we went along. We would end up spending four days in the studio and two on location, heading to each setting with different outfits and weapons for him to use. I let him dictate the pose, giving him my input in terms of what looked good for the camera. Once we shot the first round of images for the training sessions, we were able to place the JPEGs into

PRO TIP I opt for the Elinchrom Ranger system because it's fairly affordable and relatively lighter in weight than a comparable pack. It has a waterproof seal, which makes it especially handy outdoors.

JOB SHEET

CLIENT: **Rodale Press**

USAGE: **Editorial**

DESIGNER: **Ellen Nygaard**

PRODUCER/LOCATION SCOUT: **Dagmar Wong (Oxen Productions)**

FIRST ASSISTANT: **Takeshi Hayashi**

LIGHTING: **Strobe (plus existing light)**

CAPTURE: **Digital**

PHOTOGRAPHS COPYRIGHT ©**BobScottNYCInc.**

PRO TIP With digital cameras, Polaroids and handheld meters are not necessary. Actually, in this instance I didn't even use the meter in the camera-I set the exposure manually and previewed the shot until it felt right.

the book design for rough layouts, and the art director was able to see what else needed to be shot, which shots worked, and which didn't.

There were numerous locations, among them this setting with Manhattan and the Brooklyn Bridge as backdrop, and another the USA Shaolin Temple—the institution Shi Yan Ming established in New York City for training and study. I tech-scouted both locations, although it was necessary for the location scout to secure permits only for the outdoor shot. With regard to this site, I especially liked that we could use the rocks as a platform for Shi Yan Ming to stand on—much more fitting than flat, lifeless concrete.

For the outdoor shot, we brought along a mobile set cart with all the packs and heads, enabling us to move around quickly and easily. The day we shot— an afternoon in August, with the sun edging slowly toward the western horizon—the wind played with Shi Yan Ming's robe, and the clouds imbued the scene with just the right mood. But I knew that adding some lights to the shot would definitely give it a little more punch.

We employed Elinchrom Ranger packs—three in all. The use of these battery-driven packs obviated the need for generators on the street. Each pack was set at 1100 W/S, max.

Battery-driven strobe lighting comes to the fore to capture the dramatic action in this portrait.

The main light was an Octabank off to the right, with ½ CTO for warmth and added diffusion. We positioned this light at eye level, six feet away, almost squarely to his right. All the lights are on mini-rollers to make them easy to move around.

I used the ambient light to help with the surrounding environment, as well as for fill. That said, it's typically far easier for me to bring in a light and adjust it accordingly than to depend on the available daylight to produce the effect with bounce cards. So next we introduced a large silver umbrella, with diffusion to bring down the intensity, aimed at the back of Yan Ming's neck from a high angle and off to the side.

There was also a fill light in front to help with the sword. I wound up burning that down in postproduction. This light was bounced into the foamcore, from roughly the same distance away as the umbrella, which put them both at 12 feet. I had to get them out of the way of the background because of the wide lens. The umbrella was above Shi Yan Ming's height, coming down a little; the foamcore stood supported by a C-stand. The light on his feet came from the foamcore or Octabank, and then we burned it down.

I shot this on a Canon EOS-1Ds Mark II with 16-35mm lens at 16mm, on a tripod. I shot wider to capture the breadth of the scene, the bridge and skyline, as well as the in-your-face attitude that comes with forced perspective to make the shot more dra-

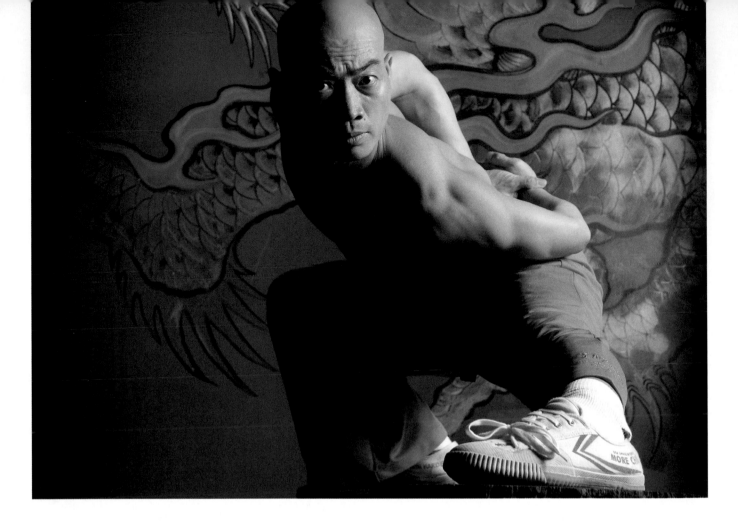

matic. I stood far enough away so that the sword extended past the lens. I used a Custom WB setting off a card reading. The exposure was f/13 at 1/250.

In post, I added vignetting using the dodge-and-burn tool in Photoshop, to help focus more attention on Yan Ming and the sword. I also increased color saturation. I burned down parts of the water and buildings in the background and then opened up the highlights in those areas where I burned down to get a little bit of detail. There was also some retouching

An umbrella on axis with the monk makes is the only light that was needed to produce this indoor portrait.

of the sword itself to soften the reflection of the foamcore that stood in the foreground. I had thought of adding a face reflected in the blade, but that seemed too contrived. This was simpler and more effective.

I didn't need to go as wide for the indoor shot, opting instead for the 28-70mm lens. This is cropped from a vertical, again, with vignetting added. I originally shot it in color and later desaturated the image in Photoshop.

The lighting was kept simple. There was essentially no daylight, with weak window light streaming in from some distance away. The monk stood five feet from the wall, and I was five feet from him, with the camera handheld. Our one light—a large umbrella with diffusion—was positioned to camera right, on axis, thereby creating a sharp falloff. Even though we were indoors, I still preferred the convenience of the Ranger pack, with no wires.

PRO TIP On this shoot I had a digital tech person handling all the file management, as well as two assistants working alongside me. We always worked off a Mac G4 laptop, but shot untethered outside for mobility. When I'm outdoors, I like the flexibility of moving around. When we were done with one card, we'd rush it over to our digital artist. Each time we changed the shot, we changed the card, working with 4 GB SanDisk Extreme 3 cards.

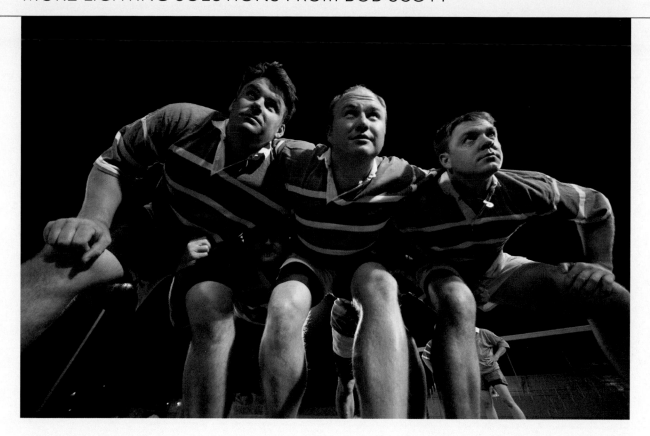

JOB SHEET

CLIENT: *S3* **magazine**

USAGE: **Editorial**

EDITOR IN CHIEF: **Taylor Drotman**

FIRST ASSISTANT: **Stacie J. Steensland**

LIGHTING: **Strobe (plus existing light)**

CAPTURE: **Digital**

PHOTOGRAPH COPYRIGHT **©BobScottNYCInc.**

My passion for sports led me to the University of Delaware's Rugby Club, to photograph a scrum formation for a 4x6 self-promo postcard that I sent out to editorial clients. The postcard even reached the Turks and Caicos Islands: it prompted the editor of a high-end travel publication to review my website and later hire me for a special project focusing on the upsurge of team sports on the islands. She arranged for me to fly over and photograph a laundry list of island sports for what would amount to a 10-page spread encompassing 14 shots. As luck would have it, once this shoot was over, another assignment was waiting in the wings—not sports-related, but on the islands.

When I arrived at the airport in the evening, I was whisked off to a stadium to photograph a practice game. For this shot, she wanted me to duplicate the promo shot from the postcard. I showed the promo card to the team, and they attempted to recreate the look.

Since I was shooting digital, we had the luxury of previewing each series of exposures, so we knew fairly quickly when we had the shot. My camera here was a Canon EOS 1Ds Mark II, with 14mm f/2.8L lens. To make the shot more interesting, we took some liberties with the scrum (technically, it should be a circle involving both teams). I was less than three feet away, obviously shooting from a low position. The camera was set to ISO 800 for an f/2.8 exposure at 1/125.

Since we were in a time crunch, I needed to keep the lighting simple. I used the existing stadium lighting for the background. Beyond that, we set up a portable Elinchrom Ranger Pack on full, with one head (with umbrella reflector) attached. My locally hired assistant hoisted the light up 12 feet on a Bogen stand (modified for travel) and held it about 25 feet away, pretty far to the side, from a slight forward angle—enough to give the shot some shape, to support the stadium lighting.

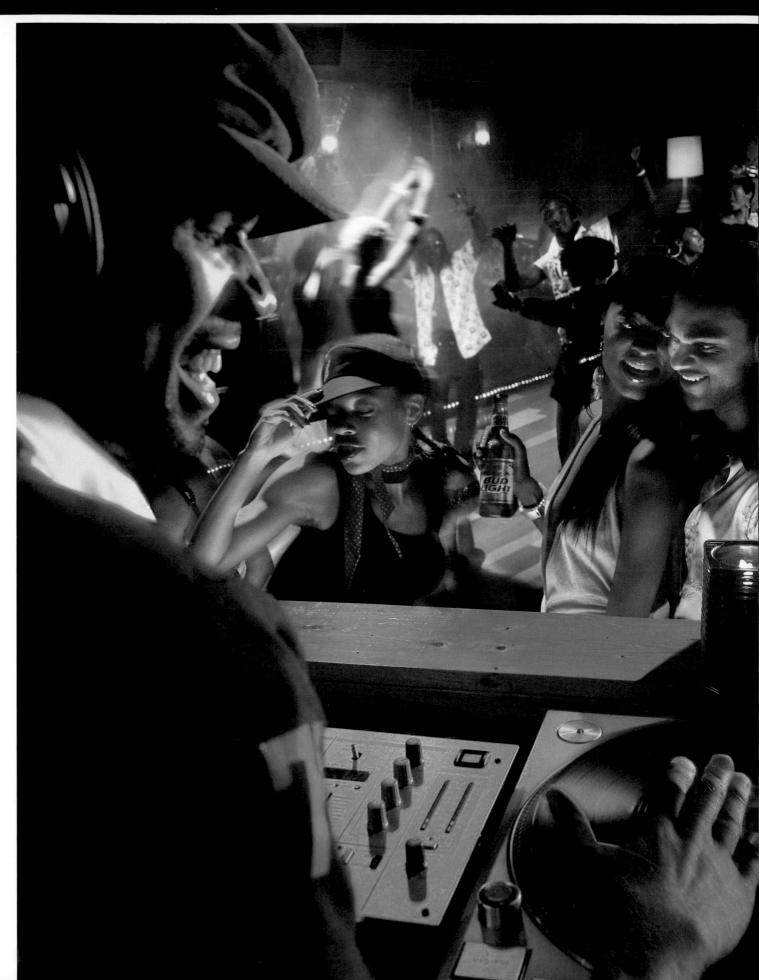

JOB SHEET

CLIENT/AGENCY: **Rio Creative**

USAGE: **Collateral**

CREATIVE DIRECTOR: **Jeff Hutson**

ART DIRECTOR: **Ron Fleshman**

PRODUCER: **Kelli Langston**

FIRST ASSISTANT: **Bryan Cirar**

WARDROBE STYLIST: **Skylar Barnes**

HAIR STYLIST: **Chaun Poplar**

MAKEUP STYLIST: **Kishina Covington (with Talent+)**

LIGHTING: **Strobe**

CAPTURE: **Digital**

PHOTOGRAPHS COPYRIGHT ©**Brian Kuhlmann**

PRO TIP I like to keep the smoke machine mobile. I have one grip whose job it is to move the smoke machine around the set, alongside another grip with a foam board to fan the smoke where we want it and spread it out, so it doesn't build up density in one spot.

It's rare to have the opportunity to go all the way back to the making of a shot, but such is the case here. The photographer's success led to the agency's success. It's a complex tale involving the creation of a mood and lighting.

The ad agency hired me to shoot a test image so they could pitch a promotional campaign to Anheuser-Busch. The theme centered on a high-energy set with a hip-hop flavor. Everything went as planned: the shot was a success, they won the account, and we got the job to shoot the actual campaign—except that the final image would be a little different. It was very important to the brewery that all talent be at least 25 (while looking 21) when the ads would break, and some of our people were a bit younger. So we had to modify the shot to some degree.

The only directive they gave me for the original shoot revolved around the position of the DJ on set. The rest was up to me. We shot on a Hasselblad 503CX with Phase One H20 digital back and 40mm lens, at ISO 50 for an f/5.6 exposure, with Broncolor lighting. Setup took three hours, with two assistants on set.

This shot caters to a hip, young crowd, with high-energy strobe lighting and a smoke machine adding to the party atmosphere.

The location was the Pepper Lounge in St. Louis. I didn't have too much trouble finding the club or getting permission to use it, since I know the owners. I had visited the club on several occasions prior to the shoot, to see it in action and to get a sense of the space. From there, I developed my lighting scheme. We were scheduled to shoot in the morning, finishing up well before the club opened. Of course, we'd have the music blasting, imbuing the room with the needed energy.

With the camera about three feet from the DJ, I directed the young people in the foreground to have fun but to continue facing the camera, since they would be prominent in the shot. Other than that, I pretty much left everyone to their own devices.

The existing club lights, or "practicals," as I call them, were left on. Contributing even more to the club atmosphere was a smoke machine, which picked up the light in the background.

The first light up—for the DJ—was a Grafit 20-inch dish, from camera right and several feet away. The camera was up on a podium, three feet above

the dance floor, with that light another six to eight inches above that, coming pretty straight at the DJ. To help separate him from the crowd, while adding depth to the scene, we gelled the light blue-green, producing the highlight on his face and spilling over onto the console below.

The dancers in the foreground were only a couple of feet from the front edge of the DJ booth. And they obviously needed their own light, especially since they were holding the product. So next we positioned a medium Chimera striplight at the foot of the DJ stand, aiming it up toward them. This had a thin warming gel. Next came a head with a P45 reflector, edge-lighting these same club-goers. This light was up against the ceiling—probably 12 feet up, shooting back down toward camera, a couple of feet behind them, gelled blue, with a medium grid. Each light was on its own 3200 W/S pack, powered down.

The bright area on the floor came from a P90 reflector with medium grid. It was set up in a very similar fashion as the light I just described, except that it was aimed into the floor and into the dancers in the background. This also produced the bright highlight along the dancers' arms while backlighting the blonde woman's hair. I added a slight warming gel.

We had two Chimeras on the right. The one toward the back had a slight warming gel, lighting the raised arm of the one dancer at the right edge of the set, as well as the girl in front. This light was positioned six or seven feet from them. The other

This photograph was from the campaign the agency landed following the success of the DJ shot.

LIFESTYLE AND PORTRAITURE

Chimera was more toward the front of the set, aimed back toward camera, edge-lighting the talent in the foreground from that side.

There was one more medium Chimera all the way up against the ceiling, lighting the booths beyond the dancers and running along the wall underneath the two practicals (top center of frame). It was right above the P90 head, with a blue gel, shooting back through the haze, helping to give it more life. It was hidden by an air duct right above the DJ's head. The final light was a P45 head all the way at the rear, throwing a blue-green highlight on the back wall, with a medium grid.

I had a Mac G5 with 20-inch monitor with me, with the camera tethered. The computer and monitor were on a rolling cart so they could be moved around as needed.

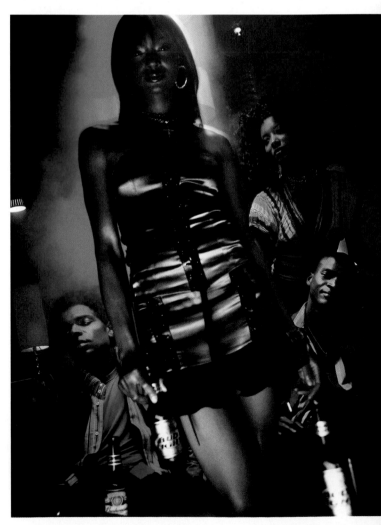

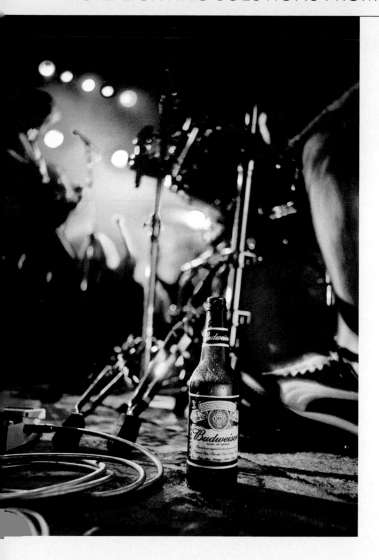

JOB SHEET

CLIENT: **Anheuser-Busch**
USAGE: **Collateral**
AGENCY: **The Shaw Company**
CREATIVE DIRECTOR: **Steve Brenner and Greg Litwicki**
ART DIRECTOR: **Marc Stitzlein**
PRODUCER: **Kelli Langston**
LOCATION SCOUT: **Charlene Colombini**
FIRST ASSISTANT: **Stefan Hester**
GAFFER: **Dave Berliner and John Sennott**
PROP STYLIST: **Bridget Anderson**
WARDROBE & PROP STYLIST: **Vivian O'Gier (Talent +)**
HAIR & MAKEUP: **Carolyn Parker (Talent +)**
CASTING: **Carrie Houk**
LIGHTING: **Tungsten and HMI (plus existing light)**
CAPTURE: **Analog**
PHOTOGRAPH COPYRIGHT ©**Brian Kuhlmann**

The Anheuser-Busch brewery had a rockin' promotional campaign in mind—showing Budweiser beer at a hard rock bar, taking center stage alongside the band. We produced this shot for point-of-purchase.

The art director and I scouted locations together and found this bar, called Off Broadway, in St. Louis. In this shot, we worked to a layout that had the camera behind the scenes, looking out toward the crowd. Still, I did have some creative freedom.

Anheuser-Busch has been moving away from a highly stylized look in their bottles, so they directed us to keep it as real as possible. On the other hand, I did try to exercise some control. The bottle did need an extra touch to look fridge-fresh, so I added a few fake ice crystals that dripped down. We also replaced the original label with one supplied by the client, to minimize retouching in post.

The dancers were all cast from a local modeling agency. We scouted probably a half-dozen different bands locally until we found this heavy-metal group, Riddle of Steel. We styled everything down to the position of the drum set and cables. I didn't give the band members any specific direction other than to tell them that the camera would be behind them and that they should play to the crowd but try to work toward camera a little bit so I wasn't just shooting the backs of heads. I had my Hasselblad with 40mm lens nestled in a sandbag on the floor, making my exposures on Kodak 160VC, which we later scanned.

Our lighting began with the existing practicals, which were variously gelled to give the scene more of a happening look. Then we added a blue 1K tungsten Par 64 right in front of the lead guitar, a yellow 1K Par in front of the drum set, and a third 1K hidden behind the drums. These "rock & roll can" lights, along with others brought to the club, were rented.

We then added two 200 Par HMIs—nice little lights that we could snoot and barndoor. There was one directly behind the beer bottle, overpowering those lights in the ceiling and backlighting the beer while adding a little bit of a glow. The second one was to the left of camera, again behind the bottle to edge-light it.

The label needed some light, so I opted for a 200-watt Dedolight, positioned to the right of camera, on the ground, very close to the bottle. There was a white card off to the right, by the Dedo, highlighting the neck of the bottle. There was also a barndoored 1200 Par HMI with blue gel (visible in frame, right underneath the drumhead). It was behind the crowd, coming back toward camera a little bit and creating all the atmosphere through the smoke.

CAPTURING THE GLOW OF YOUTH AND FIREFLIES

The assignment called for an arresting image to be used in a trade show. The photographer wanted it to be uplifting as well. Little did he realize he'd have to photograph fireflies. He managed to carry it off in this glowing montage to celebrate youth, being the master of lighting that he is.

Ideas are one thing, and execution another. I needed input from my digital artist to determine whether the image in mind would be feasible in the time allowed. He gave me the nod, and with the approval of the client, we started work on "Fireflies," our glowing tribute to our children, their future, and their never-ending world of wonderment.

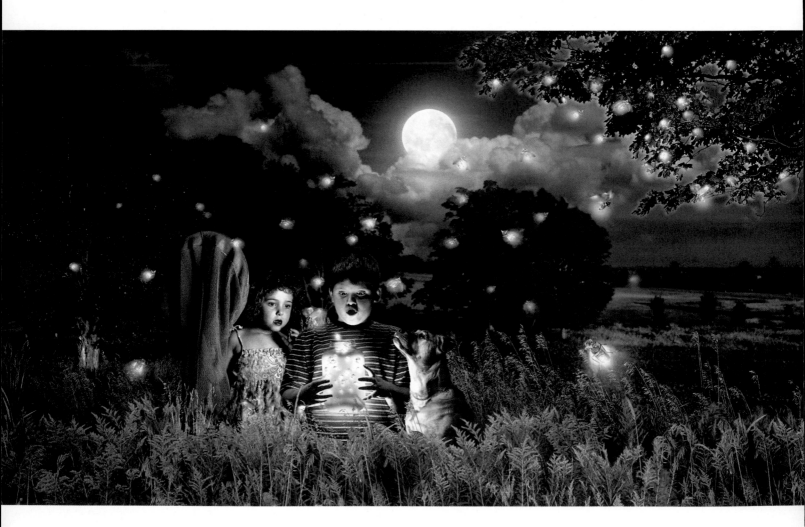

JOB SHEET

CLIENT: **Colourgenics**

USAGE: **Collateral**

DIGITAL ARTIST: **Tom Klusek (Visual Edge Projects)**

FIRST ASSISTANT/WARDROBE/PROPS: **Stephani Buchman**

LIGHTING: **Strobe (plus available light/light-painting for various elements)**

CAPTURE: **Analog**

PHOTOGRAPH COPYRIGHT ©**Don Dixon Photography**

PRO TIP Individual components may need to be shot and digitally composited from scanned film. To ensure a perfect fit, many elements may need to be shot in collaboration with a digital artist.

This shot, a digital composite, represents the wonderment that a meadow filled with fireflies inspires in our children, and was meant as an uplifting message following the many recent tragedies that befell us.

We shot the landscapes in the Caledon Hills, north of Toronto, in midsummer. I spent the day driving through the countryside on my motorcycle and made notes of different perspectives that I liked, using a compass to pinpoint the best vantage points and optimum times. I shot the harvest moon separately with my Nikon F5 and a loaner 600mm lens. It was a beautiful day, with nice, deep blue skies, but we didn't have the kind of clouds I wanted around the moon, so I shot separate cloud formations. We shot the kids, dog, and jar in the studio, using a Hasselblad and 150mm lens for everything but the landscape and fireflies. The landscapes, including clouds, we shot with a Fuji GX617 wide-field camera; the bugs, with a Nikon F5 and 105 Micro. Film for every stage, except the fireflies, was Kodak E100SW.

We began the project with a large mason jar to which we applied dulling spray. I positioned the container on a tabletop, centering it over a hole cut into the surface, thereby providing an aperture just the right size for a light to enter the jar from underneath. We recreated the glowworm effect with the help of Smoke in a Can sprayed into the jar and a 200 W/S Profoto Acute 2R head with standard reflector coming up from beneath the hole. As part of this same shot, I had the little boy hold the jar. He was draped in black felt, with his hands on the side of the jar. The light from inside the jar provided the necessary

illumination. The tabletop with the jar was at a convenient height for the boy, with the camera seven feet away. All the windows were darkened for this f/11 exposure.

Obviously, we couldn't go out and photograph fireflies performing a radiant aerial dance on demand. For our final element we headed to the Royal Ontario Museum to photograph a variety of these bugs—seven in all, in different positions—inside a lab, since they couldn't be removed from the premises. With my Nikon on a tripod, I used a Mini-Maglite to light-paint the insects, which were mounted on pinheads that were later retouched out. Clamps held everything in place. The light—focused down to a spot—was aimed at the bug from the rear to simulate a normal glow, with two dentist mirrors on either side to reflect back some of the light for frontal fill. The mirrors were no more than five inches away from the bug, in a copystand lighting stance for even illumination. Then I put a piece of black felt underneath, just to block out any ambient light that would come through, with the room lights off. Each bug received the same treatment. We shot this on Kodak tungsten film, at f/22, to ensure good depth of field. The exposures went up to 15 seconds. The firefly shots were later cleaned up a bit digitally.

Back in the studio, we moved the jar and table out of the way and proceeded to photograph the kids and the dog. The young boy was first. He held his arms behind his back—they'd be restored digitally holding the jar. It was easy getting the kids to cooperate. The dog needed only a treat held aloft for him to be glued to the spot. We digitally balanced the relative sizes of the kids, dog, and jar.

The lighting was essentially the same for all three, though they were photographed individually, beginning with the boy. We positioned a 200 W/S white soft dish with diffuser three feet directly in front of him, on the ground, aimed upward. Then I put black gobos along the sides and bottom to have the light drop off outside the torso and be concentrated in the area surrounding the jar. To simulate moonlight, I added a hairlight—a 400 W/S silver dish overhead and a little bit to the rear. That light was also hitting his shoulders.

The little girl with the butterfly net was next. The hairlight in this instance was off to the right a little bit, to be consistent with the "moonlight" position. The light for the girl also lit the butterfly net. When it was the dog's turn, we removed the hairlight. There were two 4x8-foot white Styrofoam reflectors for fill, placed to the left and right of each subject, six feet back.

We brought in a bunch of weeds from a field to be part of the set; others were added digitally. We also added the trees surrounding the kids digitally. And the entire landscape, though shot in daylight, was darkened in post.

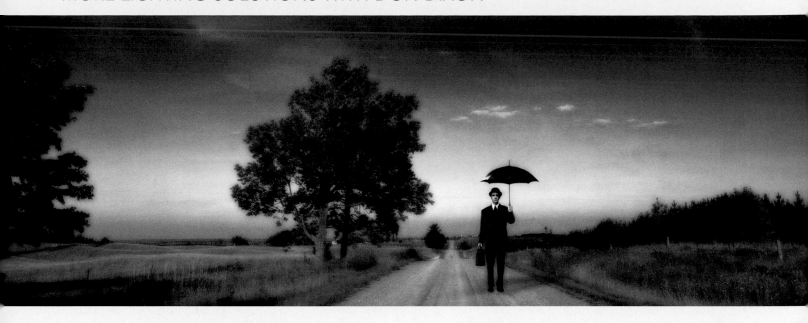

JOB SHEET

CLIENT: **AdFactor**

USAGE: **Collateral**

DIGITAL ARTIST: **Tom Klusek (Visual Edge Projects)**

WARDROBE & PROPS: **Rachel Matthews (Judy, Inc.)**

FIRST ASSISTANT: **Stephani Buchman**

LIGHTING: **Strobe (plus existing light)**

CAPTURE: **Analog**

PHOTOGRAPH COPYRIGHT ©**Don Dixon**

"Umbrella Man," as I call this piece, was intended to be fanciful and somewhat humorous—to stop people in their tracks as they walked around a trade-show floor. The client was a Toronto-based printing house.

This derby-bedecked character was a carryover from an earlier campaign, though a different model was involved in that shoot. The client approved my suggestion of putting our "Englishman" on an "English" country road—after all, it was a natural fit. It worked especially well, since I already had the country road image in my stock files, which was originally shot with a Fuji GX617.

As with much of my work, my digital artist played an integral role in making the various pieces of our puzzle fit seamlessly together. He softened the image a bit to give it more of a dreamy feel, which helped the man blend into the background. To shoot the model I employed a Hasselblad with 100mm lens, positioned 15 feet from him, for an f/11 exposure.

We shot the model—actually one of our in-house production editors—in the studio against a gray background. I had three lights on him, designed to emulate the outdoor lighting. We began with a 300 W/S grid light hitting him on the side of his face, coming in from camera left at a 45-degree angle. This light was positioned 10 feet behind him, at the level of his head, to isolate his face.

I also had a 400 W/S head up high, lighting the top of the umbrella, in the front, suspended from a super boom, a little bit off to the left. Then I added a 300 W/S head inside a 2-foot softbox in front, down low. I finished up with two 4x8-foot foamcore sheets on either side, five feet from him, for fill.

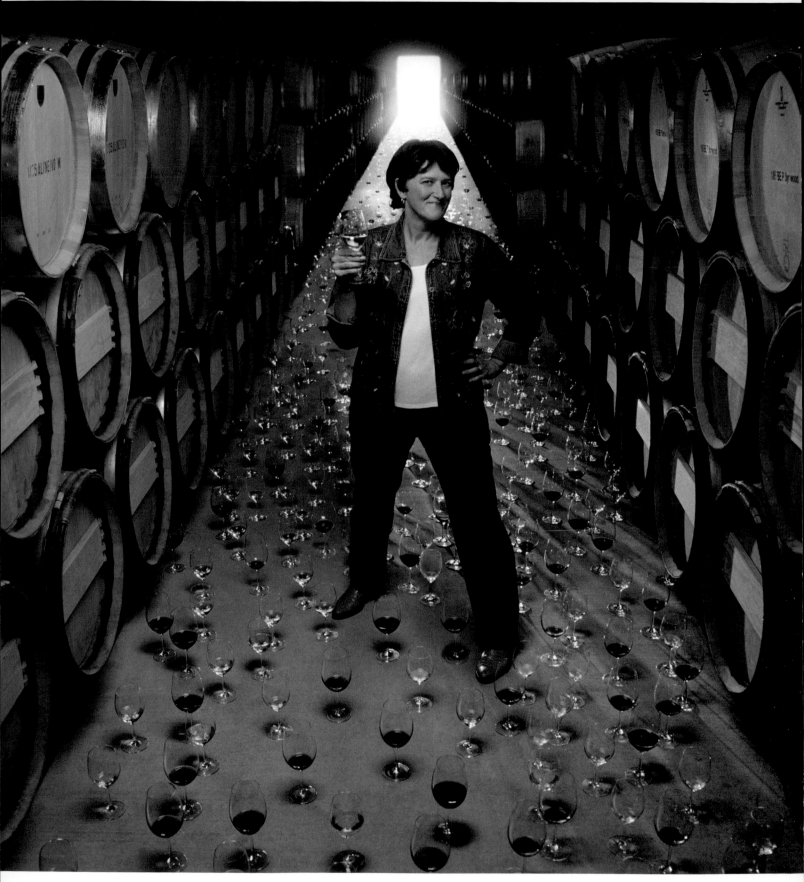

LIFESTYLE AND PORTRAITURE

JOB SHEET

CLIENT: **Woodbridge Winery**
USAGE: **Advertising**
AGENCY: **Citron and Haligman**
CREATIVE DIRECTOR: **Matt Haligman and Kirk Citron**
COPYWRITER: **Kirk Citron**
PRODUCER: **Andrea Potts**
FIRST ASSISTANT: **Joe Budd**
PROP/WARDROBE STYLIST: **Thea Chalmers**
HAIR & MAKEUP: **France DuShane**
LIGHTING/WINE BARRELS: **Strobe**
LIGHTING/OUTDOOR SHOT: **Lanterns (plus existing light)**
CAPTURE: **Analog**
PHOTOGRAPHS COPYRIGHT ©**Jock McDonald**

PRO TIP I'm not averse to shooting digital. In fact, I just finished a huge job in which I shot 25,000 exposures on a Leaf digital back. However, I still have a strong relationship with film: it's tangible. At the end of the day, that's the big draw for me—a piece of film that sits on a lightbox. It exists much more in the physical world than a digital image on a computer screen.

This series of ads, which began life as a flickering flame, has grown into an ongoing campaign, with six ads so far. As the campaign has grown in diversity, the lighting has grown in complexity. Yet it's never stopped being fun.

The shot with the lanterns was the very first ad we shot for this company, which would never have happened if I hadn't taken it upon myself to shoot it practically on spec. A call from the creative director ignited the spark. He told me about the new Woodbridge Winery account and asked how I would approach it. I donned the proverbial thinking cap and came up with a picture in which one of the winery's chief winemakers was holding a lantern outdoors, in Napa Valley, with a smoke machine adding atmosphere. I experimented with supplemental lighting. But with daylight waning, I brought out the rest of the lanterns, placed them in a circle, pulled the other lights from the set, and shot the ¼ to ½-second exposure that won everyone over. They liked the natural feel of the picture. There was also a teasing bit of mystery to it, à la moviemaker David Lynch, as the creative director had originally suggested.

That first picture had an element of fun to it—something that we'd hold onto for the duration of the campaign. Fast forward nearly three years later. My camera was then a Hasselblad 553ELX. Here, I was asked to go to a larger rectangular format, which for me meant a Mamiya RZ.

The creative director loved a shot I did with the actor Robin Williams in which he stood in a room surrounded by mousetraps. Apropos of the situation, he suggested we use wineglasses to build upon the original concept. We bandied the idea back and forth at several production meetings, trying to decide whether it should be just white wine or white and red, and how many different glasses to use—we ended up with 2,000 (mostly rented, with some of the finer goblets bought). For better translucency and color, we decided to dilute the dark wine.

The one problem we had with the location—Bell

Although the lighting is nearly symmetrical, the big blast of light from the back helps define the wine goblets and sets the tone for the shot.

Room One of the Mondavi wine barrel rooms—was that the barrels were stacked two-high, whereas we wanted them three-high so it would feel like a corridor. The winemakers were very reluctant to move barrels, as it affects the fermentation process. Fortunately, we found enough empty barrels to create a third tier.

We filled the entire space with glasses so they were touching, but when we examined the Polaroids, we realized the spacing was too tight. Several arrangements later, we arrived at something that worked to everyone's satisfaction. Setting up and filling the glasses without spilling (to avoid staining the concrete floor) along with the lighting, took hours—even with three assistants.

Our lighting—mostly Broncolor—began with the glasses. We set up a bank of three grid spots on each side, behind each wall of barrels, to rake across the glasses situated behind the winemaker and help bring out the color of the liquid and shape of the goblets. These lights, positioned low to the ground, peeked through openings between the barrels.

Then we had two more grids on each side, again behind each wall of casks, with one by the corner next to the door and the other halfway down, closer to camera. They were both positioned high enough to reach over and hit the barrels diagonally opposite.

You can see evidence of these lights on the barrels in the immediate foreground. The lights for the barrels on the left were dimmed down. The cask lights had ¼ CTO, for warmth. I didn't gel the glass lights because I couldn't play around with the color too much.

I needed to put a boatload of power through the doorway, because that's actually what's doing most of the job of lighting those glasses. The light had to look like a blaze of daylight, and the best way to accomplish that was to position two heads outside the door and behind a silk, running off two packs—each on full power. I had to get at least f/22 ½ off these lights.

Finally, the key light for the winemaker came off an Elinchrom head with ¼ CTO. This head was positioned behind a silk for a clean wash of light, and powered down enough to illuminate the model without casting distracting shadows on the floor.

In all, we used seven power packs. Basically, each group of heads (except the pair outside the door) shared a pack. I needed essentially the same light coming out of each side, modified to give the shot more dimension. In addition, I added gobos to the heads aimed at the glasses and barrels, to keep spill light off the winemaker. The final exposure was f/8 ½ or f/11. This one shot required a 12-hour day.

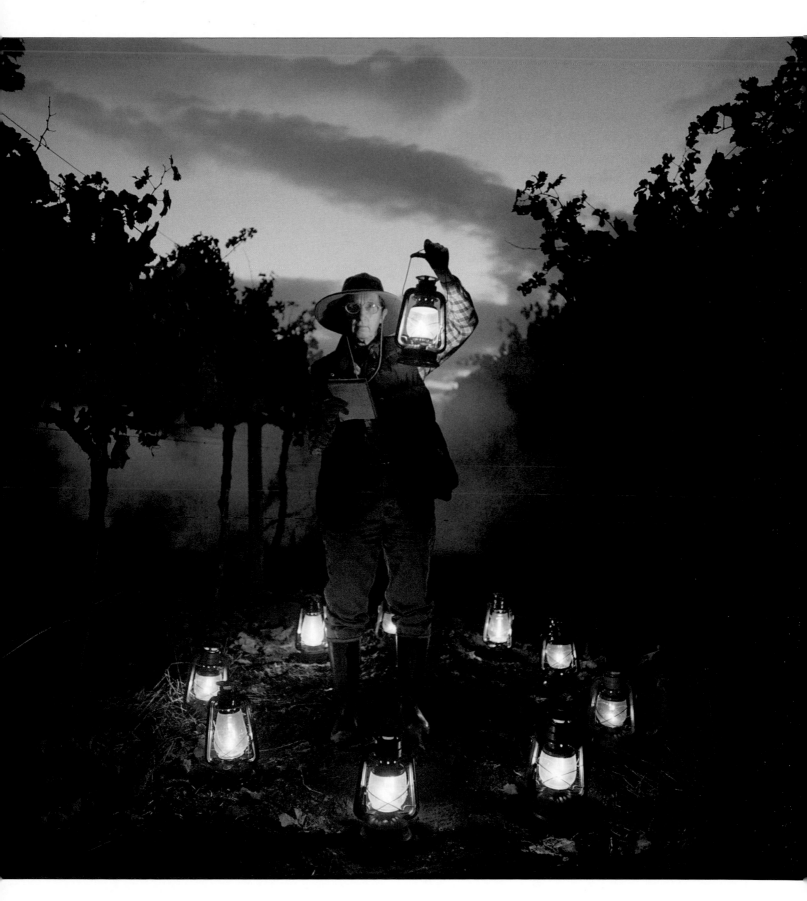

If it works, why fix it? The lanterns alone did the job, so all
the extra lighting was cast aside.

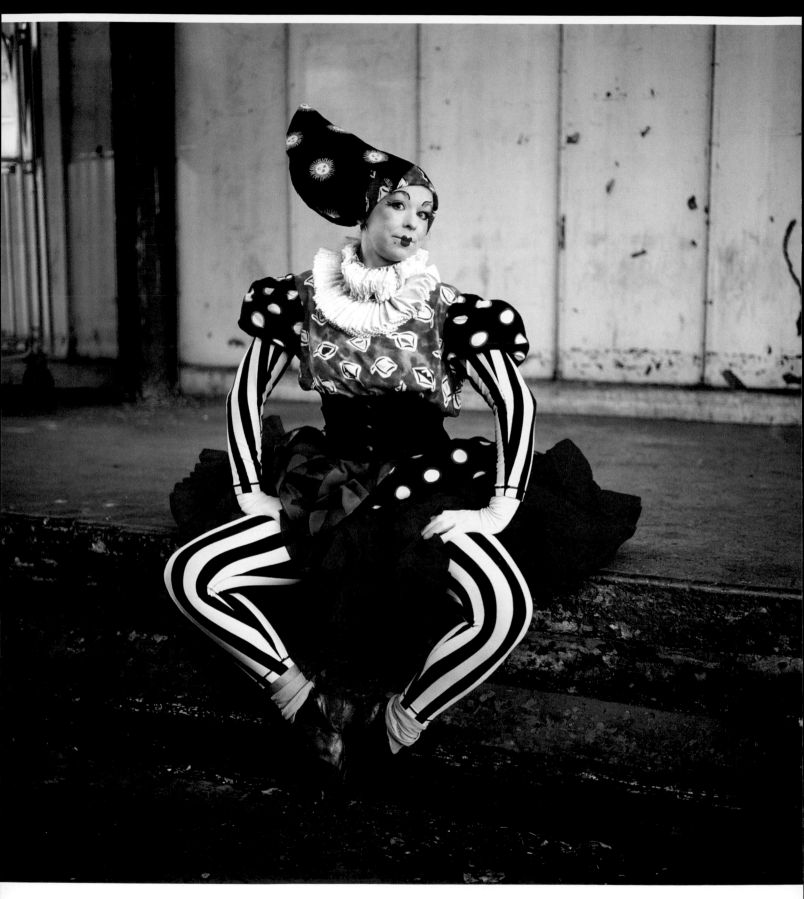

JOB SHEET
CLIENT: **Fern Street Circus, San Diego**
USAGE: **Advertising and collateral**
PROJECT COORDINATOR: **John Highkin, Fern Street Circus artistic director/co-founder, and Spike Sorrentino, production manager**
LIGHTING: **Strobe (plus existing light)**
CAPTURE: **Analog**
PHOTOGRAPH COPYRIGHT ©**Marshall Harrington**

There's no clowning around with this telling portrait. The muted tones and subdued lighting say more about the person behind the makeup than any clown act could.

The circus is a magical place for young and old alike. At its heart lies a vast diversity of talented performers. While some of the pictures from this series were used directly in advertising, others, such as this one, went into other promotional activities for posters and buttons. We worked closely with the circus on this assignment.

Our star attraction in this shot was the clown Columbina, known outside the circus ring as Cheryl Lindley. We selected her to provide a stark contrast to this loading dock at a dairy plant, which had caught my eye for some time, especially in the late afternoon light—around 4:00 or 4:30 PM. The camera I used was a Hasselblad with 80mm lens, loaded with Fuji Provia film.

One of the things that interested me about this location was the fact that the light would take on a very special quality every once in a while—one that was hard to define in words. We discovered, in particular, that one textured silver semibounced light into the wall was just unbelievable. At the same time, it blocked light from the side, although some light would creep around the trailer, resulting in that hint of raking sunlight along the wall.

We maneuvered the trailer so that it was positioned at about a 30- to 45-degree angle to the loading bay on which Columbina sat. The camera was positioned near the back of the truck, to her right. The truck served as our main light source by bouncing available light into the shot, and at the same time flagged off most of the direct light that would have hit the set.

There was no artificial light on Columbina other than a 100W/S Norman 200B, which we used as fill. This light was inside a small Chimera. We added three white, collapsible circular reflectors, one to the left and two to the right; the Norman was handheld by an assistant above the height of the reflector immediately to the right of camera.

To give the shot added warmth, I added a Lee Sepia 1, a Sinar 81D, and a Lee Coral 3 onto the lens. This whole shot was done in 30 to 40 minutes. Exposure was f/4.5 or f/5.6, at 1/125th, with the camera handheld.

A semitrailer provides the defining light for this imaginative portrait of a circus clown.

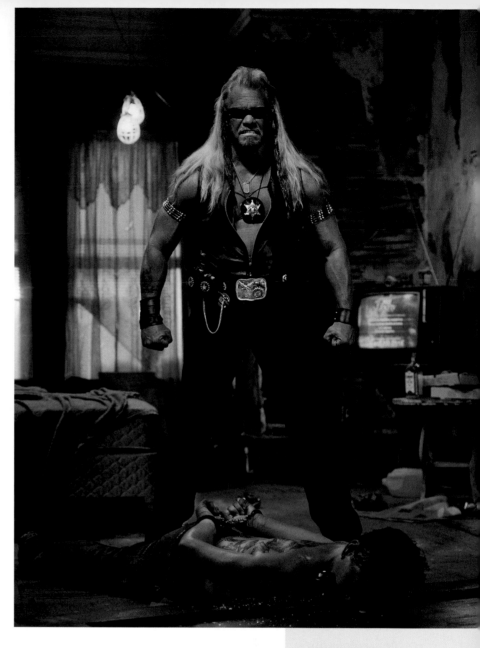

Looking at this scene, we feel as if we're looking at the 6 o'clock news—the portrait is penetrating and thought-provoking. The location is a key factor, but the restrained, quasi-noir lighting makes the shot.

The criminal had jumped bail and was on the lam. He'd found a sleazy hotel room in which to hide from the cops, but he couldn't elude Duane Lee Chapman, aka "Dog the Bounty Hunter." Dog tracked the culprit down, broke down the door, threw him to the floor, and cuffed him. We enter the scene to see our triumphant captor standing over his captive. That was the scenario we'd come up with for a feature story on this renowned bounty hunter. The handcuffed man in our little drama was, of course, an actor playing a part.

Location scouting led us to a brownstone in Harlem that was currently under renovation. The building had power, heat, water, and even some furnishings. The problem—as my prop stylist and I discovered while tech-scouting the site the day before the shoot—was that the room we'd selected was missing a few key ingredients, one of which was a bed. We chose this apartment because we saw that it would be roomy enough to work in, even after adding some furnishings and lighting. We found a bed in an upper-floor residence and brought that down. The prop stylist brought in the TV set, the hanging light bulbs in the back, the sheets, drapes, and all the bottles and beer cans, and a few other touches to give the room the look of a place that had seen better days.

Our protagonist was on set for two hours. Prior to his arrival, we'd removed the door from its hinges, and when we were ready to shoot we had our talent get in position. We had two assistants on set, along with the photo editor.

In this shot we wanted things to feel very closed-in, as if we were in a small

PRO TIP It pays to cover yourself. We did a variety of different poses, some of which showed the model getting roughed up a bit. The more staid rendition was the one the client ended up choosing.

JOB SHEET

CLIENT: *Stuff* magazine
USAGE: **Editorial**
PHOTO EDITOR: **Alisha Borth**
FIRST ASSISTANT: **Jamel Toppin**
PROP STYLIST: **Renee Yan**
HAIR & MAKEUP: **Pierra**
LIGHTING: **Strobe, Kino Flo, and incandescent bulbs**
CAPTURE: **Analog**
PHOTOGRAPHS COPYRIGHT ©**F. Scott Schafer**

PRO TIP I check locations online and with people I've worked with before. I don't send out a location scout unless we can't find a location otherwise. Even then, I usually just go out myself.

room. What was great about this room was that it was very open, with high ceilings that made it easy for us to set up our lights. The spacious interior also gave me the liberty to choose the most telling shooting angle with my Mamiya RZ67 and 140mm lens. I exposed Kodak Vericolor 400VC 220 at f/4.5, positioning the camera on a tripod as far away as possible to capture our hero full-frame.

The first light I put up was outside the building. The most difficult thing we had to do was rig the outside light to give us a sense of daylight streaming into the room. It was a Profoto ProGlobe—a diffusion dome that produces a light similar to a bare bulb, but softer and without specularity. The light physically had to reach the second floor—about 30 feet up—and was positioned on a roller stand. To keep it from toppling over with a strong wind gust, we tied it to the window, with a lot of sandbags on the bottom.

The globe light outside was powered down quite a bit. In fact, the difficulty we had—I mean, before we even lit the room—was just trying to keep it from overwhelming the windows, because I wanted to see the window treatments very clearly. I wanted all the details in the window to make the room feel dirty and scummy.

We succeeded in getting our lighting ratios down with help from a handheld meter, and then used Polaroids to lock in the exposure. We first established the ambient light, which was a combination of the TV, light bulbs, and the light coming through the room. And I knew I wanted some sort of mood to the shot. But when the model showed up, I noted his dark complexion and clothing, which would require a strong blast of light. So I began the interior lighting with a 20-degree grid on him, making sure there was little to no spillover onto the background. This light came off a boom, high up to his left, hitting the top of his head down to his belt. Then I added a 2x4-foot Kino to the right, with ½ CTB, to fill in the shadows.

Next we wanted to create the impression that we'd turned on a fluorescent ceiling light, so we put a 4x4-foot Kino Flo up on a boom, just over the bed and behind him slightly, to light the bed and provide an overall fill for the room. We wanted it to have that typical fluorescent feel, so we put a light green gel on it, giving us that dirty green look. Rather than use a typical green bulb out of the box, I prefer the control the choice in gels gives me.

There was still shadow detail that we needed to bring out throughout the shot—details that couldn't be addressed in post—so my assistant suggested we add an overall fill at about a stop and a half (if not two stops) below our base exposure. This opened the room up a bit without interfering with the integrity of any of the lighting that was already up. It was a

Lighting inside and out sets the tone, with a gelled Kino Flo helping to "dirty" up the room a bit.

bare head all the way to the left, with ¼ CTB. By the way, we had just enough light reaching the guy on the floor, so we didn't have to add other lights for him. Each strobe ran off its own 2400 W/S pack.

One final note: we left the TV on, along with the light bulb beside it. But, as mentioned, we added two bulbs—75 watts each—in the back. We had to shoot at a slower shutter speed to accommodate the scrambled TV image, which gave us 1/30. We were able to get it all in one shot, without having to strip the TV screen into the picture in post.

For the tight portrait, I switched to a 110mm f/2.8 lens for selective focus and moved in closer, shifting my viewpoint somewhat. We'd left the globe light outside, at the same intensity, but brought it up a little in post to give me more separation for his hair. I was going for a more dramatic effect. We tightened the spot, switching to a 10-degree grid, moved it closer, and brought the Kino in much closer to him as well. The function of the Kino here was simply to add a catchlight in the model's eyes and a little bit of coolness around the shadows, akin to cinematic lighting.

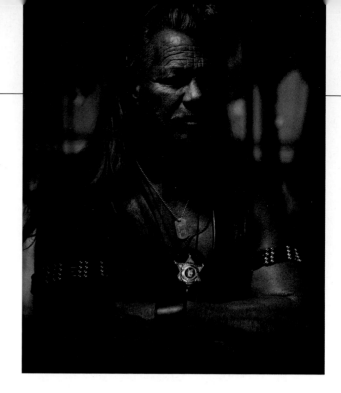

With the exterior light kept in place, the interior lighting is brought in tighter for this dramatic portrait of a bounty hunter.

PRO TIP The minimum number of powerpacks that I bring to a location would be four 2400 W/S packs. If I use a ringlight, I'll bring a 1200. I'm in love with the Pro 7B's—I use them all the time, if I'm on location. We had power this time, so we didn't need to bring those.

Lights both inside and outside the room had to recreate the seedy atmosphere that would lend credibility to this scene of the bounty hunter catching the outlaw.

Globe Light Outside Window

Light Bulbs

Overhead Kino Flo

Light Bulb

Barebulb Aimed at Ceiling for Fill

Talent

Kino Flo

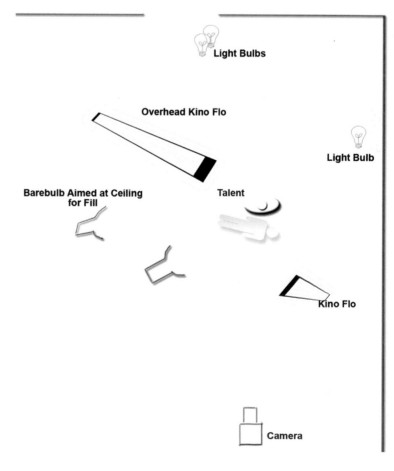

Camera

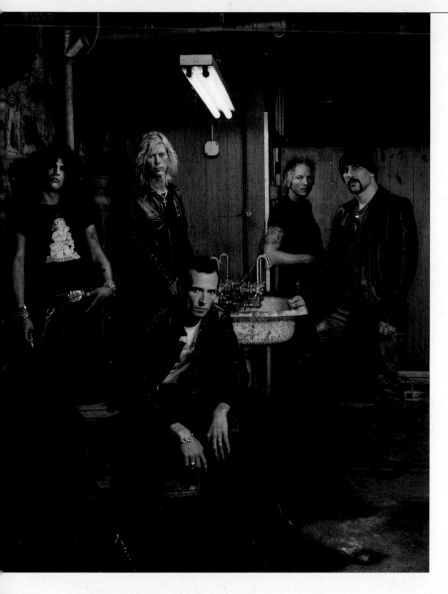

JOB SHEET

CLIENT: *Newsweek* **magazine**
USAGE: **Editorial**
PHOTO EDITOR: **Simon Barnett**
FIRST ASSISTANT: **Jamel Toppin**
LIGHTING: **Strobe (plus existing light)**
CAPTURE: **Analog**
PHOTOGRAPH COPYRIGHT ©**F. Scott Schafer**

For a feature story on the rock band Velvet Revolver, I needed an environment that was as raw and gritty as the music, with lighting to match. Although technically a rental studio, Raw Space, in New York City, provided the perfect setting. You take the space as you find it, with no fancy accoutrements, lighting as unrefined as it gets, and all the attitude you can throw at it. In fact, the area we chose to work in is more like an unfinished basement, with a staircase leading down to this dark, unadorned room. The only thing I added was a small box to sit on.

The existing lighting consisted of a combination of overhead fluorescents and a couple of incandescent light bulbs. It was perfect as is, and the only thing I used my lighting for was to augment it in a very transparent manner. The tough part was keeping everyone perfectly still, since I had the camera on a tripod and was dragging the shutter to burn in the overheads. I didn't want a ghost image intruding from motion blur after the strobes fired. (By the way, I brought the intensity of the fluorescent bulbs down in post, after scanning, so they showed full detail.) The film was Kodak Portra-400VC negative stock; the final exposure was f/8 at 1/15 on a Mamiya RZ67 with 65mm lens.

While shooting, I was jammed up against the wall with the camera. We had two Profoto heads-with gels added to give our lights a dirtier feel—running off 2400 W/S packs, each powered way down. One, a mini Chimera bank with just a hint of green gel, stood several feet forward of the camera position and to the right—almost squarely with the front band member. The other, a small Chimera strip bank with full CTB—immediately to the left of, and right above, camera—served as fill for the band member in the front and the one to his right. In post, I pulled out more of the shadow detail in various parts of the picture.

This was one of two shots with the group that day. We had them on set for maybe 20 minutes, so we had to have each setup running and ready to go when they arrived.

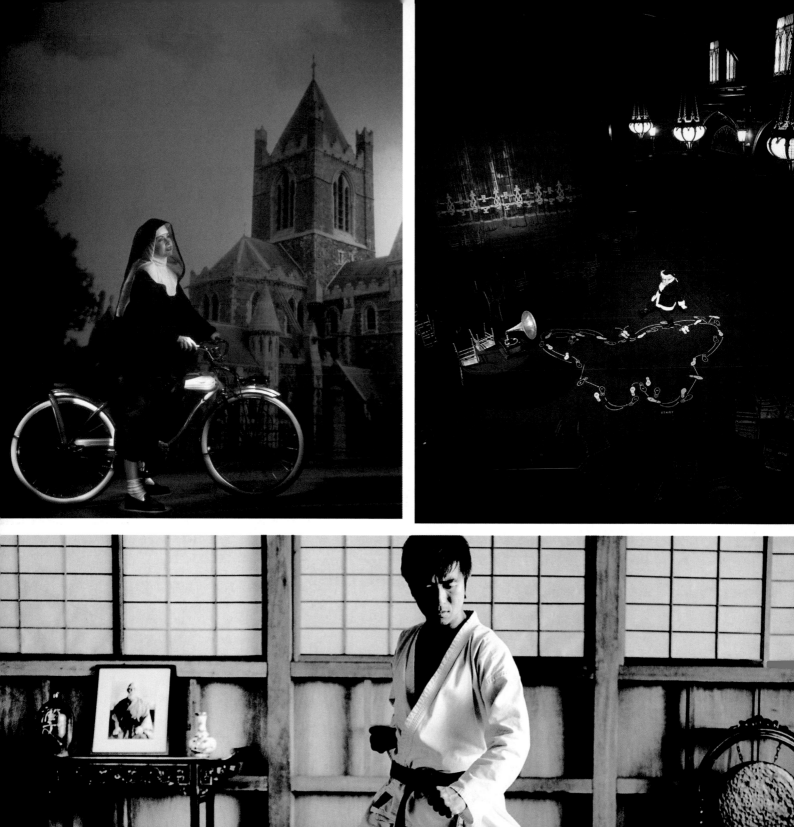
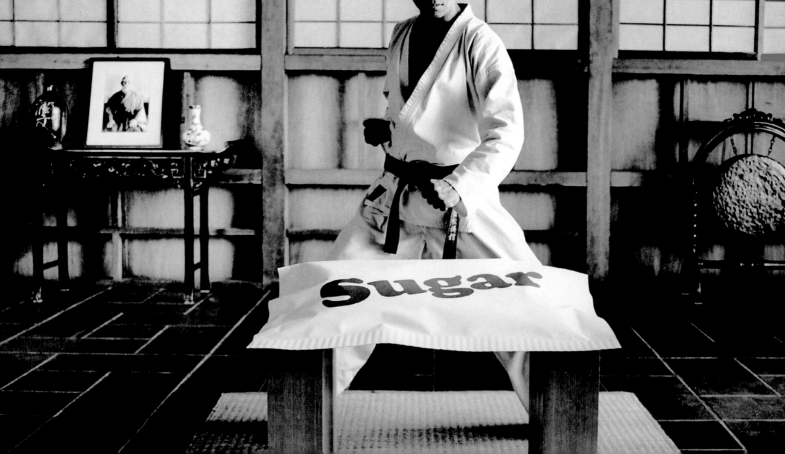

nuance,
noir, and
nostalgia

The photographers in this chapter deal with lighting that sets a tone and mood, working with themes, subjects, or elements that may date back decades. The images may be in color or black-and-white, but each bears a definable texture.

JOB SHEET

CLIENT: **Boomerang for Modern, San Diego**
USAGE: **Advertising and collateral**
FIRST ASSISTANT: **Jeremy Dahl**
CASTING: **Trish Clark**
LIGHTING: **Strobe**
CAPTURE: **Analog**
PHOTOGRAPHS COPYRIGHT ©**Marshall Harrington**

PRO TIP Day in and day out, you need solutions that are going to work for you, not ones that only occasionally lull you into thinking that you're going to get away with it.

You can show a chair—or you can show how the chair molds itself to the person seated. And what better way than to do it tastefully with nudes! The lighting helped sculpt the models while casting playful shadows that mimicked their shapes on the chair.

Boomerang is a retail outlet representing various brands of vintage modern furnishings. Simple yet sophisticated, the furniture featured here boasts a certain sense of grace and style—the same sense that needed to be captured in these pictures. So when I arrived at the empty warehouse that the client provided for our use, the dimly lit interior and bare floor and walls strongly suggested an almost noir lighting approach. We did have to paint the walls neutral gray (two coats) and lay down tiles, but that was the extent of our prep work on site.

We often used this company as a source for propping our sets. I'd been talking to them about shooting an ad campaign over the years, and they were finally convinced. The next step was casting.

Though the process of finding talent was not complex, selecting the final models and furniture was painstaking. We allowed our nude models to fit themselves into the chair of their choosing, and even to let the furniture mold their pose. We shot the casting digitally with four or five selected pieces of furniture, finally settling on three. It took two hours

to look at 20 people. The casting came out so well that we almost used the shots from that session. My only trepidation, given that the pictures might be used on posters, was the limited file size afforded by the Canon EOS 20D we used. The upshot, though, of all this was that we had a record of the poses we planned to use. Of course, it's a lot easier for the models to assume a pose at the moment, making it up as they go along. We ended up spending a couple of hours with each person for the hero shot, as it took a bit more work to duplicate the poses afterward on the day of the shoot.

Once we had the poses locked in from the casting, we didn't play around with horizontal and vertical variations for each chair on shoot day. We

PRO TIP A new addition to my lighting armory is a set of Magnum reflectors for my Profoto heads. These dishes have a unique way of shaping the light and producing an interesting pattern with captivating shadows that are more indicative of sunlight.

A Profoto Magnum reflector attached to the flash head was a key ingredient in shaping the light and character of each shot in this campaign.

shot the hero pose, and that was that. That doesn't mean that we didn't experiment at any stage in the process. During casting, we found out what the models could do and how they moved, so we played with the shots, experimenting with the furniture, shooting probably 50 or 100 frames of each person. The camera this day was a tripod-mounted Fuji GX680 loaded with Fujicolor, with lenses ranging from 100mm to 125mm, depending on the pose. Camera-to-subject distance ranged from 10 to 15 feet. We shot Polaroids and used an incident meter to arrive at our exposures. Occasionally, we spot-metered and looked at the falloff from shadow to highlight in the background.

When we originally set up the lighting, we were looking at this as a one-light shot. The key light was a Profoto Acute 2 D4 head with Magnum reflector, coming from the right, adjusted to give us the optimum shadow on the wall. But the more we examined it, the more we realized we weren't getting the tight control over contrast and tonal range that the shot needed.

So we started adding lights, for fill. We began with two Profoto 6-inch zoom reflectors, nine feet up, bounced off the opposite ceiling. All fill lights

were powered down so as not to overwhelm the set.

For the casting session, we had put up a 4x8-foot foamcore "privacy" wall, which was ironic because these models routinely walk around naked during casting and shooting, so they don't care. But that turned out to be a great fill wall—we had two heads bounced squarely into these flats. It was one of those things that happens by accident. The wall stood directly behind camera position and consisted of five or six vertical sheets of 4x8-foot white foamcore held up by C-stands. These heads were a little forward from the camera position, mandating a flag on each side of camera against flare.

We employed two 2400 W/S packs, with the key light and one pair of fills sharing one pack, and a second pair of fill lights on the remaining pack. The only thing we had to watch for was that the fill lights didn't throw any shadows.

The Magnum reflector was variously positioned low or high relative to subject level, depending on the subject. We had it on a Matthews medium roller with a Redwing boom. Sometimes we would actually drop it almost to ground level so we could get a shadow to face upward. The subject and chair were never more than one or two feet away—whatever gave us the best shadows.

PRO TIP With digital, calibrating and profiling is critical. If you want clients to be able to depend on the color in the files you send them, you have to be in the real world—which means working in a color-managed environment. It also means working with a select number of papers that you've profiled. For our digital editing, we work in Adobe RGB 1998. It's a very good, stable color space that you can depend on. I also use Adobe RGB when shooting digital—it keeps us consistent.

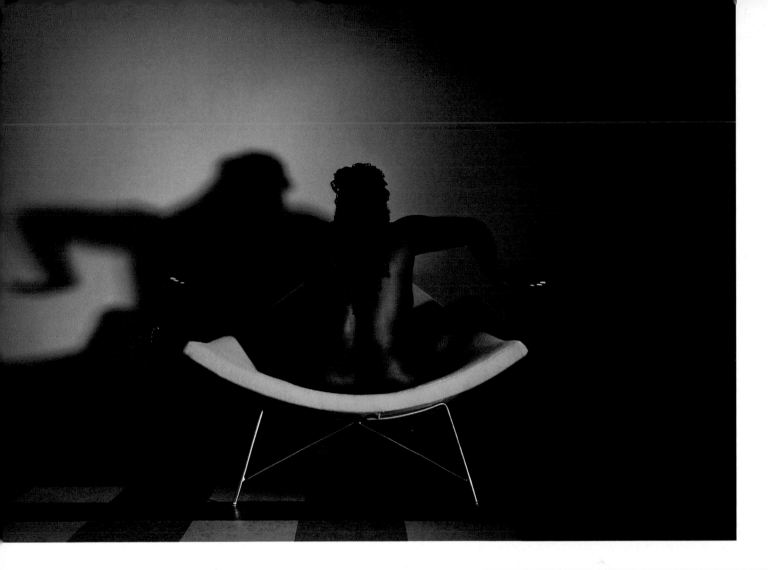

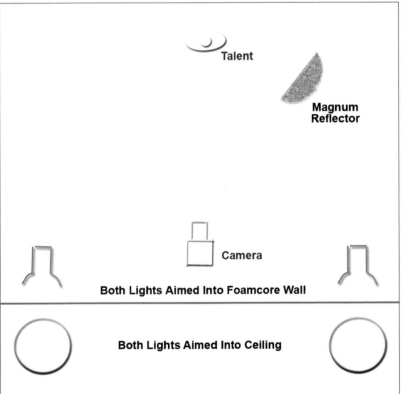

Talent

Magnum
Reflector

Camera

Both Lights Aimed Into Foamcore Wall

Both Lights Aimed Into Ceiling

PRO TIP Tech-scouting means going to look at the location to see what you'll need before the shoot. You determine whether it's practical, calculate how many lights are required, and assess electrical needs. And you ask the big question: Is it really going to work for the intended purpose? We decided against one location because we realized it would mandate a huge crew and an inordinate amount of lighting.

The lighting is almost noir in its effect, with one key light helping to mold the shapes and throw the supporting shadow on the wall.

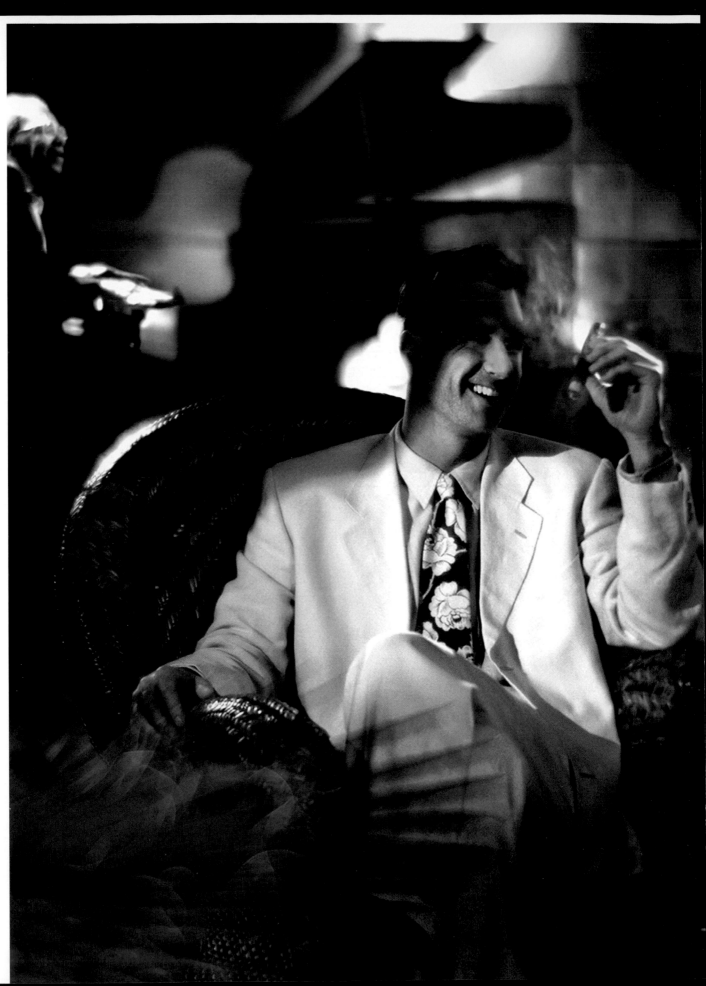

JOB SHEET

CLIENT: **Lone Wolf Cigar Co.**

USAGE: **Advertising**

AGENCY: **DDB Needham, Dallas**

ART DIRECTOR: **Jay Russell**

PROP STYLIST: **Gae Benson**

LIGHTING: **Tungsten**

CAPTURE: **Analog**

PHOTOGRAPH COPYRIGHT ©**Andrew Vracin**

PRO TIP I let part of the key model's face fall into shadow in order to add drama and mystery to the shot. That's always a big part of my pictures—in fact, I consciously try not to use a lot of fill.

The styling of the shot is clearly a tribute to an era long gone. Film-noir lighting, at the heart of this campaign, plays a vital role in taking us back in time.

Lone Wolf Cigar, a company founded by actors Chuck Norris and Jim Belushi, planned a national ad campaign that would run in *Cigar Aficionado* magazine. The campaign, extending over a period of time, featured people smoking cigars in three different situations, with a common look and theme. The first, a studio shot, portrayed a woman in the 1940s film-noir genre. The third shot featured a man wearing a white dinner jacket, standing ominously in an archway, again emulating this style. But the second photograph put a different twist on the film-noir theme, seemingly more lighthearted. All pictures were shot in black-and-white, based on the style in my portfolio that first caught the art director's eye. For our location shots, we looked for houses with a Spanish flavor reminiscent of homes that might have been found in Hollywood during the 1940s. This led us to Boyd House, in Dallas. I produced this shot on Tri-X, with a 4x5 Cambo and 12-inch Kodak Ektar lens for an f/6.5 exposure (to softly blur out the background) at 1/4 second.

We wanted this to look like a nightclub lounge. My prop stylist brought in the wardrobe and the wicker chairs, along with the palm plant, which was blurred out softly in the foreground. The palm was placed about midway between the model and the camera. This is a really deep set—probably 25 feet front to back. There was already a piano at the house.

All my lights were vintage tungstens that came out of the old Desilu studios. I started with a 500-watt key light on the left of the featured model. This light had a snoot and came down on the model from a couple of feet overhead and three feet from the side, just out of camera, hitting him so that it placed part of the face in shadow. Then I added a 1K on the left side, five or six feet back of the key light, a couple of feet above the model's head, to give an edge light off the chair, as well as off his neck. This light was scrimmed down with a screen on a snoot.

Because the model might hold the cigar with one hand for some poses and switch hands for others, I knew that the 1K on the left side would also give us the light needed for that side but not the opposite side. To remedy that I added a 500-watt light on the right side, positioned six feet back, about a foot above his head. That was snooted as well, with a small disk in the snoot to define the light more

This image is steeped in the film-noir genre. The lighting, though designed to focus attention on the cigar, is also intended to add a sense of intrigue.

sharply—so it hit only his hand, cigar, and the smoke.

The large window behind the piano player admitted little light. So we added more for him and the piano using a 2K. We hung a scrim in front of the window on the outside, then raised the light about eight feet so it provided more of a toplight, and finally pulled it back to produce just a soft ambient effect coming through the window. The light also floated across to the woman in the chair, throwing a soft light on her—we didn't want her too well defined.

The next light was a 500-watt with a snoot, on a boom positioned to the right of the set, coming over the top of the piano, to give some definition to the piano player's face. And we had a short stand to the right of the woman, giving her an edge light, to pop her out of the chair and flare out the highlights on the martini glasses and shaker.

The one thing the art director expressly wanted was fill, to see more detail in the shadows—more than I normally have in my pictures. To that end, I used a 200-watt, 2-foot softbox, just out of frame, at the camera, which was situated in a corner of the room. The camera was chest-level with the model, six to eight feet from him.

Probably one of the hardest technical problems in this shot was that stained-glass window in the background. It was enormous—12 feet wide by 20 feet high, and arch-shaped—and provided much too much light. So we hung a 16x30-foot gray canvas from Mole high-risers outside and within a couple of feet of the window, angled so as to allow just the right amount of ambient light to come through.

PRO TIP
In this job, I processed the film normally, though I overexposed one stop to give myself more flexibility in the printing. I tend to determine an initial exposure by eye, and then shoot Polaroid Polapan Pro 100 to determine the final exposure.

PRO TIP An ongoing problem we had was the cigar: we had to make sure it didn't burn out and that there was the right amount of ash on the end—about an inch to an inch-and-a-quarter. So we generally had two cigars burning.

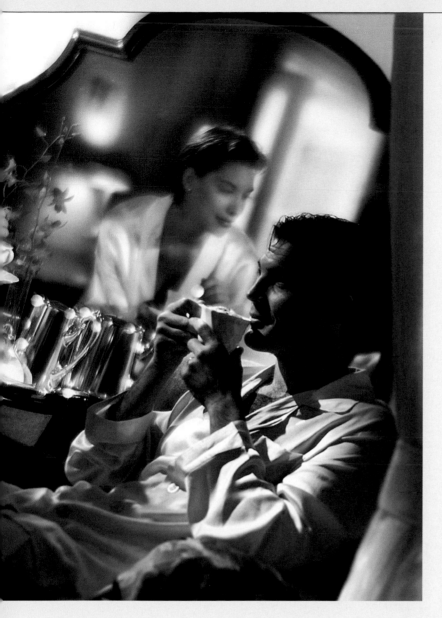

JOB SHEET

CLIENT: **City of Beverly Hills**
USAGE: **Advertising**
AGENCY: **Stranger & Associates**
ART DIRECTOR: **Mia Ellis**
LIGHTING: **Tungsten**
CAPTURE: **Analog**
PHOTOGRAPH COPYRIGHT ©**Andrew Vracin**

The client was looking for a romantic mood, reminiscent of old Hollywood, to promote travel and tourism in the City of Beverly Hills. This particular picture was shot at the Peninsula Hotel. Originally, they wanted the couple standing at the balcony, but when I came to scout the location with them, I noticed that the view was anything but romantic, so we modified the shot. To begin, we moved the 5x7-foot mirror to this part of the room, so it would reflect the balcony doors and add depth to the room. Then I set up the lights.

We began with a 500-watt tungsten head, snooted, as our key light for the male model, coming in on the male talent from just left of the mirror, positioned practically against the wall and behind him, at ceiling height. We used a similar light for the female talent, positioning it behind her and at a slight angle, practically next to the first light. His head was too much in shadow, so I added a strongly scrimmed 500-watt fill light from a low angle, aimed toward the back of his head. This light also feathered off his head and onto the woman's face.

Since we were shooting late in the afternoon, there wasn't much ambient light coming in. So we went out on the balcony, dropped scrims in front of the entrance, and put a 2K through that. That gave us just the right amount of simulated ambient light and also kept a little detail in the door panes. I'd also noticed that the wall behind the woman (visible in the mirror) was going too dark, so I added a 500-watt spot to address that area. Then we squeezed one more snooted 500-watt light, scrimmed down, in between his and her key lights, to make the silver service on the table next to the couple pop just a bit.

The next area we had to attend to was the frame of the mirror behind the woman's head. The edge was going too dark, which I corrected with a snooted 500-watt light with one-stop scrim, from the left. Finally, to add a little more depth to the scene, we hung a curtain down on the right side of the frame. To bring out the edge of this drape, I hit it with a 500-watt light, which was positioned behind it, nearly against the wall, and aimed almost into the camera. This light had a snoot and was scrimmed down two stops.

The exposure was made on a Cambo 4x5 with 12-inch Kodak Ektar lens, on Tri-X. I overexposed by one stop, with normal processing. I shot at a low level, probably two to three feet off the ground, and skewed the picture for added interest.

Working to a specific color palette requires a very studied eye in handling the lighting, especially when so many disparate elements come into play. Any designer would love this treatment that shows off various furnishings in a very stylized fashion.

The color motif plays a central role. Various elements, with lighting just as variable, appear in each pane in the client mailer.

A promo piece I produced, entitled *Green*, came to the attention of Thomas O'Brien, the head of Aero Studios—an interior and furniture design house in downtown New York City. Aero has a collection under O'Brien's name, and the company also rents out props for photo shoots.

JOB SHEET

CLIENT: **Aero Studios**

USAGE: **Collateral**

DESIGNER: **Thomas O'Brien**

FIRST ASSISTANT: **Dawn Blackman**

LIGHTING: **Strobe and tungsten (plus existing light)**

CAPTURE: **Analog and digital**

PHOTOGRAPHS COPYRIGHT ©**Annie Schlechter**

O'Brien had mentioned that he liked the Green series so much he kept it on display in his conference room. He wanted to do a promo piece that played on the blue and black color motif in the new store location. So he encouraged me to go into their existing store and photograph what I wanted, and then to combine these images in a way that reflected their designs and tastes.

I basically did the same thing I did for my original series, which was to pull various random elements together and try to make visual sense of them. The designer had wanted me to use animals again, but I argued that we've seen too many butterflies in ads recently. In the end, I decided to use little figurines I'd bought in Seville, Spain, all made of pewter and plastic, each only centimeters tall. They worked especially well with the store's wares and with the overall concept. I borrowed various store elements—lighting, antiques, and whatnot—playing on the dominant color motif.

I'll focus on the final two images in this four-pane mailer. Some of the props borrowed were items that the designer had collected over the years—things he uses to spark ideas, such as the spotlight. They certainly helped.

In the shot with the spotlight, we began with one of their coffee tables, specifically isolating the highly reflective surface and using that as our set. The white and blue object to the left was a Swedish lamp from the 1960s or 1970s. The lamp and spotlight were switched off so they wouldn't alter the mood or

character of the shot. My lighting consisted simply of a Profoto umbrella light, running off a 2400 W/S pack but powered down. I positioned this light on the left, about three or four feet away, so that it hit the lamp and spotlight.

As backdrops, I employed patterns the store used, incorporating them as visually recognizable elements. This backdrop was one such pattern. I shot a digital image of it, rendering it as an obovate shape in Photoshop to look like the light seemingly thrown by our spotlight (had it been facing the wall). I left the surrounding area in shadow, then composited this element into the picture. The background in reality was light blue, so I intensified it. The letters on the tabletop surface came from an old deco letter set originally designed for store displays. I used them to write out the name of the store, from front to back.

The final shot in the mailer focused on select items of Hickory Chair Co. furniture, which the store designs. I photographed these furnishings in the store, each separately, using an existing skylight to backlight and silhouette the back chair. I digitally reinforced the reflected image of the silhouetted piece in the wall to make it more pronounced. In contrast, I felt we needed to convey a sense of the delicate relief work in the foreground chair, so I sidelit that with an umbrella, from the top right. Store shots were done on a Mamiya RZ.

There were two additional elements in this picture: the figures and background. I shot the miniatures in my studio on a fabricated Plexiglas

This promo piece consisted of several panels, each with a different photograph that tied into the overall blue and black color motif for mailers, and also for a miniature version to be distributed in the store.

sweep, using an overhanging sheet of diffusion to soften the fill light, with the key light coming from underneath and behind the row of figures. Lighting with Lowel Totas, this picture was made digitally on a rented Fuji S2 with 35-70mm lens, at the tungsten WB setting to keep the tone initially neutral. A more controlled blue tint was later added in Photoshop. I used the reflective nature of the Plexiglas to guide me in adding or strengthening the reflections in the floor behind the figures and in the wall to the right.

To photograph the background pattern, I used the natural light in my apartment. The backdrop was a big piece of fabric—also a store design—that I hung on the wall, filling the entire frame. I scanned the image, which I then integrated it into the overall composite.

I try to color-correct to between 4800K and 5000K. In this series, where I could go bluer, I did. For instance, I actually let the chair silhouette go to 6000K, because I wanted to have the blue cast there. I also added a blue filter on the lens for this chair, for added depth. The other chair I kept neutral, letting it play with the tones in the first image in this series. Some blue filtration was also added to the tabletop set.

The finished piece, which I was also in charge of producing (albeit taking it to a printer instead of printing it myself this time) took two forms. There was a foldout mailer that went inside clear Cello envelopes, with a miniature version (business-card size) distributed in the store itself.

NUANCE, NOIR, AND NOSTALGIA

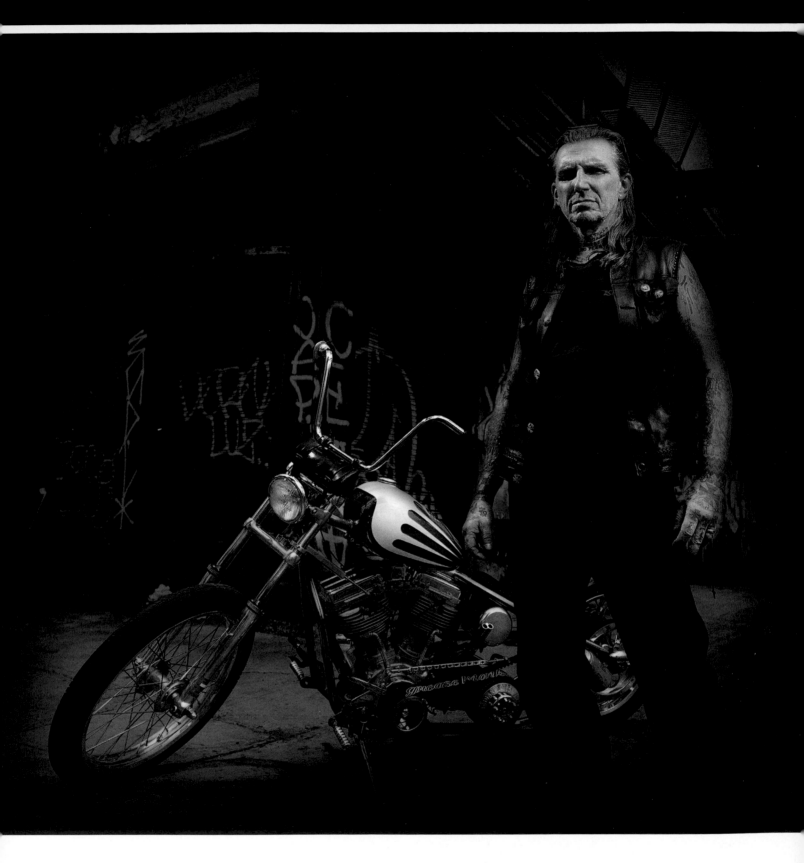

An overcast sky, tungsten film, and blue gelled lights help recreate the foreboding feel of a Harry Potter set for a book promo.

JOB SHEET

CLIENT: **Scholastic Press**

USAGE: **Advertising**

ART DIRECTOR: **Brendan Kennedy**

PRODUCER/LOCATION SCOUT: **Stephanie Cohen**

FIRST ASSISTANT: **Takeshi Hayashi**

WARDROBE STYLIST: **Deborah Francis**

HAIR & MAKEUP: **Candice Forness**

LIGHTING: **Strobe (plus existing daylight)**

CAPTURE: **Analog**

PHOTOGRAPHS COPYRIGHT ©**BobScottNYCInc.**

PRO TIP The art director said he wanted to keep the look and feel of the campaign fairly consistent with the blue color scheme of the latest Harry Potter book cover and jacket. So, knowing we'd be shooting outdoors, I immediately thought of using tungsten film to get that blue cast. For the indoor shots, I created the blue effect with heavy blue gels.

A moonlit street may appear ominous, yet it holds a certain mystery that draws us into the scene. In this case, this sense of intrigue came as a result of the lighting, which took advantage of overcast skies and gels to create a moonlight effect.

By now, we're all familiar with the magical world that J. K. Rowling invented for her protagonist, Harry Potter—a world always fascinating and often ominous, so that we wonder what awaits us around the next corner. In this scenario, we turn a dark corner and come face to face with a compelling character, in the form of "Indian Larry" Desmedt. (Indian Larry was a well-known and admired stuntman, actor, and custom bike builder who died tragically in a motorcycle stunt accident.)

This project was a rare departure for this publisher, which decided to do a print campaign to roll out the latest tome in the Harry Potter series, *Harry Potter and the Order of the Phoenix*, while also collectively promoting the earlier volumes. Their creative department put together a campaign based on the Harry Potter language, flavoring each ad with related text. In this instance, the ad pointed out that "even bikers think Harry Potter is cool enough to ride with them." (Other ads depicted a group of frat boys watching football and a woman shopping for shoes.) The image would be cropped to a square format to allow for the text below and the inset photo of the

books themselves (shot by another photographer).

Our location was the fringe of the Meatpacking District on Manhattan's West Side. Even though we'd be practically around the corner from my studio, we still had to get client approval, as well as a location scout to provide us with all the necessary data and visuals for the site. I had three assistants on this shoot. Indian Larry came dressed for the shoot but also brought along a change of clothes. All we did was powder down his face a little.

The art director told me this shot might also be used on bus kiosks, so we needed lots of detail—which, for me, meant shooting medium format. My choice was a Mamiya RZ Pro II with 65mm lens (to give the shot more presence) and Kodak Portra-100T. We'd be shooting from a low angle, six feet from the talent, with the camera on a tripod. A comp provided the basic framework. From there I directed Larry in various poses, sometimes speaking, other times sitting on the bike. In each instance, I wanted that gritty biker attitude.

Since this part of the street was practically empty, with almost no foot or automotive traffic, we didn't

LIGHTING FOR A VINTAGE FEEL

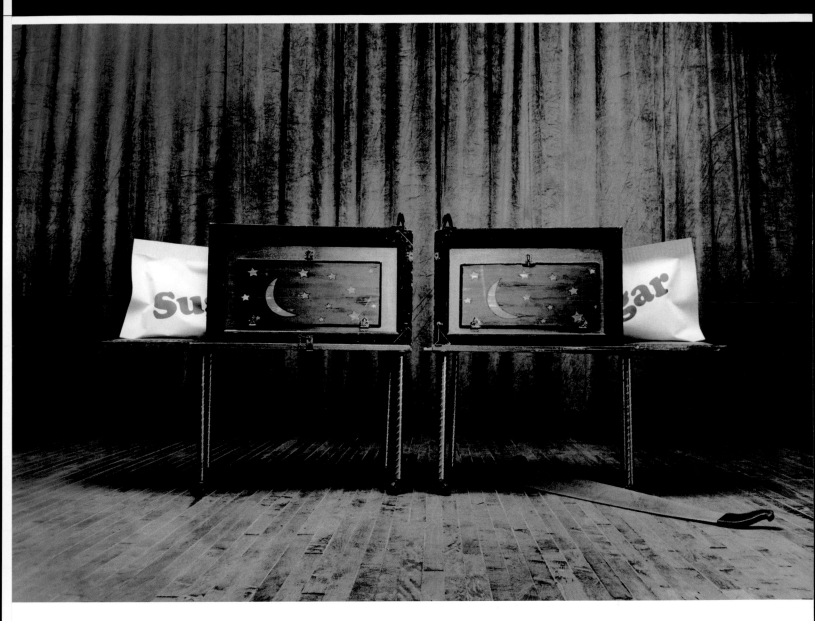

C apturing a vintage feel in a photograph sometimes takes more than props or lighting. Toned prints make a clear difference in conveying the client's message.

Quaker was introducing a diet-conscious breakfast cereal—a variety of oatmeal with half the sugar of their other Quaker Oats–branded products. The campaign would consist of two different ads for the U.S. market—this shot and one produced in a dojo, with a martial arts master delivering a karate chop to the bag of sugar. Only in the dojo case the bag was shown intact, with the hand just above the point of impact. In both instances, the bags were props: one full bag and, for this shot, two halves.

The concept is to show that a new breakfast cereal magically delivers all the taste with half the sugar. The lighting supports the vaudevillian feel of the shot.

JOB SHEET

CLIENT: **Quaker**

USAGE: **Advertising**

AGENCY: **Element 79/DDB (Chicago)**

ART DIRECTOR: **Mark Imfusino**

PRODUCER/LOCATION SCOUT: **William Anderson**

PROP STYLIST: **Debra Day**

PROP DESIGN/CONSTRUCTION: **Ground Zero**

PRINTER: **Robert Cavalli (Still Moving Pictures, LA)**

LIGHTING: **Strobe**

CAPTURE: **Analog**

PHOTOGRAPHS COPYRIGHT ©**David Allan Brandt**

PRO TIP We paid special attention to the shadows underneath the box to make sure the legs would show. We also had to make sure the sugars on both sides were lit well enough to read as open bags. Most importantly, the lighting had to have a nice moody quality.

For these ads, the client had requested we shoot color, given certain time constraints, with the intent of afterwards converting digitally to black-and-white. Having established myself in the black-and-white genre, I knew what could be achieved if we shot black-and-white and printed accordingly. So in the end, after shooting Kodak Portra, which would be delivered as digital files, I decided to shoot Plus-X also and asked my printer to rush toned prints on lith for me to give to the art director before he left. The prints were heavily manipulated in the darkroom in terms of the texture, mood, and overall quality. What drove me to take the monochrome route was one thing the art director had said: they were going for a silent-movie quality, which I interpreted to mean a vintage feel. The client loved our treatment.

I shot this picture on a Fuji GX680, staging it in the Orpheum Theater in Los Angeles. The sugar bags were not the only props: We needed a magic saw box so we could "saw" the bag in half for our underlying theme: half the sugar. Our prop stylist found what we needed and, given the time constraints and tight budget, we chose this route instead of fabricating from scratch a box to our specifications. We did modify it slightly, adding the decals on the front to give it somewhat of a vaudeville quality, and adding the head and leg extensions at the base to hold the two sugar halves.

Key to the setting was the curtain and wood floor. That was the only part of the theater you would see in the ad. Our initial thinking was to shoot in color, so we looked for a stage with a curtain that would support the tone of the shot. This one happened to be a deep maroon and fit perfectly, in black-and-white or color.

I brought a combination of my own and rented Normans into play. Each pack was 2400 W/S. The background lights were clamped to a crossbeam that ran the length of the stage, which was around 30 feet. We had six heads running off three packs, which we also attached to the beam. Stretched forward from underneath the lights to another lower bar in front was a black velveteen cloth acting as a flag. We used this cloth to get the light to gradate off toward the bottom of the curtain. These lights were placed quite high and aimed downward, simulating theatrical lighting, probably 10 to 15 feet from the background.

Next we had two medium Chimera softboxes overhead and out of camera—about six feet above the box halves, again to simulate stage lighting.

They were hitting the top and front of the magic box, but primarily the bags of sugar, while reaching the floor.

We then added two grid lights to the right of camera, giving us that hot area that gradates out from the center on the front of the boxes. These lights were about six feet high, positioned about one-third of the way in from camera.

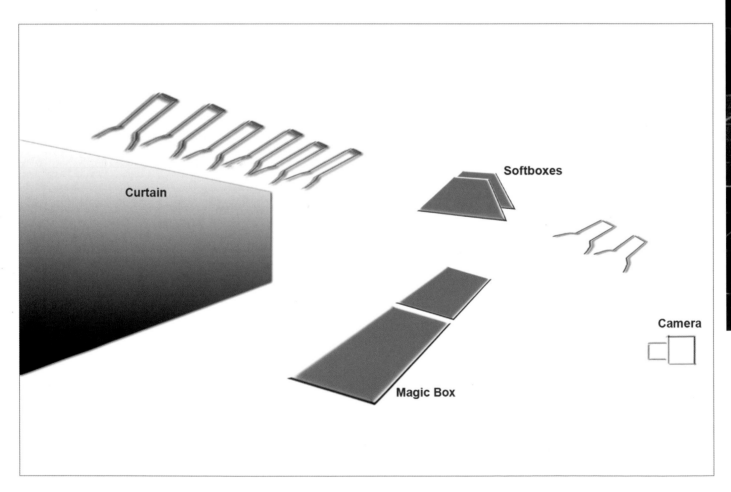

Curtain

Softboxes

Camera

Magic Box

The concept behind the lighting setup was to simulate stage lighting, with a bank of overhead lights gradating off the background and softboxes and grids aimed at the star attraction.

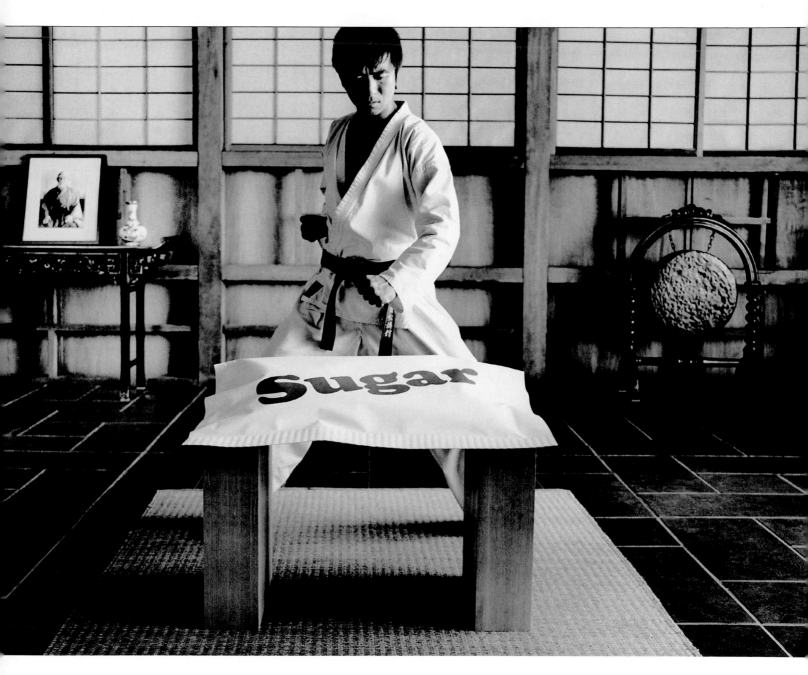

A different take on the same theme, this shot is designed to show that the product contains less sugar than traditional products. Once again, the lighting is key to the vintage look.

SPOTLIGHTING SANTA DANCING

umor once again comes to the fore when we find Santa first learning to dance, then successfully dancing with a partner—and all for a classic consumer Christmas catalog. The spotlight is clearly on the man in the red suit.

Nieman's art director had seen my sourcebook ad involving a Santa and found the feel of that shot appealing. As a result, she awarded me this job to shoot the front and back covers for their Christmas catalog, which they title *Le Book*. There were no layouts, but there was one stipulation: they always have a butterfly in one of the cover shots. It doesn't matter how. I chose to bring the butterfly into the shot on the back cover, and to do so in the form of instructional dance steps that would be laid out on the carpet to help Santa learn the moves. A sign-maker produced the dance steps. I knew at the outset that the back cover shot would be flopped. The cover shot shows Santa with a dance partner, having mastered the routine.

All the lights remained the same for both shots, for an f/4 exposure at between two and four seconds. Dragging the shutter would allow us to get the existing lighting into the picture and give the set more character. I used a Mamiya RZ, with a 65mm lens to encompass the breadth of the room, exposing on both Fuji NPH 400 (color neg because it's very forgiving under such conditions) and RHP.

We found the perfect setting in San Francisco: the Regency Ballroom. The client liked it because the red decor worked with our Christmas theme. Beyond that, I wanted these pictures to have a nostalgic feel, and the vintage gramophone we had brought in played to the notion. While the model came

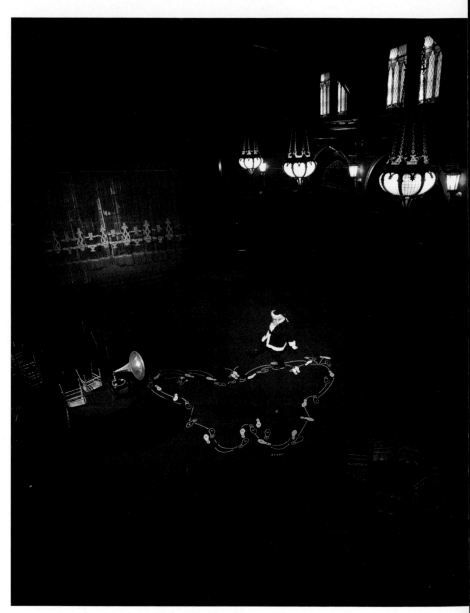

Spotlighting highlights this scene for a Christmas catalog. To support the timeline thread for the front and back cover shots, the back cover image is flopped in the catalog.

NUANCE, NOIR, AND NOSTALGIA

JOB SHEET

CLIENT: **Nieman Marcus**

USAGE: **Collateral**

ART DIRECTOR: **Amy Adams**

PRODUCER: **Andrea Potts**

LOCATION SCOUT: **Birdman Inc.**

FIRST ASSISTANT: **Dan Goldberg**

PROPS & WARDROBE: **Kenedy Whitman**

HAIR & MAKEUP: **Matt Monzon**

LIGIITING: **Strobe (plus existing light)**

CAPTURE: **Analog**

PHOTOGRAPHS COPYRIGHT ©**Jock McDonald**

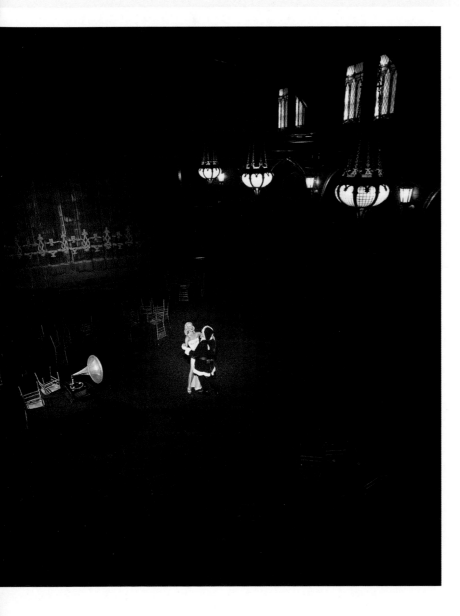

from a local talent agency, the Santa character was a professional Santa, with his own, genuine beard. His suit came from the American Conservatory Theater.

The first thing I had to do was position the camera up in the organist's loft, 30 feet up and 60 feet from the dancers, to afford a good, unobstructed view of the scene, especially the dance floor. That meant we had to lay out the dance step pattern so that the butterfly would be clearly recognizable from a high angle. This alone took hours—it was maddening!

Employing strobe lighting to freeze the action, I brought in a number of Broncolor Flooter spotlights, positioning three on each side of the set to bring out detail and give the room some character. The middle light on each side was bounced into the ceiling and the other lights raking the walls' wood paneling. Then we added another Flooter, aimed just at the gramophone. Practically piggybacked over the camera was one more Flooter for the dancers. Coincidentally—and entirely unintentionally—the lights on the gramophone and couple created a quasi-butterfly pattern on the floor. These two lights needed a bit more warmth, so we added a ¼ CTO gel over each.

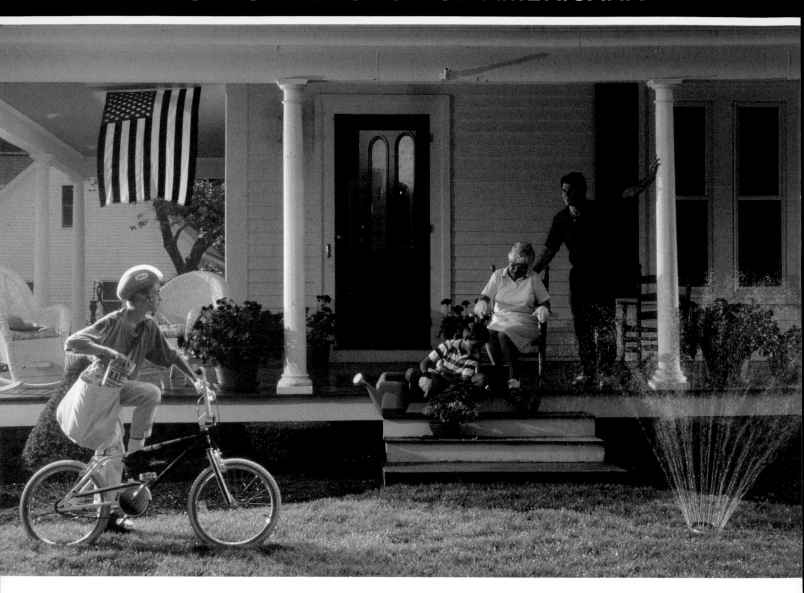

This typical rural scene was created from scratch. Adding to the difficulties was a sun disappearing over the gables of a nearby house, which called for some clever maneuvering to bring back the sunlight.

Capturing a slice of Americana began by substituting a bank of umbrellas for the sun and adding lights on the fly.

It may look like a scene out of Norman Rockwell's America, but that really was not our intent. Despite such things as a bicycle helmet hinting at a more contemporary scenario, the shot did have the nostalgic feel of a bygone era. The aim of the picture, for the cover of a mutual fund prospectus, was simply to portray the kind of life you could lead with your money invested wisely. We produced probably ten shots for this client within a two-year period.

There was no layout. The creative director and I, along with other members of his team, brainstormed the concept collectively. He explained the purpose of

JOB SHEET
CLIENT: **Colonial Management**
USAGE: **Collateral**
AGENCY: **Dickerson Group, Boston**
CREATIVE DIRECTOR/DESIGNER: **Jack Dickerson**
FIRST ASSISTANT: **George Panagakos**
LIGHTING: **Strobe**
CAPTURE: **Analog**
PHOTOGRAPH COPYRIGHT ©**Lou Jones**

the shot, the target audience, and the age-group they were addressing. I came up with some layouts, as did they, and together we arrived at this shot. Of course, you never find exactly what you sketched. So part of the process was finding a location that would fit close enough to our draft to make the picture work.

The location we found was just outside of Boston. Once the home was secured, I did most of the prep several days before the shoot, designing about half the lighting. We brought all the lights—four cases—from my Boston studio.

The first thing I do when tech-scouting a location is to determine where the sun will be during critical moments of the shoot. It was late spring, and the sun was quickly moving behind the building to the rear. When I did the math and realized that it was not going to be optimally positioned, I decided to substitute my lighting for the sun to give a glowing light. I brought in three large Balcar white-surface umbrellas, setting them up as a bank to act as my sunlight and main light source, gelled with a Rosco half sun. They formed a 7- to 8-foot arc on the far left, just out of camera, extending from the front of the porch outward. The rimlight on the delivery boy was coming from this light, as was the rimlight on the two pillars. It was also hitting the wicker chairs. Remember, these lights were set up prior to the day of the shoot.

On the day of the shoot, I had three assistants with me finessing all the details. Some of the things we added to the scene included the American flag, sprinkler, and flower pots—all brought by my studio manager, who acted as producer and wardrobe stylist. The large rockers were there already. That was one of the things that made the shot work. The talent came from various modeling agencies.

The shoot day started around 9 AM. It took a few hours to fine-tune the lighting and select wardrobe. The shot finished at 2 PM. We had to manicure the grounds. Once we started, we found it necessary to move some things around: the people on the porch, the flowers, and even the flag. The flag, by the way, was in shadow, requiring one grid light behind it, positioned against the house. Keeping the light hidden while the flag blew in the wind was not easy—we had to time the exposures carefully. The one constant was the boy on the bike. We knew he had to be exactly where he was in the shot.

We intentionally left the door ajar. Although this may give the impression of a safe and inviting environment, it was not the primary reason. With the door closed, the exquisite cut-glass windows became a lifeless void. We kept trying to light it when closed, but nothing worked, so I added one grid (off a 2400 W/S pack) with a yellow gel behind the open door angled to optimize the effect.

The other trouble spot was the sprinkler. We

kept it running, but the spray was invisible to the camera. I added an umbrella off to the right (on a 2400 W/S pack), positioned low and far enough away so that the sprinkler wouldn't get it wet.

My camera was a Hasselblad with 80mm lens, loaded with Kodak E100SW film. I was positioned about 30 feet. Finally, to add one last very important detail: There was a 4x8 foamcore card catching the light from the umbrellas for the boy, coming from slightly to his left, almost down on the ground and aimed upward at him. It didn't help too much, but just enough. Because the shot was so wide, we couldn't get it as close to him as we would have liked to.

PRO TIP I originally thought that I was going to be able to get away with a lot of sunlight with some fill. As the sun was going down behind the building to the rear, I realized that I had to add more and more light, and it had to be more and more realistic. So I found myself using more and more of my equipment and gelling the lights. I was literally creating the whole shot on the fly.

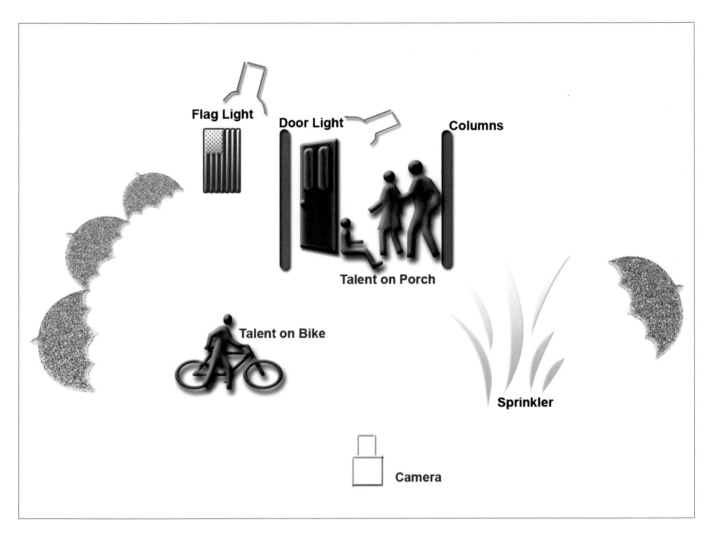

Flag Light

Door Light

Columns

Talent on Porch

Talent on Bike

Sprinkler

Camera

The starting point was a bank of umbrellas to replace a disappearing sun, with other lights helping to bring out supporting elements.

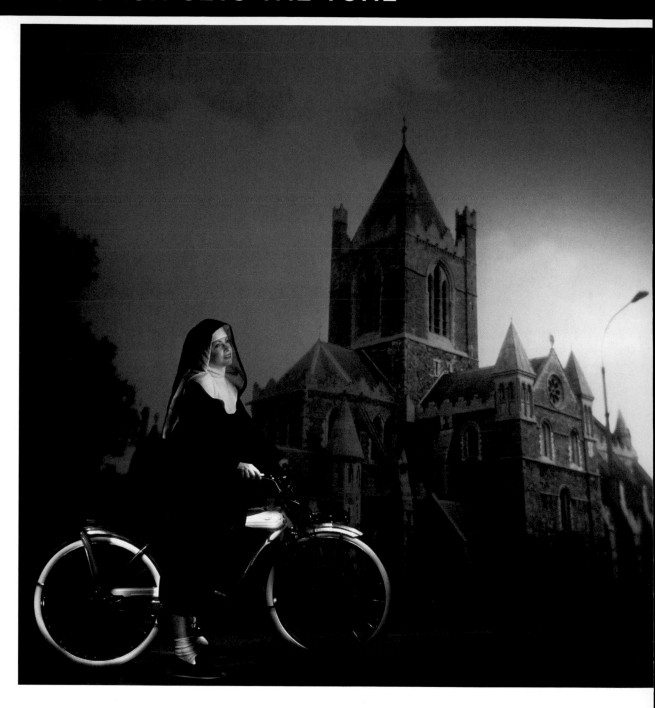

Here's an example of good old-fashioned photography employing in-camera masking, which may soon become a lost art. Shot partly on location, partly in the studio, this photograph blends the old with the new, with lighting playing a supporting role.

The bard's words resonate as I reflect back on this photograph featuring our twentieth-century nun. Although we may not recognize the habit she's wearing as modern, we can say for certain that there's something incongruous in

This photograph began life with a Holga camera and grew to some degree as in-camera masking was introduced to overlay the live image of the nun and bicycle against a backdrop of an old church.

JOB SHEET

CLIENT: **Social Service Auxiliary of San Diego**

USAGE: **Advertising**

FIRST ASSISTANT: **Stacie Kinney**

LIGHTING/CHURCH: **Existing light**

LIGHTING/NUN AND BIKE: **Strobe and light painting**

CAPTURE: **Analog**

PHOTOGRAPH COPYRIGHT ©**Paula Friedland Studio, Inc.**

PRO TIP The process of in-camera masking routinely involves still lifes and inanimate objects. Dealing with people, we suddenly found ourselves concerned with motion: the person had to remain perfectly still for both parts of the exposure, because if there was any activity when we went to the second pop, you would notice her outline as a result of that movement.

her conveyance—nothing in the bicycle reflects the Renaissance or the times during which the church behind her was constructed.

The incongruity actually did not factor into the success of this assignment. The client contacted me to produce a direct-mail campaign to raise funds for the Sisters of Social Service. Everyone agreed with this idea, using the bicycle as a vehicle to bring traditionally old concepts into the modern age.

For the background I used a stock image I had shot of a church in Dublin, Ireland. I originally photographed the scene using a Holga camera, which produced some vignetting—that was on Kodak T-Max 120. I then had an 8x10 black-and-white print made from this negative, and shot this print on 4x5 Fuji Provia. I followed up by inserting that 4x5 transparency into an in-camera mask, which I then placed in the back of a Sinar 4x5. That would establish the church setting as the backdrop for the shot.

This process involved a two-part in-camera exposure, with all the studio windows blacked out and all modeling lights off for the duration of the exposure. The first in-camera exposure was for the white cyc wall backdrop, to allow the church to record on film. I needed the wall to be as white as possible to bring out the church exposure when exposing the nun in the foreground afterward. The nun and bike would remain in position, in silhouette for now, thereby forming the shape of the mask. The nun and bicycle stood about 25 to 30 feet from the back wall.

We positioned two Broncolor Compuls lights far back, close enough to the cyc wall to blast it to pure white. The two lights, fitted with standard reflectors, were positioned at about a 45-degree angle to the cyc, 20 feet apart, left and right behind the nun and six feet from the wall. Because the lights were far behind our central figure, they wouldn't bleed onto the foreground. The first exposure involved one pop of the background lights, at 1/60 sec.

My 4x5, equipped with a 115mm lens, was angled so that the nun appears to be standing on the sidewalk. The original background exposure was a little fuzzy from the Holga optics, getting slightly fuzzier with each additional step en route to the final stage.

I switched over to the time-exposure ("T") setting for the second exposure. We had already positioned a grid spot close to the ground, two feet from our subject and aimed upward to light the nun's face. Any spill would be directed toward the ceiling, away from the background, thus avoiding any exposure to the church. Set to half-power to give us room exposure-wise for the next step, this light was then popped at 1/60th.

Next, my assistant light-painted the costumed model, along with the bike, for 40 seconds. We used light painting for the subject because it allowed us to control exactly where the light hit without fear of spilling onto other parts of the shot. Essentially, we had the model standing frozen in position for about two minutes. The overall exposure was f/22 3/4. We Polaroided heavily.

architecture, interiors, and hospitality

Architecture and interiors are demanding in every respect, requiring attention to every detail. Hospitality, which often adds a lifestyle element, may be less restrictive when it comes to lighting and viewpoint—allowing more personal expression.

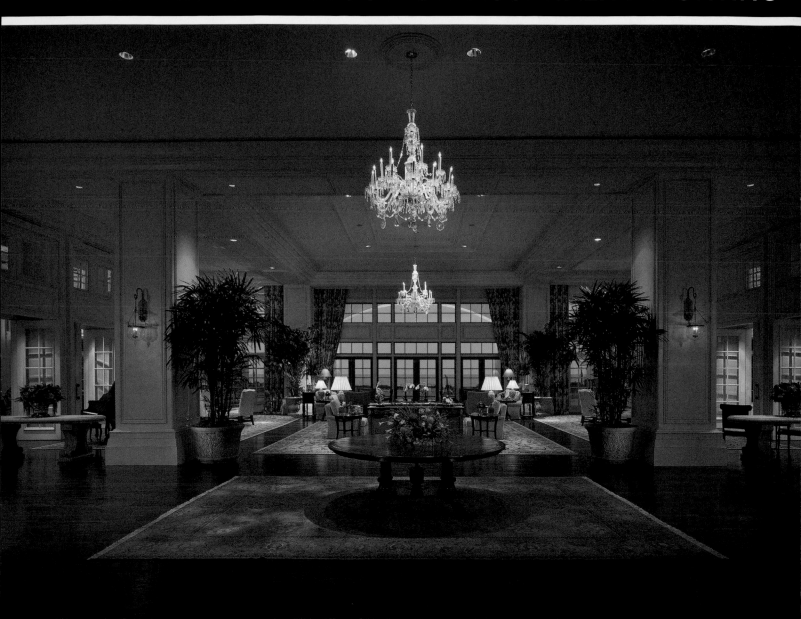

Some spaces require minimal attention, but not this lobby. Photographer and crew had to move heaven and earth to make everything symmetrically balanced. The process took hours, even before lights were in place. And because this was a wooden floor, moving anything was a very delicate operation.

The Sanctuary at Kiawah Island is a new five-star resort located just outside Charleston, South Carolina. When it comes to hotels and resorts, there is always a wish list. From the wish list we used extensive scouting to boil down a realistic array of shots we could produce during this 10-day shoot in July.

PRO TIP The difficulty with shooting people in a lobby, such as this, is that we're dealing with a 30-second base exposure. Also, given the scale of this room, people would be insignificantly small. Moreover, this shot is more about the design and grandeur of the space.

JOB SHEET

CLIENT: **The Sanctuary Resort**

USAGE: **Advertising and collateral**

AGENCY: **The Meridian Group**

CREATIVE DIRECTOR: **Shane Webb**

DESIGNER: **Hirsch Bedner Associates**

PRODUCER: **Jennifer Kilberg**

FIRST ASSISTANT: **Abdiel Thorne, Michael Heape, Matthew Horton**

PHOTO STYLIST: **Janet Grayson**

FOOD STYLIST/BALCONY: **Jack Case and Janet Grayson**

LIGHTING/LOBBY: **Tungsten and Kino Flo (plus existing light)**

LIGHTING/BALCONY: **Strobe (plus existing light)**

CAPTURE: **Analog**

PHOTOGRAPHS COPYRIGHT ©**Lee Gordon**

PRO TIP I travel with roughly 35 to 40 cases of gear in an extended cargo van. We carry hotlights and strobes, as well as all the modifiers that I may need, which includes six 2000 W/S powerpacks that output to 13 strobe heads. I rent HMIs where needed.

Two of my assistants had trucked the gear from Florida. My photo stylist, one assistant, and I flew to Charleston and met with the producer, creative director, and client on site. The only unknown we had to contend with was the weather—and, as luck would have it, a hurricane struck, which meant we had to modify the shooting schedule. We made the most of the one and only clear day and worked around inclement weather conditions the rest of the time. We averaged two to three shots per day. All the photography was done prior to opening day.

The hotel lobby is almost always on the shot list, especially when it's as opulent as this one. The first thing we had to do was evaluate what the existing lighting was doing without the influence of daylight, so we hung two 20x20-foot lengths of duvateen outside, over the windows along the back wall. One of my assistants was in control of a computerized junction box (provided by the hotel) that controlled all the lobby lights, raising and lowering them so we could see their effect. When it came time to shoot the picture, that duvateen drape then came inside and was hung behind camera to prevent reflections

onto the various shiny surfaces around the room.

In addition to using Type 55 Polaroid, I tend to do considerable incident metering and spot metering to determine overall exposure. In this case we spot-metered specifically to get a better sense of what values we were getting from the various light sources. The optimal exposure value for the magic hour reflections in the room was EV5 at this time of day (measured through the glass widows off the deepest blue sky).

I squared off the camera and sandbagged the tripod with three 15-pound Matthews flybags, one on each leg—an essential step when there's a flurry of activity surrounding the camera. The camera was a Sinar f2 with Schneider 72mm XL lens and 81A filter for added warmth. Film was Fuji RTPII, for an exposure of 30 seconds at f/22.

We moved whichever pieces of furniture could and needed to be moved. We also changed out all practical lamps with lower wattage bulbs in the sitting area and toward the back of the room. Where we couldn't switch out the bulbs, such as the chandelier, we had our computerized system do the job.

Extensive rearrangement of furnishings and considerable lighting, extending outside the lobby, combine to show the grandeur and opulence of this space.

We had nearly 40 lights on this shot alone—various Mole Richardsons and LTM Peppers, all Fresnels, with Kino Flos added for flavor. My lighting was designed to complement the symmetry of the space. That said, the adjoining rooms did add some variety, as did the piano in back. Right and left, respectively, beyond the doors are a ladies' tearoom and a men's bar. There was a little more light in the tearoom than in the bar, so we had two 1Ks in the tearoom and three 1Ks in the bar, with the lights bouncing into cards or adjacent walls.

Outside the building on the balcony were four 1Ks illuminating the arch, spaced equally from left to right, extending the full width of the lobby. These lights were bounced off the underside of the overhang to give us a sense of this structural detail.

Our lighting inside the lobby addressed the symmetry of the space and therefore was practically identical on either side, with a couple of exceptions. One was a 200-watt Mole, coming from the right, edgelighting the glass sculptures atop the second table (behind the one in the foreground). Another break with our symmetric lighting scheme involved adding a 200-watt Mole Inkie with snoot for the piano, coming from inside a doorway to the left.

Our symmetric lighting scheme encompassed lights coming first through the doors. To the left (and right) of the large stone table, we had a Kino Flo for the table and plant. Still moving along the left (and right) side of the room, we had a 200-watt Pepper with barndoors, on the plant alongside the column. We also had a 420-watt Pepper, from left and right, illuminating the seating area behind the left foreground plant. Likewise, we had a 100-watt Dedolight

illuminating the plant against the left rear wall (and obscured by the foreground column). Throughout the shot, lights were hidden by posts or otherwise out of view, some of them extremely low and hidden by planters.

I also had one 500-watt Lowel Totalight on each side—on the far back side of each column, bounced into 32x40-inch white foamcore cards, angled down at 45 degrees. They added a rolling light back into the room, as fill. Additional lights included a 200-watt Mole to the left and right of each column for adjacent areas.

We bounced another 200-watt Mole into a 4x4-foot card that stood on a pigeon stand, with the light hitting the front face of each stone table (left and right). Alongside this light we had a 100-watt Pepper giving us a highlight at the base of each planter. Another 200-watt Mole on a floor stand on each side and aimed toward the seating area raked light along the carpet, creating some highlights on the floor while hitting the wooden serving table. We added more 100-watt Dedolights to bring up the values on the front of the couch. The mottled pattern on the carpeting came from the existing ceiling lights.

For the lights in the immediate foreground, we placed at the left and right corner 1Ks, bounced into cards at a 45-degree angle and supported from a C-stand. Also, as fill, we had two additional 1Ks with a full scrim, bounced into foamcore. From each side, we had one 100 Pepper aimed at the foreground floral arrangement on the table, and alongside each a 420 Pepper Zip (a small soft light with directional egg-crate modifier) to light the legs of that table.

The balcony picture introduced the lifestyle element of a hospitality shoot. We had two key lights, both positioned at the opposite end of the terrace. First there was a 22-inch beauty dish with grid coming off a boom arm, at 2000 W/S (on its own pack), and focused on the head and torso of our couple. Then, a few feet to the right, we had a medium Chimera aimed at them to blend with the daylight

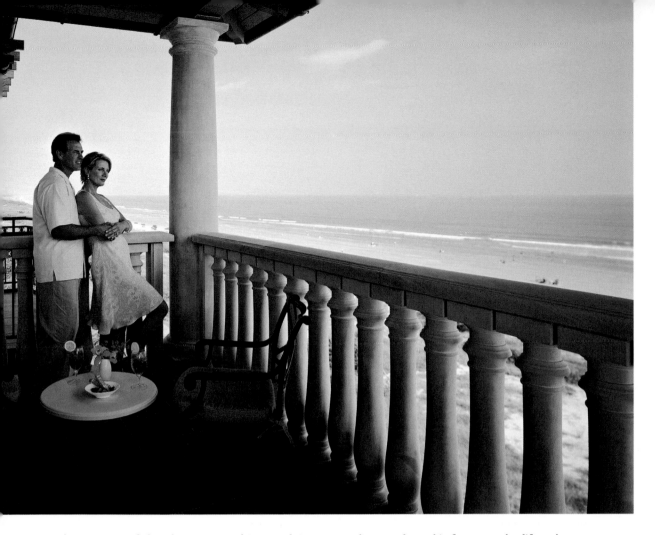

The majority of this shoot was architectural. However, shots such as this focus on the lifestyle aspect associated with the resort, showing a couple enjoying a romantic moment. The tight space mandated that most of the lighting be positioned on either side of camera, against a retaining wall.

and the beauty dish, also at 2000 W/S. The space was very tight, with a wall separating adjoining balconies. The boom arm actually came in on the set over that wall. The camera was up against the wall in the left corner.

We also needed some fill light, so we added one 1200 W/S head (suspended from a C-stand) and bounced it into a 32x40-inch card angled down at 30 degrees. The slate tile was still too dark, so we brought that value up with another 32x40 fill card bouncing back an 800 W/S light. We diffused this head, wrapping it in Cinefoil to prevent flaring the lens. All the balcony lights had a ¼ CTO.

We made this shot on a 4x5 Sinar f2, with Schneider 90mm XL lens, exposing Fuji RDPIII for ¼ sec at f/16.3. We added an 81B and polarizer on the lens to compensate for the slight overcast and shade. We produced this picture on one of the last days of the photo shoot, with everyone crossing their fingers in hopes that the sky would remain relatively clear.

JOB SHEET

CLIENT: **TRO/The Ritchie Organization**

SECONDARY CLIENT: **Tully Health Center, Stamford**

USAGE: **Collateral**

FIRST ASSISTANT: **Bruce Hilliard**

LIGHTING/TRACK: **Tungsten**

LIGHTING/LOBBY: **Tungsten (plus existing light)**

LIGHTING/EXTERIOR: **Existing light**

CAPTURE: **Analog**

PHOTOGRAPHS COPYRIGHT ©**Edward Jacoby**

PRO TIP When I have to fly, I send the lights ahead to the location via bonded courier (FedEx or freight). Or, if possible, I will rent, but that's rare.

Every architectural shoot has its rewarding moments, such as when you come across the clean lines and warm color scheme of an indoor running track complete with colorful columns. Bringing all this out required the lighting to be strategically positioned around the track. You might call it "track lighting."

There was no time to tech-scout in advance, so I made do with digital photographs that the client had sent over. Upon arriving at Tully Health Center in Stamford, Connecticut, we spent a couple of hours doing a run-through to determine what needed to be done. I brought my trusty Sinar f/2 4x5 camera to the shoot, employing a 150mm lens for the track shot, a 90mm for the lobby, and a 105mm for the exterior. The camera for the track shot was tucked into an adjoining hallway between a wall and column—hence the visibility of both elements framing the shot left and right, respectively.

I trucked all my gear to the location. All the lights were Mole Richardson 650-watt focusable Fresnels. I didn't do anything to control the existing light—the fluorescents. There was no need: I discovered that Fuji NPL (long-exposure) negative film is quite capable of rendering fluorescent lighting as neutral white. This is a good example of an interior that has to be photographed without people. Not surprisingly, we shot late in the day, after hours.

For the track shot, I started lighting in the small room at the rear. The head was aimed into the room from the right, six or seven feet high. Although it was only a small space, a black hole back there would have been distracting.

Our next light went over in the right-hand corner of the space—actually two lights, each aimed at a sideways angle and somewhat downward onto the track, producing those two cones of light that add dimension to the track surface. The second light also hit the pillar on the left edge of the frame, while the other reached the purple post. I then added a light down on the lower floor, aiming it upward to provide some detail in the interior curve of the track.

Next, we positioned a light off to the left of camera, practically against the railing, so that it hit that wall on the right edge of the frame. Another light was aimed onto the surface of the track, also from camera left, placed almost up against the railing. We had yet two more lights addressing the back of the track on the left. One was aimed primarily at the

Though the focus of this shot and the lighting is on the track, lights still had to be positioned all around this level to bring out adjacent areas.

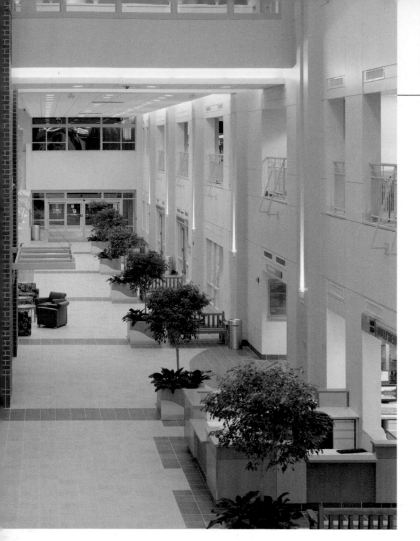

Lit largely by available light, the lobby needed little besides a few lights to highlight the area to the rear and a couple of other select spots.

wall, with the other directed mainly at the track floor while also hitting the wall. Since the focus of the shot was on the track, I didn't attempt to light the area below this level. The existing fixtures took care of that.

Exposure for the track was 10 to 12 seconds. I always shoot stopped down to f/22 and very often at f/32, because I really like to have as much depth of field as possible.

Next we moved to the lobby of the building just after darkness fell. There are times when I don't use much lighting at all, because I feel it would just make the shot look fake. In this instance, I used one 650 Mole soft light coming from the lower right-hand corner aimed at the planter and reception desk. I also

The photographer's lighting had to reflect the designer's intent, with lights providing good coverage of the track area—and even bringing out recessed spaces.

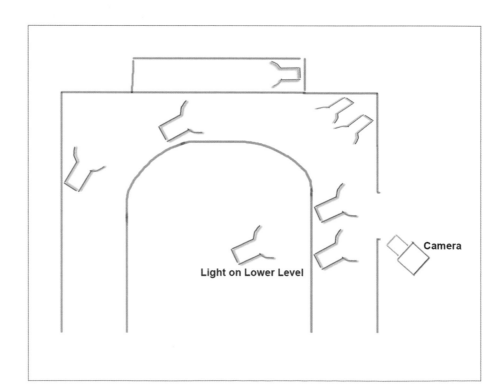

Light on Lower Level

Camera

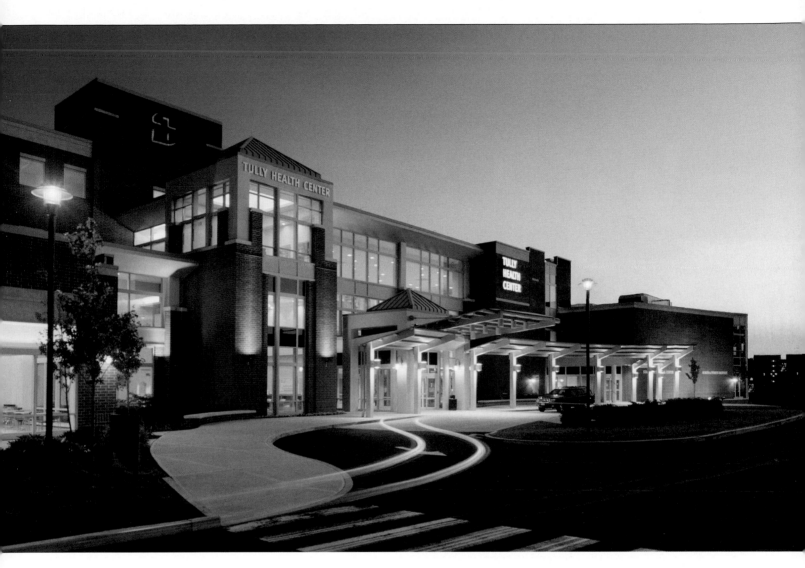

This view at dusk is enhanced by the trail of headlights during a long exposure.

threw some light (two 650 Moles Fresnels) onto the wall toward the back, along the right side of the shot. There was also a 650 Mole soft light directed at the chair in the seating area halfway along the left-hand side, to help bring out the color. Exposure on this shot was 10 seconds at f/22. The track shot was next.

The very first shot in the job was this one—the exterior, shot at dusk. Here I worked strictly with the existing light, adding a polarizing filter to my lens for a 30-second exposure, which allowed me to catch the blur of the car coming into the shot. That one element was staged, with my assistant driving our dark-toned truck. All in all, I started on this shoot at 4 PM and worked through until midnight, for a total of 13 shots.

PRO TIP Every interior is different, but generally I work with the existing interior lights on. Frequently these lights are an important element—after all, they were part of the original design. Also, turning the lights off would leave black holes where the fixtures are visible in the shot. My job is to augment the lighting, which means being especially watchful of contrast and lost detail.

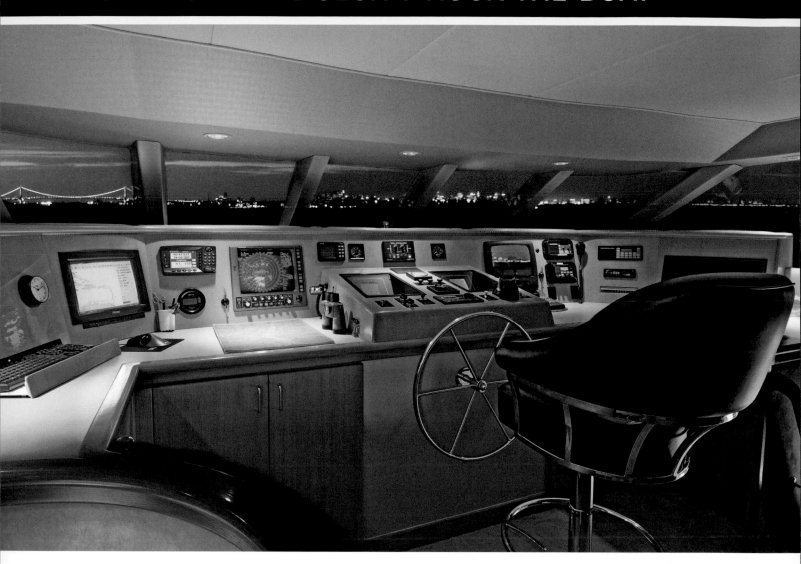

Architectural photographers are called to photograph every sort of building—but a boat? That's precisely what needed to be photographed in this project.

Photographing is a passion of mine. A recent assignment let me combine my passion with my recent expansion and diversification into architecture and interiors. My job was to photograph the interior living and dining spaces of a 106-foot Westship motor yacht for a promotional brochure. An interior designer, with whom I had worked before, designed the boat's interior spaces, and she especially appreciated my ability to work quickly.

On this job, we did 19 shots and were in and out within hours, arriving at the dock by 7 AM on a summer's day. There was no time to tech-scout in advance. I was given a quick tour of the boat, and then set about shooting on a Nikon D2x, mostly with a 12–24mm DX Nikkor lens. The camera for the bridge shot was tripod-mounted, with the lens at 12mm. All the shots were in Jersey City, New Jersey, alongside a pier at Liberty Landing.

Bracketed exposures provide the means to composite a final image that shows detail where needed, such as the instrumentation on the bridge. Several strobes augment the available light. Also shown: three bracketed exposures from which elements were pulled.

JOB SHEET

CLIENT: **Boat owner**

USAGE: **Collateral**

INTERIOR DESIGNER: **Designs by Beverly (Rumson, NJ)**

LIGHTING: **Strobe (plus existing light)**

CAPTURE: **Digital**

PHOTOGRAPHS COPYRIGHT ©**Jeff Smith**

PRO TIP I've found I can control perspective in Photoshop just beautifully, even better than with the PC lenses I use occasionally. On most of these shots I needed a wider lens than the 28 PC optic would afford me, especially when coupled to the D2x, which is not a full-frame dSLR.

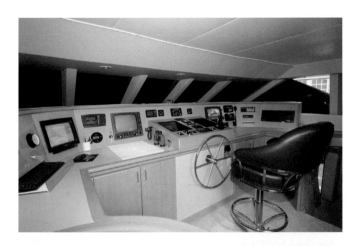

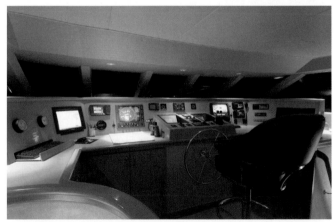

I had carte blanche to photograph anything and everything. The only props I brought with me were a bouquet of flowers. The captain and crew were tremendously helpful with styling and prepping: for example, they helped me put black paper over the windows where needed, and they added the fruit basket, champagne, glasses, and other accoutrements on their own.

I brought as much gear as I usually take for an interior, but I ended up bringing out only one 1200 W/S Comet pack and three heads, plugging them into outlets on the boat. The existing light did a great job in many situations, so I needed my own lighting here and there. The bridge was one shot that required more light, especially since we had blacked out the windows with seamless paper from the outside, which helped control the interior contrast as well as block out an unappealing view. I bounced a 400 W/S head off a bulkhead behind the chair, which opened the space considerably. And because we were balancing this light to the available tungsten illumination, we used an 85B gel on the head.

The bridge was elevated, so that the stairs on the left went dark, as did the other recessed area on the opposite side. I brought in one 200 W/S head for each, keeping them hidden in the recesses of each space. But I didn't gel; instead, I let the light go blue, as contrasting accents. You see a little of the blue light from the back of the chair. To allow the tungsten light to burn into the exposure, I exposed for 1.3 seconds at f/7.1. I adjusted white balance in the Nikon Capture software. Because I had bracketed

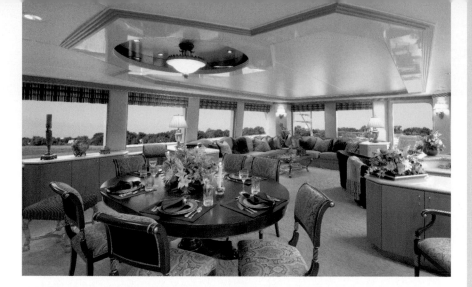

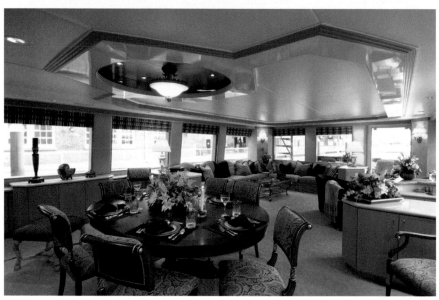

Different parts of the main saloon are photographed so as to arrive at usable elements for the final composite. In addition to the ambient light, two small banks provide fill. Also shown: the original digital capture that clearly illustrates areas wanting in one way or another.

my exposures extensively, I was at liberty to take the next step. I was able to pull any of the instruments or radar screens from a good exposure of the element and composite it into the final shot.

There was still the matter of the windows. I had a picture of the New York City skyline and the Verrazano-Narrows Bridge that I had shot, which I enlarged, cropped down to the necessary proportions, and dropped in to give a scenic view of the bridge.

We then moved to the main saloon. The only things visible through the windows were a dingy old wharf and a very uninviting industrial setting, which I knew would require dropping in some appealing scenery. In this instance, we couldn't take the same approach as before because exterior light was needed for the exposure. We also had to be careful not to blow out the windows with daylight, because flare would have made it difficult to produce our composite image.

I again shot multiple exposures, taking into account the outdoor brightness and increasing the exposure for the interior. Added to the available daylight, I had one small bank to the left and another bank to the right. Both lights were aimed straight into the room, standing about four feet up and tilted slightly downward.

I not only bracketed for the composite but also photographed individual sections of the room, making separate exposures for the ceiling, the table and chairs in the lower half of the scene, and the middle of the room, which included the mullions and

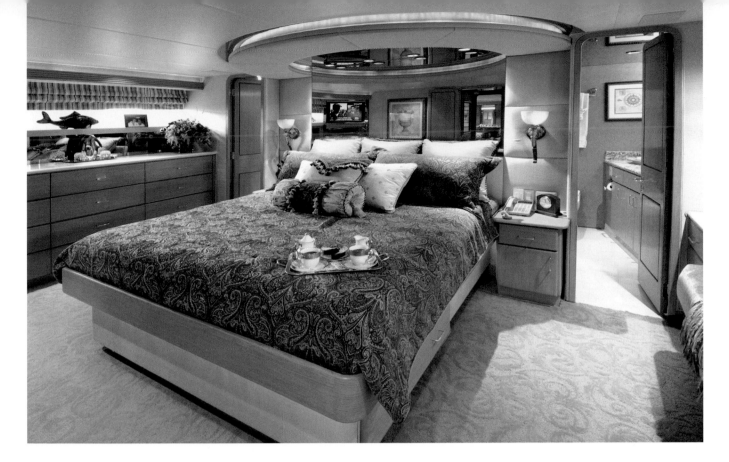

Only one small strobe is needed to capture this view of the master bedroom.

windows. I maintained camera position and focal length throughout. You'll notice the reflections in the ceiling. I picked up the new scenery and used it in place of the original reflections.

Finally, we arrived at the master cabin. The crew was nice enough to add the tea setting without prompting. Though there was daylight coming in from the left, the predominant available light was tungsten. The only light needed for fill was one head bounced off the wall to my left. I attached an 85B gel by Velcro to a Nikon SB-800 flash. Only the pillows needed separate attention; the simple trick was to make one additional exposure for them and drop that element into the final shot.

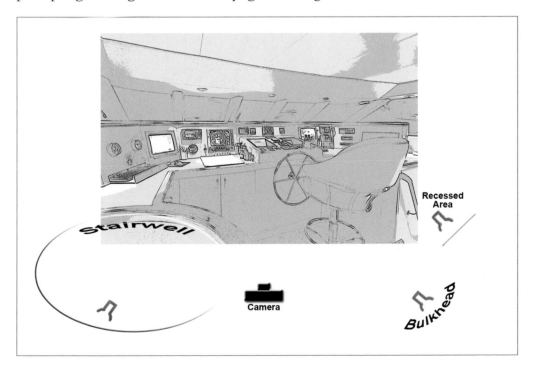

Since the windows were blacked out, the lighting had to simulate a daylight experience without appearing artificial.

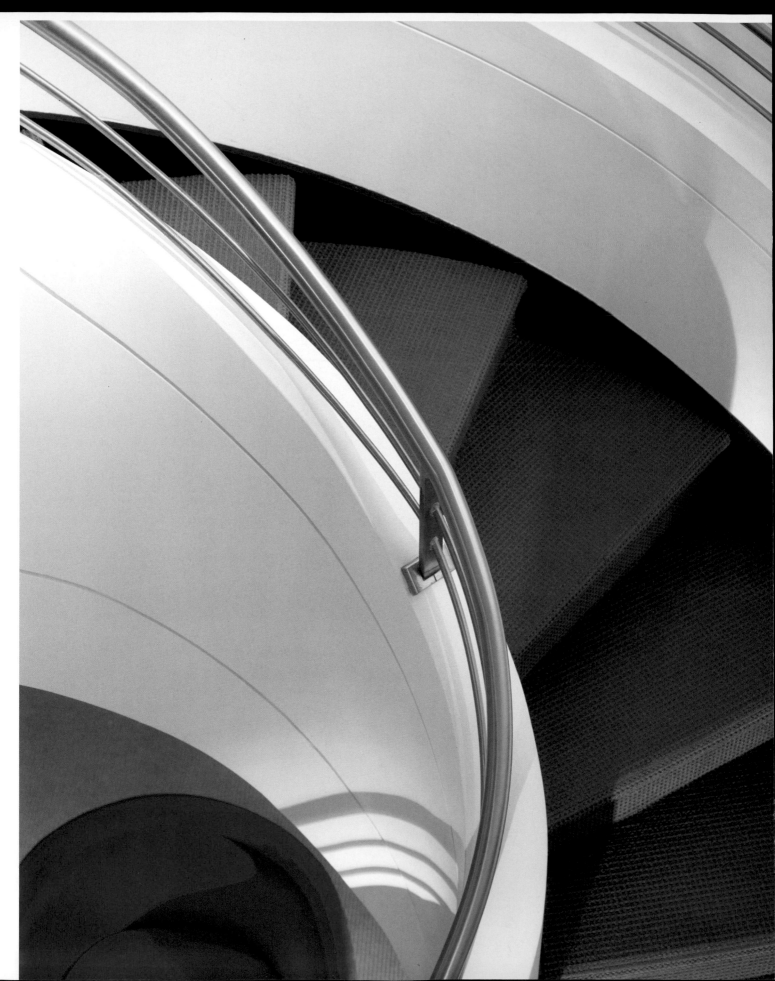

JOB SHEET

CLIENT: **Childs Bertman Tseckares, Architects, Inc.**

USAGE: **Collateral**

ARCHITECT: **Robert Brown**

FIRST ASSISTANT: **Bruce Hilliard**

LIGHTING: **Tungsten**

CAPTURE: **Analog**

PHOTOGRAPH COPYRIGHT ©**Edward Jacoby**

PRO TIP Although I didn't use one here, I always carry around numerous small, circular scrims that fit on the front of my lights, which are a handy resource. For example, you can scrim a light to reduce a hot spot on the back of a chair. I also use barndoors to keep stray light off certain areas and to hold shadows down. And the two may be used in combination for even tighter control.

Photographing interiors is not just about shooting wide, open spaces. Sometimes the client wants to focus on the details. And at times, such as in this shot, the details present themselves when least expected.

We were in the offices of a Boston law firm with an unusually keen sense of design and a collection of furniture to match. I had just finished photographing the premises when I happened to be standing and looking down over a parapet, enjoying the tasteful collection of artwork and furnishings. And that's when the stairway and chair caught my eye. In a matter of minutes, the chair was moved to this spot, lights were in place, and the picture was taken. It turned out that this was the image of choice, and the client has used it several times since.

The simplicity of the shot belies its complexity. We had one barndoored 650-watt focusable spot that raked across the steps, placed a few feet from the foot of the stairway, fairly low to the ground, and aimed upward. The next light, also with barndoors, went up on the second level, off to the left, and hitting the front-left side of the stair. Another light was on a line with this one, but higher up, so that it was lighting the far right wall of the staircase. This caused the shadow, created by the bottom light, to gradate softly. Another light was barndoored on the upper landing and positioned to rimlight the handrail.

We put another light off to the left, on the lower landing, so that the spiral stair—specifically, the three flowing lines of the handrail—intercepted this light, casting a mimicking shadow on the near wall, seemingly behind the chair. The light was just at the height of the handrail, with a snoot so that it picked out only a portion of the railing.

There was another barndoored light, quite high and to the right, coming in over the stairway and hitting the chair. I also put a soft light on the green rug to help separate the chair from the floor. Finally, there was a scoop light coming from under the stair, to the right, and fairly high. All lights were 650-watt focusable spots.

I shot this space with a 4x5 Sinar and 120mm Schneider Super Angulon, on Fuji 64T. Type 52 black-and-white Polaroids were used to judge composition and evaluate exposure. The camera was on the second level, looking downward at about a 60-degree angle.

Shadows are an integral part of this shot, with lights coming in from above and below to form an appealing interplay of lines, shapes, and patterns.

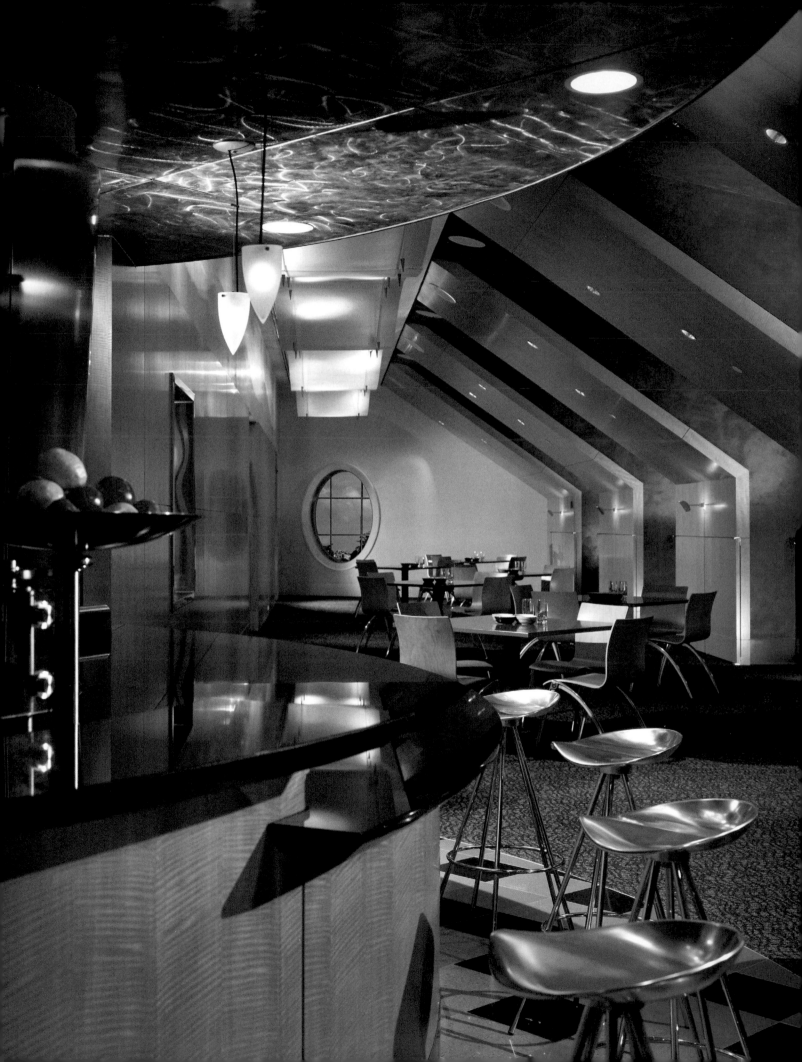

JOB SHEET

CLIENT: **Childs Bertman Tseckares, Architects, Inc.**
USAGE: **Collateral**
ARCHITECT: **Robert Brown**
LIGHTING: **Tungsten**
CAPTURE: **Analog**

PHOTOGRAPH COPYRIGHT ©**Edward Jacoby**

PRO TIP Lately, I've been using lights of lower and lower wattage. That works well when incorporating available indoor light, and it keeps fuses from blowing. It also helps the shot when you have control over the existing lights, turning them on or off or dimming them as necessary. Lighting fixtures tend to be an important part of the design, so it's a good idea not to let them all burn out.

It's called a servery—a fancy name for a corporate cafeteria in this semiexotic setting of Hamilton, Bermuda. I prepped the shot at midnight, with actual photography commencing at 3 AM. The entire assignment at this site, which included other rooms and exteriors, took us four days. Each day, I would start at 6 or 7 PM and shoot until about 5 AM the next morning, with the aid of one locally hired assistant.

The dining alcoves (to the right) remained nearly hidden from view, as the client required only a hint of their presence. However, the client did want me to emphasize the overall design of the room, and also the materials, such as the brushed stainless steel above the bar, the wood at the base, and the black granite that ran along the top, along with the tiles on the floor, and the rug pattern. It was important that all of it be included so that no one would question the level of quality of the materials. That was why we lit the walls of the alcoves, to show off the mottled pattern.

Setting up required us to make a few small changes to the room: we removed some tables, but added a fruit plate on the bar and dishes and glasses on the remaining tables to throw in a little color. It took some time to arrange the four stools at the bar so that they intersected in a visually pleasant way, considering how prominently they stood out in the shot.

I shot this space with a 4x5 Sinar and 120mm Schneider Super Angulon, on Fuji 64T. Type 52 black-and-white Polaroids were used to judge composition and evaluate exposure. I began my lighting in the four recessed areas because I knew they were an important starting point to add a sense of volume to the room. Each had a 650-watt Mole-Richardson scoop soft light, seated atop a dining table, and aimed upward along the mottled blue wall.

At the rear was a door just to the left of the oval window, which we decided to leave black in the dead of night. We placed two 650-watt focusable spots inside the door, one aimed at the far wall, the other hitting the table nearest the wall. They were eight feet up, one next to and above the other, so that the lights crisscrossed. We also had two additional 650-watt spots, on short stands, in the stainless steel opening beyond the tomatoes on the bar. They lit the table closest to the camera and the floor back behind the table, while also highlighting the metal pattern of the window frame. To emphasize the floor, there was another 650—on a short stand, four feet up—on the floor just below the curve of the bar.

My main light was a 650 Fresnel positioned at a 90-degree angle to the camera, off to the right, about eight feet high and aimed at the very front of the bar. The rimlight on the rod supporting the vegetable plate came from this light. We also had a 300-watt focusable spot to highlight the brushed metal overhang above the bar. This light was off to the left, behind the bar. We then returned to the first (more fully visible) alcove to add a highlight along the front edging, with the aid of a 300-watt light through silk, sitting on the floor. Select lights were scrimmed to keep areas from going too hot, with barndoors used where required to keep stray light off certain areas.

The camera was higher than I normally shoot, about five feet up. I often shoot fairly low. A long time ago I learned a little secret: that photographers shoot interiors too high, at eyelevel, and that it doesn't work. Don't tell anybody.

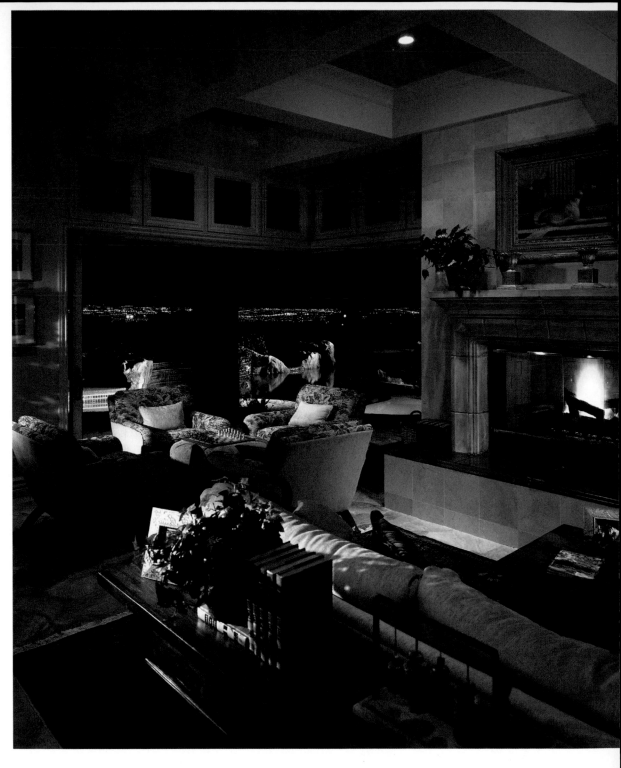

A residential interior needs to look lived in, not sterile—which means that a photographic depiction should do no less. As such, the space may need to be populated by certain accoutrements, or a fireplace may need to be lit, as we find here.

Tungsten lighting reinforces the existing lighting scheme to fill in areas of importance throughout this residential space.

JOB SHEET

CLIENT: **Integrity Publishing/*Las Vegas Design Resources* magazine**

USAGE: **Editorial**

LIGHTING: **Tungsten (plus existing light)**

CAPTURE: **Analog**

PHOTOGRAPH COPYRIGHT ©**Jeffrey Green**

PRO TIP I don't normally tech-scout a location. After working with numerous interiors, I can work pretty quickly to come up with the best lighting solution without a lot of preproduction.

I knew we were going to be shooting at dusk. I also knew this would be the cover for a home furnishings and interior design publication, which meant leaving enough room at the top for the magazine title.

Although I didn't tech-scout this house, located in Henderson, Nevada, I did know it was a living room with a view of Las Vegas in the background. And though we went there just to shoot this one picture, I still needed to truck five or six cases of lighting gear to the job. What's more, even though this was an interior, I knew we would be lighting the outdoor swimming pool just enough to hint at its presence through the glass doors.

We didn't really have to do much in preparing this living room, aside from moving a few things around, such as the chairs and framed picture, as stylistic touches. We did add the magazine to give it a lived-in look. Also, we lit the fire in the fireplace to give the room a more inviting feel. Otherwise, no propping was involved. We got there at 5 PM, in anticipation of dusk, which would be around 7 or 7:30. The whole shoot lasted three hours, from setup to breakdown. I had one assistant on this job. The homeowner was there, as were a couple of staff members from the magazine. My camera was an Arca Swiss F-line Classic with 90mm lens. Film was Fuji 64T (pushed one-third), for an f/22 exposure bracketed at between 8 and 15 seconds.

Our lighting began outside by the pool. I put up two Lowel 500-watt DP lights to the right—they're hidden by the wall, strafing across the water, giving us enough light to see the edges of the pool. These Fresnel lights had ND gels to reduce their intensity and were set midway between flood and spot, with barndoor panels configured parallel to each other. These lights stood five or six feet up, on heavy-duty Bogen stands.

We left the interior incandescent lighting on in both this and adjoining rooms. Now we had to fill in with our lighting, which involved one barndoored DP from the left, gelled down with neutral density, and aimed at the center of the two chairs with the pillows on them. This light was three or four feet to the left of the chairs and six feet up.

I wanted to imbue the shot with a sense of depth, by layering the lights so that individual areas pulled the viewer through the whole room. To that effect, I then added a Lowel Omni to the far left, a little forward of the camera position, with this light barndoored down in a tight spot configuration. You can see it hitting the picture frame, plant, and top of the sofa.

I had another DP bounced into a 60-inch white umbrella, three or four feet to the right of camera and six or seven feet up, as overall fill for the room but specifically lighting up the ceiling and the right part of the sofa. This light created an inadvertent shadow from the plant on the fireplace, which I later took out. Finally, there was one more fill light, to the left behind the chair. This was an umbrella with a 300-watt Omni, for the chair, but allowed to spill over onto the sideboard behind the coach.

I timed the shot to coincide with the optimum color in the sky and just the right intensity of flame in the fireplace. We had a window of five minutes to truly capture that moment.

MORE LIGHTING SOLUTIONS FROM JEFFREY GREEN

I switched over to a Canon EOS-1Ds for this assignment, attaching a 24–70mm lens (set to 28mm), for an exposure of 2 seconds at f/13, ISO 125. I find that with this medium I can shoot a lot more images in a day, more efficiently, and with greater creative control. If I need the movements of the view camera, I can get some of that with perspective-control lenses. I needed something tighter; otherwise I would have used the 24mm tilt-shift optic. Another plus is not having to scan film—not to mention the fact that the clients really prefer digital because they want the images turned around as soon as possible. If there's a client on site, I shoot with the camera tethered; otherwise, I shoot untethered.

The client, an interior design firm, planned to use these pictures in **Canadian Interiors** magazine, as well as in the designer's portfolio. We went with tungsten here because of all the existing down lights, as well as the landscape lighting outside, which included an uplight on the palm tree outside. The kitchen was already well lit and didn't need much. Even the aquarium lighting was more than adequate, so we left it alone. However, in post, we did have to remove some reflections off the fish tank, and, in general, had to adjust contrast a bit.

One area that demanded immediate attention was the hallway past the aquarium, where the tree-like plant was standing. I had an umbrella placed there with a 500-watt DP to the left, filling the entire area. Then I placed a 100-watt MiniMole, diffused, down on the floor, lighting up the cabinet to the right, which gave us the vertical highlight. Behind to the left was a 300-watt MiniMole bounced into the white wall, to give a little more fill on the foreground. We had one more 100-watt Mini adding a glow below the fish tank, in the large glass wall where the kitchen cabinet ends, which came from behind. I also had a 300-watt Arri with heavy diffusion by the sofa, six feet up and from the right, hitting the couch and spilling a bit of light onto the doors.

JOB SHEET

CLIENT: **Jacqueline & Associates**
USAGE: **Editorial and collateral**
DESIGNER: **Jim Young**
LIGHTING: **Tungsten (plus existing light)**
CAPTURE: **Digital**
PHOTOGRAPH COPYRIGHT © **Jeffrey Green**

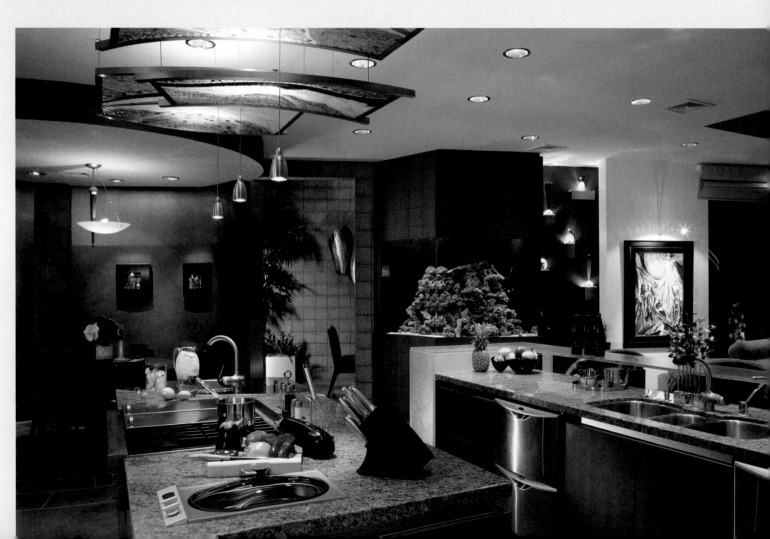

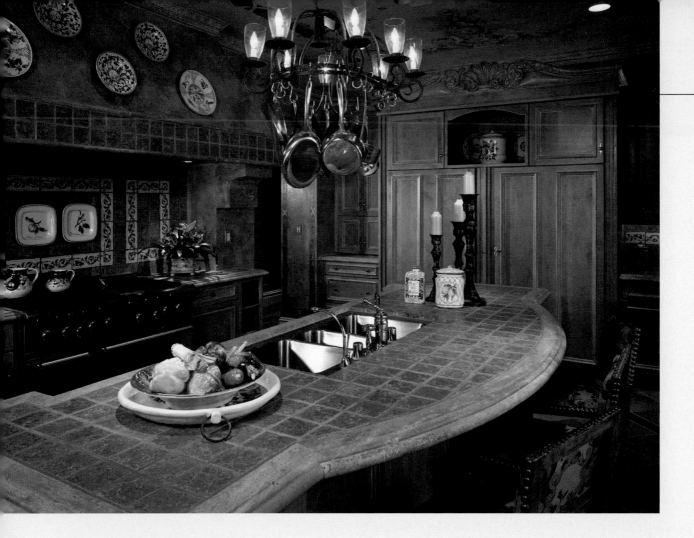

JOB SHEET

CLIENT: **Merlin Contracting**

SECONDARY CLIENT: **Ultimate Kitchens**

USAGE: **Collateral**

LIGHTING: **Strobe (plus existing light)**

CAPTURE: **Analog**

PHOTOGRAPH COPYRIGHT © **Jeffrey Green**

The key in this kitchen was to blend the ambient lighting with the flash. More to the point, I had to ensure that the flash didn't overpower the existing light.

This kitchen was one of seven or eight shots. Although the building contractor was initially the one who hired me to shoot this home, the kitchen designer also needed pictures of the space, so this one picture had to serve both their needs. As a result, I shot it from a couple of different angles, just to cover myself. The kitchen designer remained on site but largely allowed me to shoot the picture the way I envisioned it. My film was Kodak 100S loaded into an Arca Swiss with 90mm lens, for an f/22 exposure at 1 second. I Polaroided to determine my exposure. Because this was a daytime shot, with daylight streaming into the room through a large window, I used strobe, specifically White Lightning.

The main light was a 60-inch white umbrella on a 3200 W/S monolight—at full power, positioned to the left, a little bit behind the camera, reaching almost all the way up to the ceiling. Next, I added a large Photoflex bank with a 3200 W/S head at half power to address the archway to the right. The bank was positioned horizontally, six or seven feet from the chairs and four feet off the ground. The area outside the doorway to the left still needed some light. So I added a head with diffusion, about two feet back from the entrance and five feet up, aiming it into the kitchen so that it hit what looks like a cabinet (but was really the refrigerator). This light also added separation for the hanging plant.

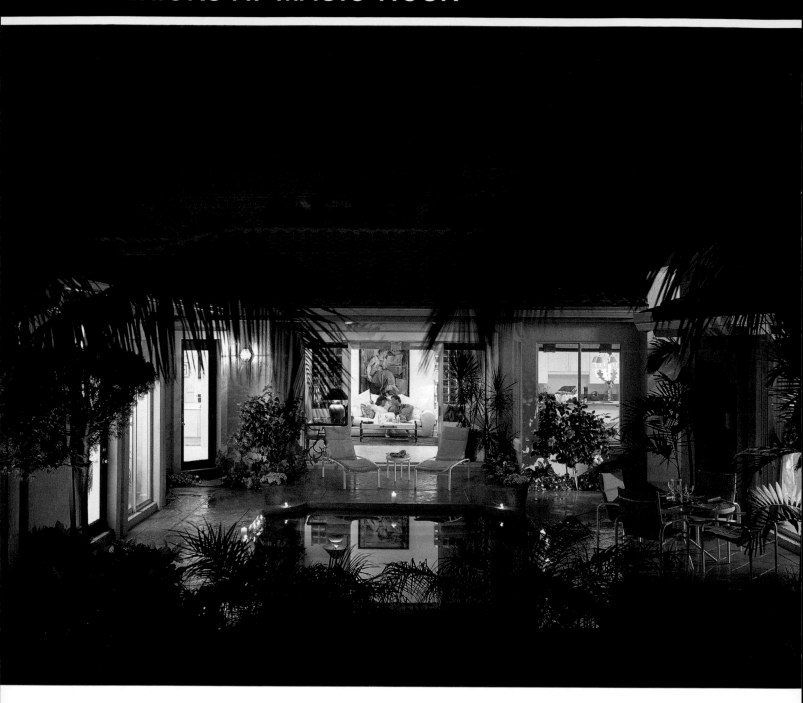

"Magic hour" comprises the few minutes at dusk when the ambient interior light and lingering daylight mix without overpowering each other—the moment when those last rays of the sun add just a hint of cobalt blue to the sky on tungsten film. It imbues the scene with a magical quality.

More than two dozen strobes and hotlights recreated the natural atmosphere of this lovely villa shot at dusk.

We had a choice in homes when shooting this new development, providing both daytime and evening renderings for magazine ads and brochures. For the evening shot, I chose this southwest-facing property, with the sun setting behind

JOB SHEET

CLIENT: Santa Barbara Community Development (Florida)

USAGE: Advertising and collateral

AGENCY: Wexler McCarron & Roth

CREATIVE DIRECTOR: Bob McCarron

PHOTO STYLIST: Vivian Poulos

FIRST ASSISTANT: John Cohen

LIGHTING: Tungsten and strobe (plus existing light)

CAPTURE: Analog

PHOTOGRAPH COPYRIGHT ©Lee Gordon

PRO TIP Shooting architecture doesn't always involve sterile-looking spaces. Our mandate here was not to showcase this property simply as an architectural rendering, but to present it with a hint of lifestyle, showing people clearly enjoying themselves. And that involves considerably more work and preparation.

me so I could capture this scene at "magic hour."

When determining my camera position, I took everything from the sky to those quiet reflections in the pool into account. To fully capture the flavor of this courtyard home, it was necessary to go inside—not simply shoot a façade. It also meant that we would need to add props, since the deck area was sparsely furnished, and that we would have to move existing elements around to meet our needs. We hired models out of a local Miami agency to pose as our fun-loving couple.

But all this paled in comparison to the work we would have to do setting up the lights, which came to nearly 30—a mix of tungsten and strobe. In setting up our lights, we also had to focus attention on the architectural design and the ambiance of the surroundings. Three assistants and a photo stylist helped me put all the pieces into play.

In lighting this space, the first thing we did was to replace all the visible existing incandescents with lower-wattage bulbs, to prevent them from burning out during a long exposure. It was also important that any installed lights simulate the ambient lighting.

At the outset, I should mention that all my LTM Peppers are scrimmed and gelled with one-quarter or one-half CTO for added warmth. The scrims used are metal, in different densities, and some are half-scrims, with only half the light head covered. Every single light is flagged, with some further controlled with Cinefoil. All the 100-watt and 200-watt

LTM Peppers are Fresnel focusing spots. Moreover, all the strobe heads—Normans—are black-wrapped with Cinefoil, and each head run off its own pack. Unless otherwise noted, the strobes were converted to tungsten balance with a full CTO, and often another half CTO for warmth.

We employed twelve 9-foot stands, four 12-foot stands, a boom, and floor stands secured with gaffer tape. Most of the lights were positioned inside the house, behind glass doors. Only five lights were on the deck outside.

The palm frond coming in at the far right anchored the lower corner of the photograph, adding an element of interest, so it was important to get some light on it. Coming from inside the room far right, we had a 100-watt LTM Pepper, half-scrimmed on the lower half of the light. The angle also allowed this light to illuminate the glasses on the table. The table itself was lit with a 200-watt LTM Pepper, positioned above the previous light. And there was a 420-watt LTM soft light to the left, behind an egg-crate panel to help direct the light onto the pool deck.

In addition, we had a 1K Lowel Totalite, bounced off the rear wall of the room on the right, positioned near the ceiling, almost in line with the 100- and 200-watt lights mentioned above. This threw a wash of light onto the deck.

Inside an alcove leading to the main courtyard entrance—you notice that it's brighter at the top,

above the palm frond—we added a 2000 W/S Norman 10-inch dish with a half-stop Rosco diffusion. This light was bounced off the ceiling and wall to simulate an entry light. There was also a 200-watt Pepper on a 6-inch floor stand, lighting the hibiscus plant and flowers of the kitchen windows.

Then I bounced two 200-watt LTM Peppers off the kitchen ceiling and walls, along with a 1200 W/S strobe bounced off the ceiling and appropriately flagged. That completed the kitchen lighting.

Behind each of the two "blue" windows in the living room—which were glass block windows—was a 2000 W/S 10-inch dish with one full stop of diffusion and no CTO filtration. They produced the daylight blue effect to contrast with the overall warm colors. These were the only lights powered by generators in this shot. Two additional 1200 W/S heads, both diffused, were bounced individually into each of the living-room corners to provide ambient light.

At left, but still concentrating on the area facing the camera directly—there were two 2000 W/S strobe heads with 22-inch parabolic dishes and honeycomb grids plus diffusion—one on a boom, and one on a 12-foot stand, coming in from the upper left front corner, illuminating the couple on the couch. An 800 W/S grid spot was at the lower left corner hitting both the coffee table and models.

Then we had a 100-watt LTM lighting the fruit on the table between the two deck chairs. This light was positioned behind the front living room wall, upper left.

Moving to the left side of the house, we had a laundry area (with a black frame around the door). We positioned a 500-watt Berkey Colortran hotlight (flagged and filtered), which we bounced off the back wall of that room. To that we added a 1200 W/S strobe bounced off the ceiling to further illuminate that room. Because there was frosted glass on the door, I needed to increase the amount of light in that room so that it would be of equal value with the other areas that I lit.

Coming from inside the guest bedroom to the left was a 2000 W/S strobe, with diffusion, illuminating the hibiscus plant to the left of the living room. There was also a 1200 W/S strobe above that head bounced off the ceiling. This light had a half-stop diffusion and

created a wash of light back down onto the patio. We then added a diffused 650-watt Berkey Colortran head bounced off the wall to bring up light levels in that area of the courtyard.

Moving to the far left front, there was a 1K, 6-inch Sweep-Focus Fresnel Berkey Colortran, with barndoors, bounced off a white card, opening the courtyard with a wash of light while also illuminating the entire pool surface.

There were still several more lights. A 200-watt Pepper was positioned underneath and a little to the right of the 1K light, illuminating the face of the two deck chairs. It was scrimmed and flagged to reduce the intensity of the shadow.

Way in front was a 100-watt LTM, coming out of the bottom left corner, which skimmed across the surface of the pool and brought up the tonal values of the planter on the opposite side, along with the pool rim on that side. Finally, there were two 100-watt LTM Peppers all the way in the bottom right front corner. These did essentially the same thing for the left side of the courtyard area, while also helping to highlight the legs on the patio furniture and add separation from the background.

The f/16 exposure required 6 seconds during the peak magic-hour moments, extending to 8 seconds as the skylight waned. The film was pushed one-half stop on 4x5 Fuji 64T Professional, shooting with a Sinar f Plus and 120mm Super Symmar HM with self-cocking Prontor shutter, which enabled me to shoot faster. In all, we shot about 15 sheets of film. Setup took nearly five hours—for just three optimal minutes of shooting.

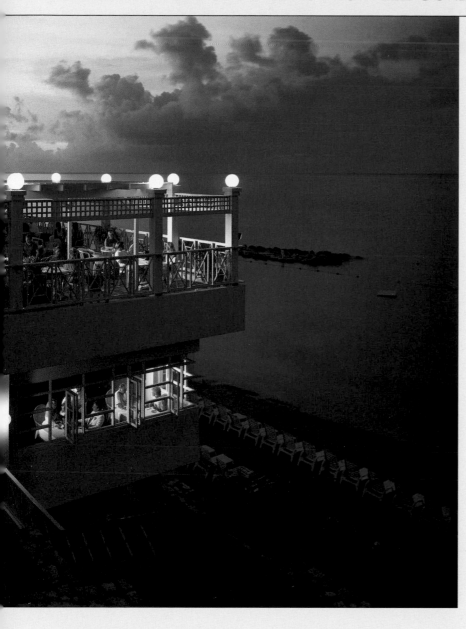

JOB SHEET

CLIENT: **Sandals Resorts, Ocho Rios, Jamaica**

USAGE: **Advertising and collateral**

AGENCY: **Tinsley Advertising**

ART DIRECTOR: **Dan Peterson**

PRODUCER: **Rick Balter**

FIRST ASSISTANT: **Mickey Pantano**

PHOTO STYLIST: **Michelle Richie**

LIGHTING: **Tungsten (plus existing light)**

CAPTURE: **Analog**

PHOTOGRAPH COPYRIGHT ©**Lee Gordon**

I stationed myself on a nearby hill, again shooting during magic hour. The shot would be used for a brochure and international magazine ads. Both professional models and guests served as patrons at this two-tiered gourmet restaurant in Ocho Rios, Jamaica.

We kept the existing lights in the shot (the restaurant lights and even those globe-shaped fluorescents that contributed a contrasting tone) and pointed an existing 500-watt floodlight onto the chairs on the beach. All the lights we introduced were placed to the far left. We used both the available AC and three rented Honda 5500 generators to power the lights.

There were a total of four 200-watt and two 100-watt Peppers lined up, but variously directed to illuminate the space above. For the space below I used three 200-watt and two 100-watt Peppers similarly arranged. These each had a one-half CTO, scrim, and barndoors or flags. One 420-watt LTM soft light, with egg-crate facing, CTO gels, and blackwrap, was also used on each floor and positioned more into the shot (but out of camera) to add an overall wash of light over the tables. In addition, we bounced a 750-watt Lowel Totalite off the back wall on each floor to provide a subtle ambient fill. Exposure, with a 4x5 Sinar f Plus and 120mm Super Symmar HM lens, was at f/11.3 for between 6 and 8 seconds, on Fuji 64T Professional pushed one-third stop.

Photographing a museum presents numerous challenges, as we will learn in this project. One of which is dealing with a stubborn light that refuses to be triggered back in a rotunda.

The museum hired me to shoot a number of photographs for a luxurious coffee-table book to be sold in their gift-shop. Planned as the opening section, these pictures were intended to give you a sense of the museum experience. With an editorial feel in mind, we shot on 35mm, using a Nikon N90S with 20mm lens and Kodak E100SW. Arriving before dawn gave us enough time to work before the influx of visitors. We used the staff as our museum-goers.

To complicate matters, there was some construction going on, with scaffolding completely covering the right side, up on the balcony behind the columns, thereby restricting my viewpoint. So, with the camera almost up against that bust in the foreground, we had to direct attention toward the left side, which was free of building materials.

The exposure was based in part on the available light coming through the dome. Our lighting encompassed Balcar packs ranging from 2400 to 6400 W/S. We carried in 30 heavy-duty extension cords in order to spread electrical load, and we probably used every one of them. Working with the museum's senior manager for creative services, I also brought in three assistants and a producer, who doubled as an assistant, to help put this shot together.

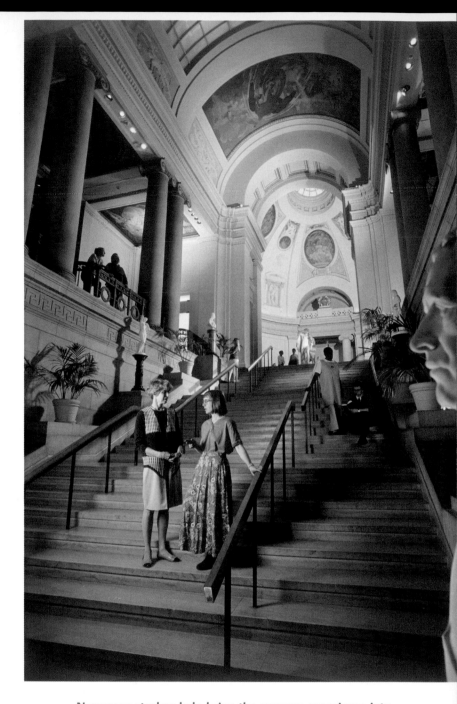

Numerous strobes help bring the museum experience into focus. One troublesome light, all the way in back, was triggered manually to have it sync with the rest.

JOB SHEET

CLIENT: **Museum of Fine Arts (MFA), Boston**

USAGE: **Editorial**

PROJECT COORDINATOR: **Janet O'Donoghue, MFA**

PRODUCER: **Paul Gagne**

FIRST ASSISTANT: **Ian Tuck**

LIGHTING: **Strobe (plus existing light)**

CAPTURE: **Analog**

PHOTOGRAPH COPYRIGHT ©**Lou Jones**

The first light that went up was on a high-boy, in the rotunda, just behind the column to the right, raised as high as it would go. This was a bi-tube without reflector, running off a 6400 W/S pack. I wanted to fill up that area with a warm light simulating the museum's own floodlights, so I put a 1/4 Sun gel on that head.

The next light was a large softbox at the very bottom of the stairs, to light the two women in the immediate foreground. This was a Plume Wafer, positioned a good eight feet from them, just above head height, enough to throw some light on the stairs behind. One 2400 W/S pack was shared between this light and another on the statue next to the camera. The light on the bust was actually among the last we set up. I used a grid on a bare head, aimed upward from near the floor. This allowed the bust to play a role in establishing the grand scale of this setting, while also hiding some of the scaffolding.

The next light, after the softbox, was the one at the top of the stairs, to the right, in front of the scaffolding. It hit the edge of the arch of the ceiling on the right side, and then the rest of the mural that was up on the ceiling (top, center of frame). I eventually took the grid off this 5000 W/S head in order to get enough light, then tweaked it down a little bit, also using Cinefoil to keep it from spilling too much.

The area where the two people are standing by the railing (above, left) went dark, so I had to add another light, with a grid, aimed at the ceiling. This light also helped illuminate the mural (above, right) and provided separation for the individuals. This light was positioned high but hidden by the columns. The head and the one inside the room to the right shared a 5000 W/S pack. In the room I gelled the light with a half Sun so that it had a very warm look, to better define the space.

Then we added a grid spot, powered way down, for just a hint of light on the two people on the stairs. I just wanted to pull them away from the background. The head was positioned behind the planter on the right, and aimed up so it didn't throw any shadows.

The next light was a 2400 W/S head, off its own pack, for the two ladies all the way in the back. This light also hit the sculpture that's roughly at the physical center of the shot, and was placed almost on the floor, from the left, on axis with the two women.

With all these lights in place, I shot another Polaroid and noted that the top of the stairs and the left side of the picture (below and to the right of the railing) went dark, which meant we needed one more light. So, hidden by a plinth behind and to the right of the woman who's standing midway up the stairs, is a low-powered 3200 W/S grid spot. This head raked light along the stairs, so that you could actually see them, and reached all the way over to the other side.

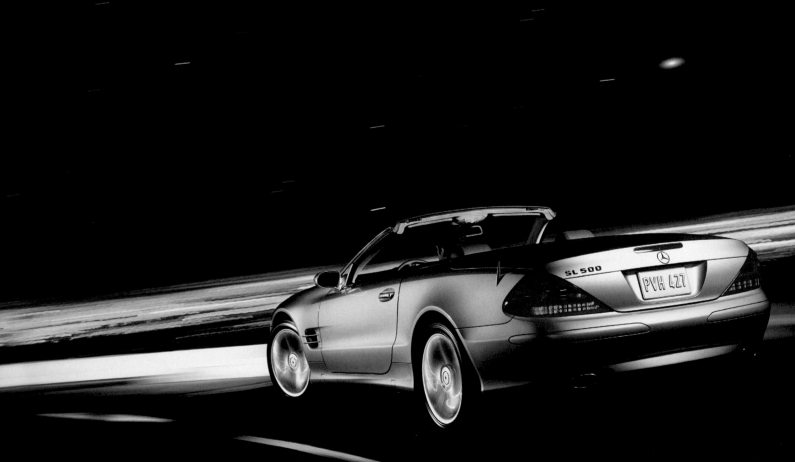

It's one thing to photograph a car in the studio—but quite another to shoot it on location, where we encounter evanescent and unpredictable environmental factors and yet another level of creativity. Lighting, too, is on a different plane.

How do you light a fountain together with a luxury automobile? With a lot of painstaking effort, as we'll see.

The layout depicted a Mercedes C-Class luxury car against a fountain. That said, the fountain couldn't be splendiferous, such as the one at the Bellagio in Las Vegas—we were eyeing something a bit more modest and subdued. Location scouting led us to the Music Center in Los Angeles. Specifically, we situated ourselves in a courtyard between the Dorothy Chandler Pavilion and Music Center in downtown L.A., so a lot of the velvet ropes, tables and chairs had to be removed. We didn't need to have the street blocked off, since this was on private property, but we did need permits from the Music Center, as well as from the City of Los Angeles.

Even though it was raining on and off, we still needed a water truck to control the amount of water on the ground, and especially to create some puddles. The prep company detailed the car beforehand. On site we spray-painted the tires

The lights practically encircled the car for one exposure, while other lights backlit the fountain when shot separately at night. The two images were then composited.

JOB SHEET

CLIENT: **Mercedes-Benz North America**

USAGE: **Collateral**

AGENCY: **The Designory, Inc.**

CREATIVE DIRECTOR: **Ulrich Lang**

ART DIRECTOR/C-CLASS MERCEDES: **Lynn Laguna**

ART DIRECTOR/SL-CLASS MERCEDES: **Dean Fuller**

PRODUCER: **Mark Harrelson**

LOCATION SCOUT: **Greg Robinson**

FIRST ASSISTANT: **Arthur Karyakos**

LIGHTING/C-CLASS MERCEDES: **Strobe (plus existing light)**

LIGHTING/SL-CLASS MERCEDES: **HMI**

CAPTURE: **Analog**

PHOTOGRAPHS COPYRIGHT ©**Charles Hopkins**

PRO TIP Why not shoot the fountain and car as one shot? I wanted to shoot this car under daylight so you could see what it looks like. To enhance the effect, we used a very short shutter speed with a leaf shutter. At the same time, we jacked up the power to the strobe heads to compensate.

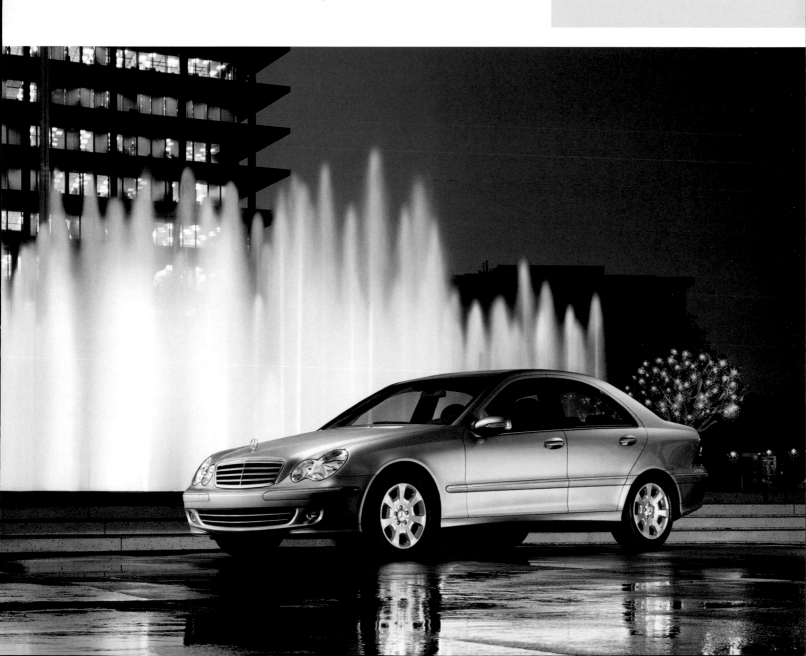

black, blacked out the grille, cleaned the windows, and set the seats in their upright positions. My producer, who was part of the on-site crew, coordinated activities with the Music Center liaison. We had an extra production assistant routing people around the set to deal with the pedestrian traffic.

We set up the lights—all Profoto—for the car and fountain that morning, with each light running off its own 2400 W/S pack. The car remained on set, but the lights for the car were removed when we shot the backdrop under darkness. The background consisted of not only the fountain but also the stairs, surrounding ground, and reflections. The client composited the shot digitally.

The car exposure on Fuji Velvia 50 was f/16 at 1/250 on a Toyo 4x5 with 210mm lens (same lens on both exposures). This exposure cut down the amount of ambient light and gave the car more of a nighttime look, even though it was shot in the daytime. For the car exposure, the lights behind the fountain were turned off. The car lights were off for stylistic and legal reasons. Camera-to-car distance was 70 feet.

Our first light, a Profoto strip light, addressed the front end of the car, positioned horizontally, three feet off the ground. It appeared in the picture and was retouched out. To light the side of the car we had a wide grid, out of frame from the right, three feet off the ground and 15 feet away from the car. We used it to get the reflection in the water. Next came a head aimed at the sheet metal behind the back door, which stood 10 feet up and about 15 feet away. On another 10-foot high-roller was one more light, in frame, near the front of the car, overhanging the bumper. The final car light stood three feet up, fairly close to the front of car, from camera side. These last three lights had wide dishes with diffusion. (We hammered together a 2x2-foot frame and stretched diffusion over it.) These five lights basically formed an arc swinging around the camera side of the car, from front

PRO TIP There's no standard formula for photographing cars on the road. We chose a rear view here for variety and the feel it conveyed— that of going places in style. That, combined with the sense of movement and the sloping angle of the shot, defines performance in a classic vehicle.

bumper to taillight. We flagged off the car from the diffusion screens left and right against flare.

Lighting for the fountain at night was considerably simpler. It consisted of a bank of six lights, five feet up and five feet from the fountain, with open heads—a wide dish, but no diffusion. The fountain was under remote control, and we caught it as the spray reached its highest point. We wanted some blur in the water. We bracketed anywhere from one to six strobe pops at f/22, for as long as 30 seconds. We shot Polaroids continuously, especially on the fountain exposure, because we didn't know how the strobes would light up through the water or what the final effect would be. The digital retoucher took an earlier exposure of the car that we liked and stripped it into the final shot, which gave the picture more of a monochromatic look.

The shot of the Mercedes SL-Class—their flagship sports coupe—was part of the same job, albeit produced for a different dealer catalog on a different day and with a different art director. Working to a layout, we shot this in San Pedro, California, at an overlook that extended from a parking lot. This stretch of the lot was not curved. The white lines in the frame are road tape that we put down temporarily. We had the wheels turned to make it look as if the car was going around the bend. We also tipped the camera to give it the appearance of moving downhill.

There was a slight incline which helped sustain the car's movement. With the parking brake off, we pushed the car and let it roll very slowly. The vehi-

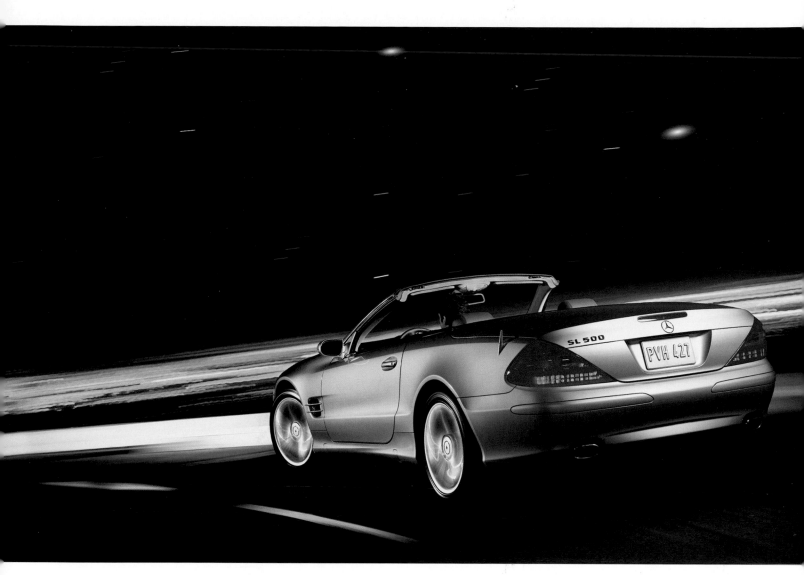

The car moved slowly, with hotlights providing the key illumination. Moving car and star field were shot separately and composited.

cle was moving only an eighth of a mile per hour, with a camera rig attached. I followed its movement on foot, triggering the camera remotely with a PocketWizard. The entire movement of the car was perhaps 20 feet. The city background was part of this exposure. We shot the car at f/16 for 12 seconds, using a Toyo 4x5 with 120mm lens, loaded with Fuji Velvia 50. All our lights here were Arri HMI.

We used nine lights on the car. We had six 1.5K heads enveloping the car from camera side, front to back right taillight. All these lights stood 25 to 30 feet

PRO TIP Keeping the engine on when using a camera rig would result in considerable vibration on the arm, producing an unsharp picture. So you push the car and let it roll, or sometimes pull it with a rope or cable. As is typically the case, the rig was attached to the car, and, in this instance, was retouched out by the client.

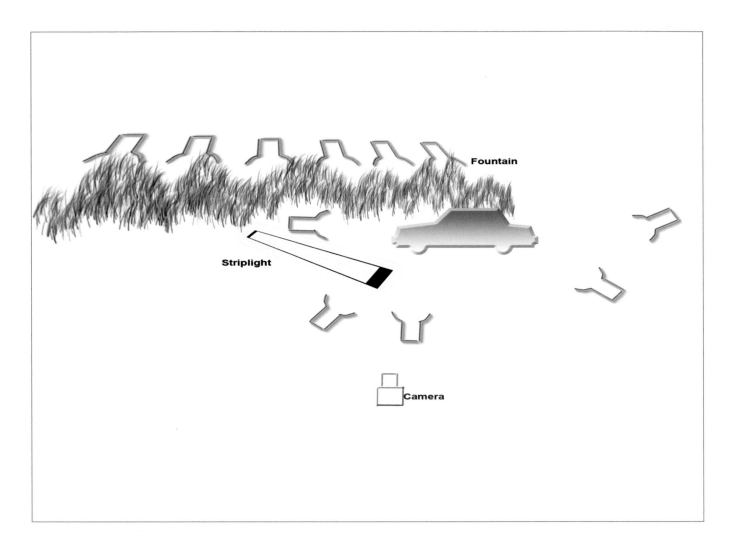

While one set of lights surrounded the car, another bank of lights came at the fountain from behind, in almost a glowing tribute to this luxury vehicle.

from the car and five feet up, with the exception of the light over the taillight. That head was 12 feet up to provide a nice top light. We added one 2K around the front, finishing with two more 2K heads aimed at the curb. All these lights were Fresnels, set to throw a medium spot pattern with barndoors. We started at 9 AM and we were ready by 1 PM. We produced this exposure in the evening.

We shot the star field separately, several days later, in the desert, near Death Valley. With long exposures, you have to be far away from the city, or the sky turns white in minutes. Exposures ran from five seconds to four hours. This was probably a 30 or 45-second exposure, and the client enhanced some of the movement in the stars.

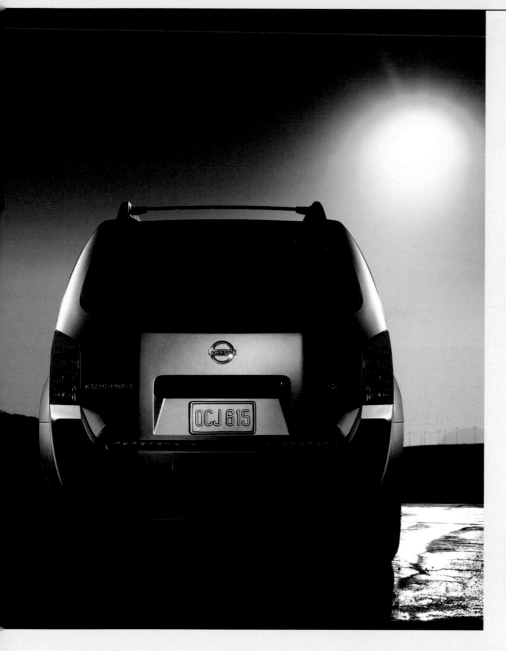

JOB SHEET
CLIENT: **Nissan USA**
USAGE: **Collateral**
AGENCY: **The Designory, Inc.**
ART DIRECTOR: **Siewlin Theah**
LIGHTING: **Strobe (plus existing light)**
CAPTURE: **Analog**
PHOTOGRAPH COPYRIGHT ©
Charles Hopkins

I shot this Nissan Pathfinder following a layout the art director had provided for the cover of a dealer catalog, coinciding with the launch of this new vehicle. She wanted me to shoot the rear end of the vehicle but to give it a very sculpted look and to include the sun. The location, a road on the top of a hill in the desert, was somewhere outside Lancaster, California. Having acquired the necessary permits, we arrived on site at 11 AM and finished by 9 PM. After tidying up a bit, we wet the road with a bunch of five-gallon water bottles that we'd brought along for this purpose. The prep company had blacked out the tires and part of the undercarriage and actually put up some black inside the vehicle so that we couldn't see through it.

This was another shot in which we used a fast shutter speed to kill the ambient light. Our exposures, based on Polaroids, began at 1/500 second, arriving at this final exposure of f/22 at 1/125, on Fuji Velvia 50. I employed a Toyo 4x5 with 240mm lens, 50 feet from the car, shooting from a height of two feet. I added a graduated ND filter over the lens to bring down the intensity in the sky at the top left of the frame.

Our lighting was Profoto. I'd wanted to use one striplight on each side to shape the sides of the car, but it was too windy, so we ended up using Profoto 2400 W/S heads with the wide dish and diffusion, one per side, six or eight feet from the car. Then we added two lights, aiming them squarely into the back for the Nissan logo and license plate. Both have moderately fine grids. We designed the lighting to be more dramatic and not quite even on both sides, which meant working against the inherent symmetry of the shot to some extent.

Since the location was in the desert, with prevailing winds and a lot of airborne dust coloring the atmosphere, there was already a warmish tone in the sky. I chose to bring it up a notch with the addition of an 85C grad filter over the lens.

LIGHTING A SHIP OF THE DESERT

What do a camel and a car have in common? Performance. Now the question is: How to depict it in an ad. The answer takes us to places as far-ranging as the Mojave Desert and then back to the photographer's own studio.

Mercedes was introducing a new turbo diesel engine into their 320 Class automobiles in national magazine ads in the United States and Canada. This performance car was designed to go faster and farther and to be more powerful than anything they've had thus far, with great gas mileage as well. Now think of a camel—the proverbial "ship of the desert"—and you picture a powerful and classic performer able to go long distances without the need to refuel constantly. This beast of burden naturally recommended itself as the icon for the new car/engine combo, driving the concept forward, with the desert as an equally suitable backdrop. The layouts we were given melded the two concepts, with high-powered engines on a camel, taking the main theme even further. They wanted something a bit quirky and offbeat, and my studio was prepared to deliver.

For starters, we needed a desert background. A trip to the San Bernardino Mountains and the Mojave Desert gave us our backdrop. We shot this scene with a Hasselblad and Phase One P25 digital back, with 50mm lens. We already knew

Each element had to be shot separately. Whereas the engine and harness were shot with strobe lighting, the camel was shot by daylight, as was obviously the desert backdrop.

JOB SHEET

CLIENT: **Mercedes-Benz North America**

USAGE: **Advertising**

AGENCY: **Lowe Roche**

CREATIVE DIRECTOR: **Jeff Hilts**

ART DIRECTOR: **David Glen**

PRODUCER: **Connie Chan**

FIRST ASSISTANT: **Luna Simic**

PROP STYLIST: **Martine Blackhurst**

LIGHTING: **Existing light outdoors; strobe indoors**

CAPTURE: **Digital**

PHOTOGRAPHS COPYRIGHT ©**Don Dixon Photography**

PRO TIP Incorporating the engine in the shot was not simply a matter of shooting it and dropping it into the final composite. We had to shoot it in perspective, anticipating that it would be duplicated on the far side of the camel. That also meant shooting the interior in such a way so it would be represented correctly.

this would be a composite, so the next stage involved photographing the camel. Here we turned to the Metro Toronto Zoo and, with their permission, photographed a Bactrian camel using a Nikon D2x with 105mm micro lens. There was only one problem: the layout called for a Dromedary, the one-humped variety. Digitally, we modified the animal's features, providing the one hump typical of the Dromedary. Until that point, both elements were shot by available light. However, there was one discrepancy: the desert was shot late in the afternoon, whereas the camel was photographed at midday. We digitally added a shadow for the camel with just the right opacity and perspective to create a natural fit.

The next component was the engine—actually a jet engine, which required a trip to a private jet plane manufacturer. We photographed the engine in several different ways so that we could show it saddled to the camel on both sides in the correct perspective. Two of the images focused on the interior components, so we could build each engine digitally in the correct fashion. The camera was, again, a Nikon D2x with 105 mm lens.

The first engine exposure—our basic shot—required two lights to show the side of the engine.

We used a large softbox above the camera parallel to the horizontal length of the engine. Then we added a hard light, from the left-hand side to highlight the cowling around the front of the engine.

We also needed a couple of shots with the camera aimed into the engine from a slight angle. For this we employed a 4-foot Chimera softbox on the top left-hand side of the cowling, and then added a 4x8-foot sheet of foamcore underneath on the floor to bounce light back up from a bare head off to the left, three and a half feet off the ground with a No. 4 Balcar grid. In addition, because it was very dark in there, I had another head with a No. 2 grid firing into the engine cowling itself to light up the inside. I basically used the same lighting for the second and third elements, handholding the camera as I simply moved around the engine for each respective view.

The final element was the harness—actually my studio manager's belt, which we stretched out digitally. Again, using the D2x and 105mm lens, we lit the belt with a softbox, making this the only element shot in the studio. The belt lay on a sleeping bag with the softbox backlighting it, which provided the dark edge along the front of the belt. All the strobe exposures were shot with the Profoto Acute lighting system.

What better way to represent an ultra-high-performance vehicle designed to go the distance than with a camel powered by jet engines!

LIGHTING THREE VEHICLES ON THE MOVE

I t's one thing to light one vehicle on a bridge, but something else to light three—especially when they're all moving. Keeping pace with this activity requires a special approach.

The headline says it all: "You're either with us or you're behind us." This triumvirate of automotive force represents the newest group of performance vehicles to roll out of Detroit. Left to right, they are the 2005 Dodge Viper, Neon SRT4, and Dodge SRT10 RAM. They are shown in motion to give you a sense of the power the driver can have behind the wheel. We worked to a rough layout that basically outlined three cars in formation. The time of year (February) dictated the location (Miami) with the bright lights and colors of the city as backdrop—which also happened to coincide with the art director's preferences.

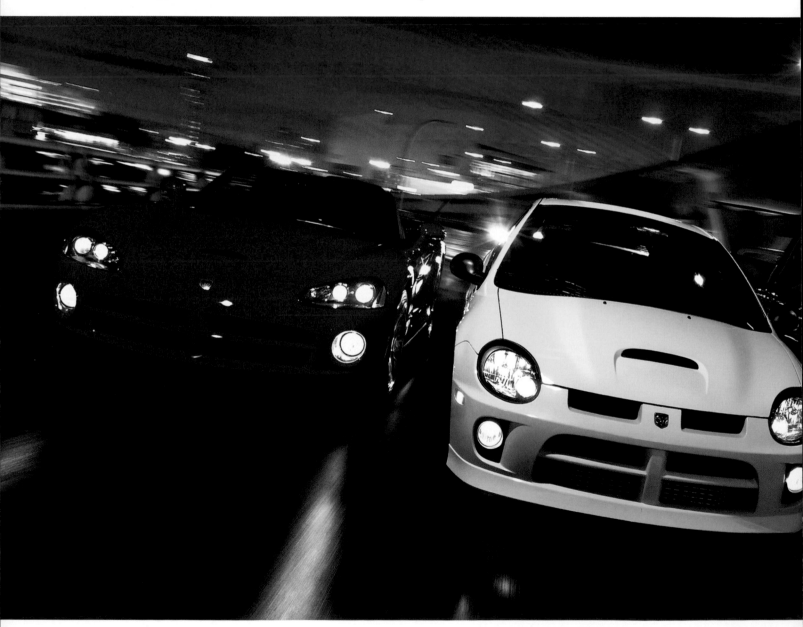

JOB SHEET

CLIENT: **DaimlerChrysler**

USAGE: **Advertising**

AGENCY: **BBDO Detroit**

ART DIRECTOR: **Philip Macavoy**

FIRST ASSISTANT: **Rob McGowan**

RIGGER: **Jim Robbins**

LIGHTING: **HMI, tungsten, and a car's headlights**

CAPTURE: **Analog and digital**

PHOTOGRAPHS COPYRIGHT ©**Don Johnston/Johnston Images**

PRO TIP I designed my own rig, which extended 15 to 24 feet from the car, with the camera triggered using a PocketWizard. On my cue, the rigger pulled the car, and after giving him a second or two to build momentum, I triggered the camera.

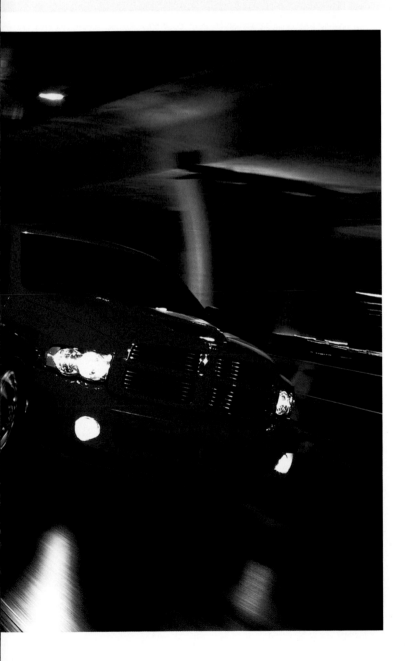

We did a tech-scout the day before. I was already familiar with the location, so I knew the ins and outs of working there. Even though this section of the bridge was not in use at the time, we still needed to secure permits beforehand. I had a freelance producer/coordinator, three assistants, a rigger, and the police all on site.

Prep involved sweeping and wetting the road. The client had someone on site to prep and detail the vehicles after they were delivered to us. We also blacked out the windows. But the most time-consuming part of the job was finding the right angle for the camera rig, which extended out a short distance in front of the vehicle. That can take a long time with three cars, positioning each car optimally and determining which lens to use. The rig was attached to the yellow car. We started at around 11 AM and didn't wrap until 11 PM.

We shot both digital and film. The film we used was Kodak 100VS daylight transparency on a 4x5 Sinar with 120mm. Digital capture was on a Phase One back attached to the Sinar, but with a 65mm lens. We dragged the shutter for an exposure of 10 seconds at f/32.

Lighting three vehicles in formation is considerably tougher than lighting just one, as it requires a combination of HMI and tungsten lighting. Tilting the camera added a dynamic element.

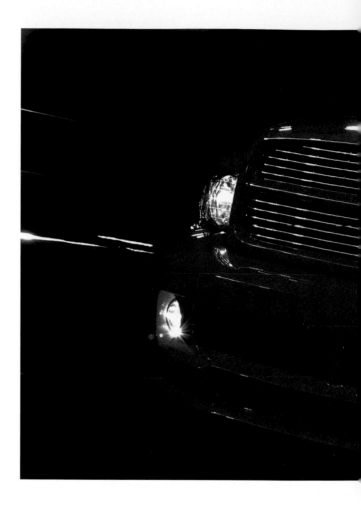

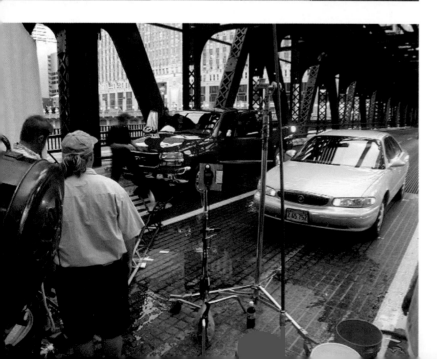

All the cars were hooked together with cable, which, like the rig, the agency retouched out. No one was actually driving any of these cars: they moved only two to three feet, with someone in another vehicle pulling them.

We had some existing light over the span to begin with—one of the things that's so neat about this location. But obviously it wasn't enough. Our main lighting focused on the front of the three vehicles: easier said than done when you have three overlapping machines. We had a high boom arm with an Arri 100-watt HMI looking down, above the front right headlight of each vehicle, which is why the shadows under them are so tight. We also had two 1.2K HMIs as fill, positioned farther back from the boom heads and lower down. The 1.2Ks were maybe 30 or 35 feet in front of the cars, whereas the 100s were just out of frame, 12 feet up.

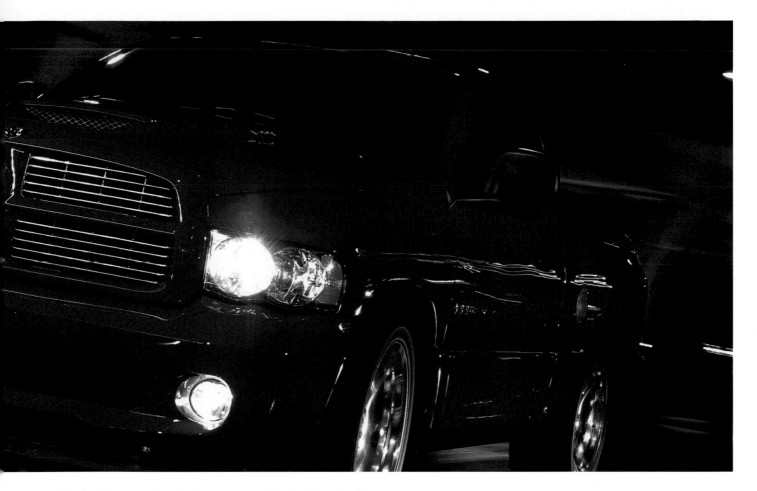

The lighting was largely the same as with the trio of vehicles. One noteworthy difference: more light-painting was involved.

Well behind our trio, we parked a rented car, with the headlights turned on and no one inside, to light the side of the Viper and Ram. You might say this was a fill light. We also had two 2Ks about 50 feet back, hidden behind the middle car, to throw additional light onto the vehicles.

There was also one 100 HMI addressing the railing on the right, coming from in front of the truck, and another positioned in front of the leftmost vehicle, for the left railing. Everything except the HMIs over the cars and the car headlights in back was flagged.

Often, when I do these night shots, I light-paint with a 100 HMI and fill in where needed on the car. As a result, every take comes out different. We did that here: an assistant monitored behind camera, with the shutter open and the cars in motion; and keeping out of view, I walked across the width of the

PRO TIP The advantage to using a rig is that you can use long shutter speeds to blur backgrounds without blurring the vehicle, since they move in tandem.

road with light in hand, holding the light by the handle to avoid getting burnt.

The headlights had to be timed, since they can stay on for only about a second. The car-prep guys put dimmers on two of the vehicles' headlights, but not the Viper, so that car's headlights had to be turned on and off.

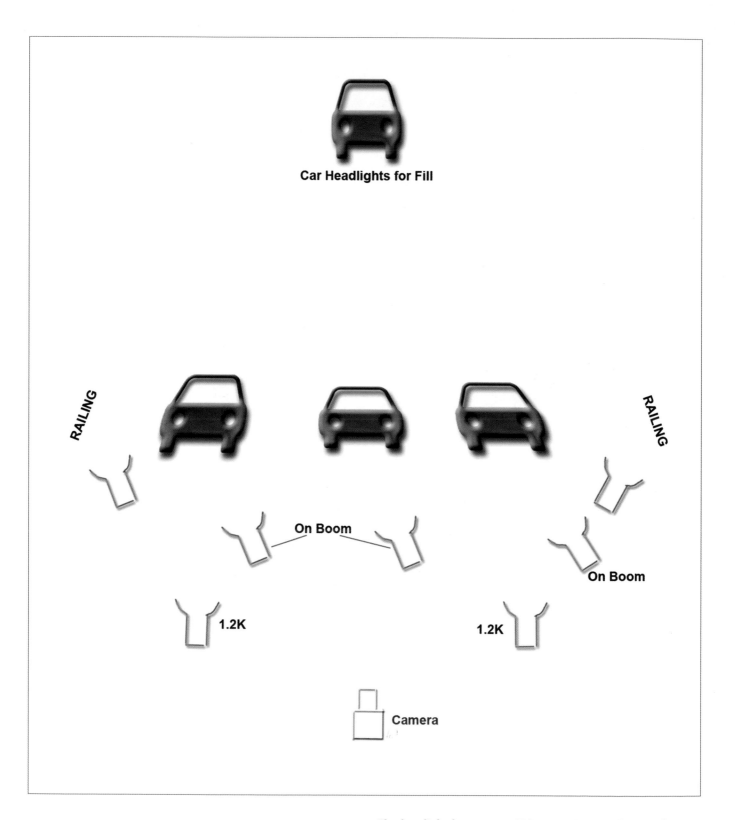

Car Headlights for Fill

RAILING

RAILING

On Boom

On Boom

1.2K

1.2K

Camera

The key light here was a 100-watt HMI on a boom, above the front right headlight of each vehicle. Other lights, including a car's headlights from behind, served as fill.

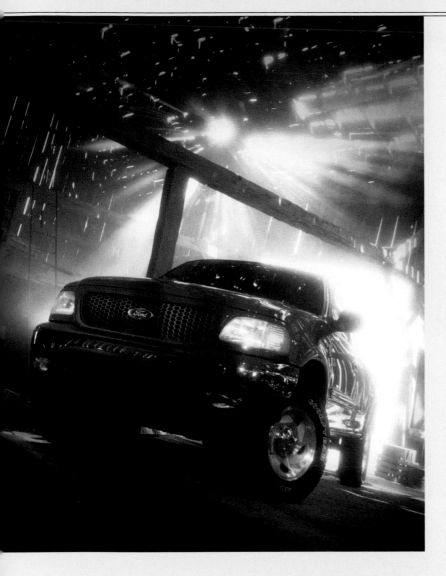

JOB SHEET

CLIENT: **Ford Motor Co.**

USAGE: **Collateral**

AGENCY: **J. Walter Thompson**

ART DIRECTOR: **Bob Laperriere**

LOCATION SCOUT: **Warren Martin**

FIRST ASSISTANT: **Rob McGowan**

GAFFER: **Joe Stonkas**

LIGHTING: **HMI and tungsten**

CAPTURE: **Analog**

PHOTOGRAPH COPYRIGHT ©

Don Johnston/Johnston Images

The art director thought it would be cool to show this Ford F-150 pickup in one of the many barns found here in Michigan, with light streaming in through the slats. After extensive location scouting in the area, we picked this structure. When I walked in and saw the sun's radiance lighting the scene exactly as the art director had envisioned, I knew we'd found the right barn. Only one thing: we couldn't depend on sunlight to do the job, opting instead to rely on our own lighting to simulate the effect. This called for a 12K HMI.

The site itself didn't require much preparation, aside from moving a few things here and there. We did fashion a prop fence on the spot and positioned it in front of the camera, so that from where I was shooting the only reflection in the bumper would appear to be a natural part of the setting: a fence, not the camera or myself. I used a Pentax 6x7 with 45mm lens, to take everything in, with the camera very close to the truck and the truck standing maybe 15 feet from the barn entrance. I added an 85C filter to give the scene that warm, glowing feel you'd normally get from sunlight. Film was 120 Kodak E100 VS. The headlights and parking lights were left on—the only ambient light sources worthy of note, since our lighting would essentially blow out every other existing source of illumination.

We powered our lighting for this f/16 exposure with a huge generator. My gaffer took the rented Arri 12K HMI out back of the barn and mounted it to an articulated boom arm, a good 30 to 40 feet up. He positioned this monster light, our "sun," so that it shone through the slats in the roof and back around and through the entrance behind the pickup.

We also needed some way to make the shafts of light visible as such, so we brought in a fog machine. That went in the left-hand corner of the barn, in the back. We also wanted to make the fog more visible overall and especially to create a glow around the front of the truck, so we added a 1200-watt HMI in the background, to backlight the fog, which also provided some fill.

Then it was necessary to light key details. For the front grille we brought in a 1200-watt HMI, which we positioned six feet up, to the left and just a little forward of the vehicle, aiming it through a cookie cutter that the art director had fashioned out of slats of wood. We also used a Matthews soft silver-surface reflector, positioning it between the 1200-watt HMI and a 4x8-foot foamcore bounce card, employing both reflecting surfaces to throw some more light into the grille and bumper and to reflect white into this area. In addition, we had two 2K Mole-Richardsons behind the truck, each at about a 45-degree angle to the vehicle. The one on the right stood a few feet up, adding some sparkle to the wheels, while the one on the left, hidden by the truck, was considerably lower to the ground and helped separate and light up the ground around the truck. All our lights had barndoors. Diffusion screens were used on selected lights as needed.

corporate and industrial

Corporate and industrial photography encompasses some of the most diverse and challenging environments out there. Each situation and subject—whether an office complex, museum, industrial plant, or high-tech gadgetry—must be suitably lit to sell the company or institution to existing and prospective clientele and investors.

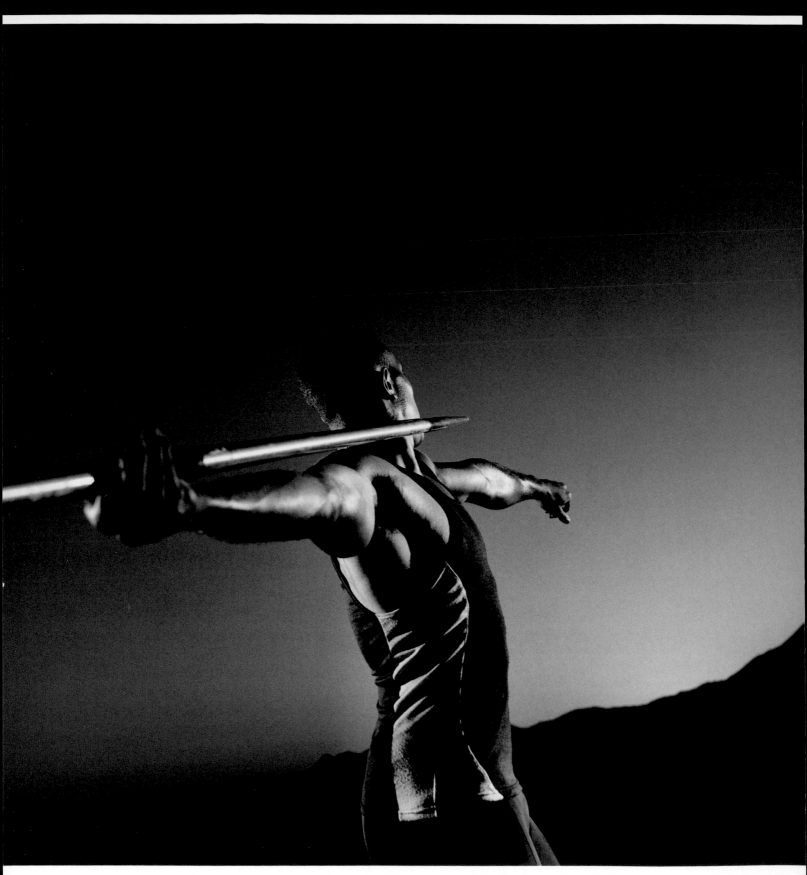

JOB SHEET

CLIENT: **Nicholas-Applegate Capital Management**
USAGE: **Advertising**
AGENCY: **Digitas**
ART DIRECTOR: **Jason Komulainen**
ART BUYER: **Diane Macpherson**
PRODUCER: **Bob McGinness**
FIRST ASSISTANT: **Pete Breza**
WARDROBE STYLIST: **Eliana Ben-Zeen**
HAIR & MAKEUP: **Maya Murakami**
LIGHTING: **Strobe**
CAPTURE: **Analog**
PHOTOGRAPH COPYRIGHT ©**David Allan Brandt**

PRO TIP To me, the key in picking and lighting the wardrobe was to put the emphasis on the javelin and the model's arms, head, and chest—because that's where the javelin thrower's strength lies. And the accent light on the hand was designed to accentuate that forward thrust even more, supporting the central motif.

I cons have an amazing way of representing corporate America. The key was in the lighting, which had to sculpt the body and in the process convey a sense of continuity between javelin and athlete while expressing forward movement.

The javelin thrower represents strength, strategy, and forward movement with a decisive aim—precisely the image this financial services firm sought to portray. While working to a layout, I chose to make this statement even more powerful by rendering it in black-and-white. Also, I chose to include the ridgeline in the shot to reinforce the idea of moving in a forward direction. We added vignetting in the prints I delivered to the client.

Because I was already familiar with this Ojai, California, location, it didn't require a location scout. We did, however, need to do a casting for the javelin thrower with an agency that specializes in athletes. We were looking for someone with a working familiarity with the sport, so he could assume a convincing pose. This athlete fit our requirements perfectly, even coming to the shoot with his own javelin. The stylist provided wardrobe. We oiled our athlete down a bit to make his skin more shiny. I wanted to get a hot, metallic look on his skin to make it look as if the javelin were an extension of his arm. To me the drama was in the lighting, in terms of making it really stark and contrasted—and reflective off his body.

We started setting up in early afternoon. I employed a Hasselblad with 80mm lens for this $f/5.6$ ½ exposure on Plus-X. Shutter speed varied with the position of the sun. To add to the dramatic flair, I shot from a low angle, crouching down with the camera on a tripod. I was maybe five or six feet from the athlete. The shot was taken just as the sun went over the ridge.

All our lights—Normans—had barndoors. We began with a 10-inch Fresnel on the right as our key light. That was the light we were using to get the reflection off the model's skin and the javelin. Then we added a 6-inch Fresnel closer to camera, to the right, as fill for the rest of his body. These lights were

The lighting had to support the notion of strength and forward movement, and an important part of that was capturing the sheen on both the javelin and skin.

maybe 12 to 15 feet from him. The lights were positioned just above his head, with the 10-inch Fresnel even higher, angled to correspond to the tilt of his arms. Both lights shared one 2400 W/S pack.

Sharing a separate pack were two additional Fresnels coming in on the model from behind (camera left). Specifically, a 10-inch Fresnel on the left was designed to fill in and give the body added dimension while providing separation against the background, while a 6-inch Fresnel was barndoored down tighter

to put a little kicker light on the back of the hand holding the javelin.

Although I had a notion of which would work best, it's always best to cover the gamut just in case an art director feels differently about a picture—which is always a possibility. We shot this both with the sun above the ridgeline and below it, hidden entirely from view. My vision of this image was borne out when we saw how the setting sun gave us that glow with the gradation in the sky.

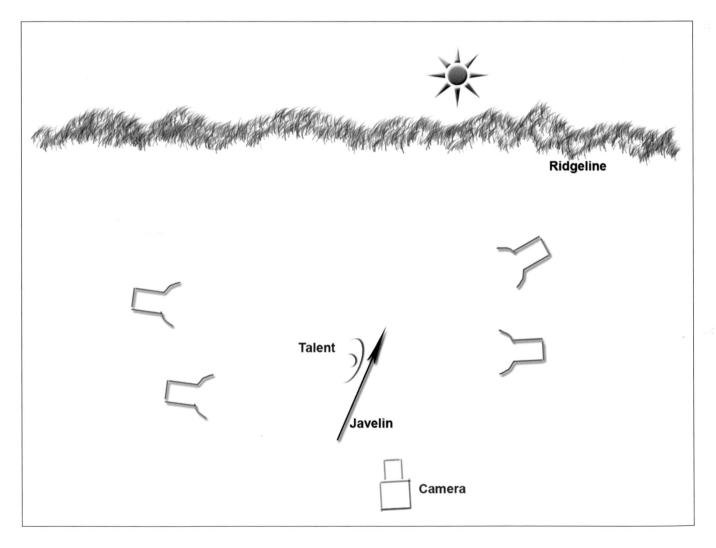

With the sun just over the ridgeline so that it became a supporting element, the added lights had to emphasize the feeling of forward movement and strength that the shot required.

PERSONAL VISION

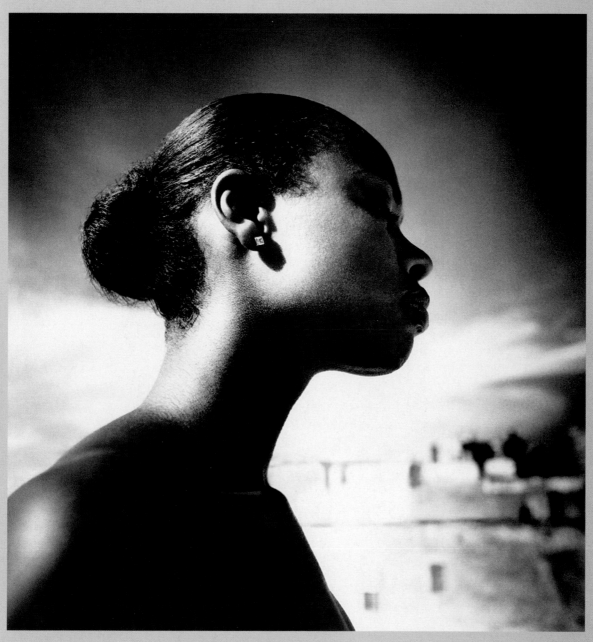

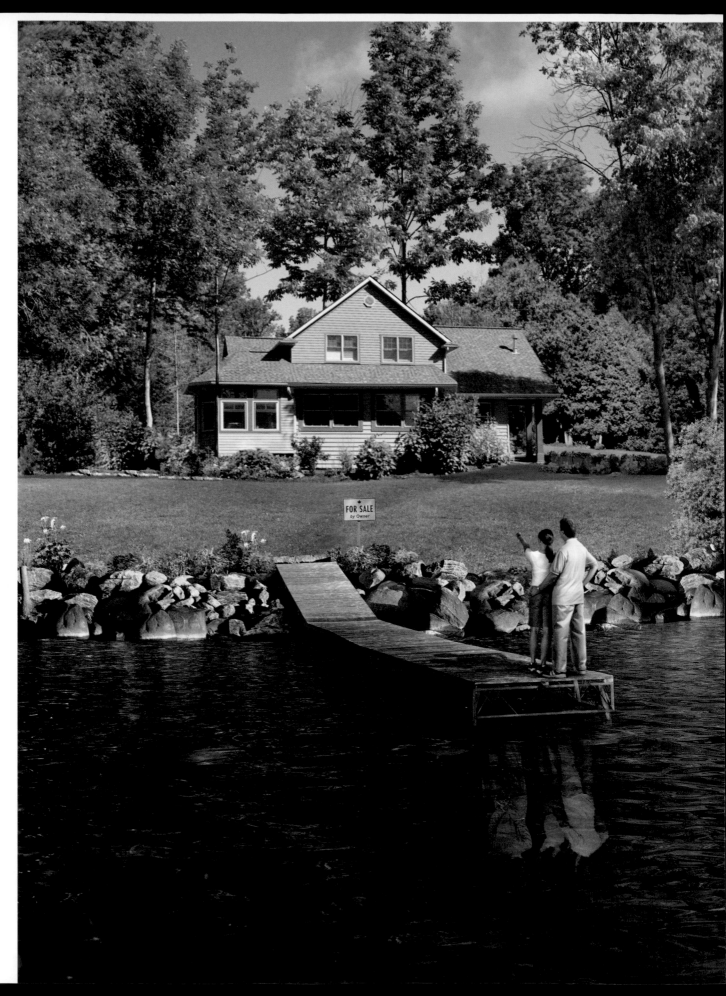

JOB SHEET

CLIENT: **Freedom 55 Financial**

USAGE: **Advertising**

AGENCY: **Bright Red Communications**

CREATIVE DIRECTOR: **Leslie McCallum**

ART DIRECTOR: **Doug Bramah**

PRODUCER: **Connie Chan**

LOCATION SCOUT: **Ezio Molinari**

FIRST ASSISTANT: **Luna Simic**

WARDROBE STYLIST: **Martine Blackhurst**

HAIR & MAKEUP: **Anna Nenoiu**

LIGHTING: **Daylight outdoors; strobe in studio**

CAPTURE: **Digital**

PHOTOGRAPHS COPYRIGHT ©**Don Dixon Photography**

PRO TIP When you introduce digital elements into a shot, you open yourself up to a world of possibilities. We could have left the water level as it was, and perhaps no one would have noticed. But the message behind the picture would have been lost if we hadn't corrected the foreground elements. Using the original dock would have meant leaving the couple in shadow—and that, simply stated, would not have worked for the ad.

S hooting from a boat takes dedication. But this time it wasn't enough: numerous elements had to be shot and edited for the final composite. Throughout, the lighting stood paramount, dictating the direction each phase would take.

If you invest your money smartly, the ad implied, you can afford to buy your dream cottage by the time you reach retirement age. It was up to us to photograph that dream cottage. With the help of a location scout, we found the perfect place—or what might be the ideal home with a little help. The house we found was a little too big and a touch too fancy—and lacking in certain other respects, as I'll explain. It was situated in a rural area north of Toronto, fronted by Lake Simcoe.

The layout for this national consumer magazine campaign (in Canada) called for a view from the lake, which meant shooting from the water. The location scout not only found the house but also secured a 30-foot powerboat for us to work from. I should add that not all the elements were shot from the boat: the work shed was shot from land. I used a tripod to make sure perspective was correct. Everything that shows water was shot from the boat, with the camera also on a tripod.

Along with the boat's owner, my digital artist and I boarded early in the morning and set out a short distance from shore so that we had a good view of the house. We brought along a Hasselblad with 50mm lens and Phase One P25 digital back, together with a Mac G4 laptop for on-the-fly compositing. The same camera and lens were used for all outdoor shots, with the exception of several details photographed with a 150mm lens.

Our early morning shots gave us the house in bright sunlight but left much of everything else in shadow. So we had to come back in the afternoon to take advantage of the best light for the rocks and dock in the foreground. With that done, there was

This intrepid photographer had to go out on the water to shoot parts of this scene, and then return to terra firma to photograph the human component. When capturing the separate elements, the trick was to impart a consistent feel to the lighting.

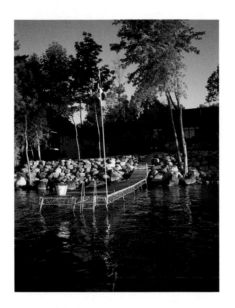

PRO TIP Why not shoot the people on the dock to begin with? Yes, we could have erased the agent and dropped him into the reflection afterward. But by shooting this element in the studio, we had total control. We didn't have to worry about sudden gusts of wind or waves crashing against the dock and getting people wet—not to mention the risk of somebody taking a misstep into the water. Most important, we were relieved of the added expense of bringing the models, along with various stylists, on location with us.

still the matter of the grass and water. The original perspective from the cottage shot showed more rock than lawn, so we had to drop in a lawn (we went out to the University of Toronto for that). And on the day of the shoot the water was too rough, so we had to wait and shoot different water and then drop that element in. Beyond that, when you look at the original shot you'll notice that the breakwater reaches a bit too high. So we digitally lowered that otherwise distracting element. There were other details that had to be finessed digitally back in the studio as well.

We started at sunrise and shot until about 9 AM, and then we shot in the evening light as well, from 5 PM onward. Why go back? Because we needed to flop those rocks in the foreground: The light wasn't right in the morning—it was just too hard, so we

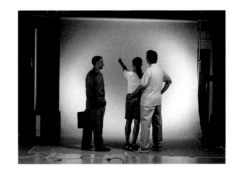

shot that element in the afternoon and flopped it, doing likewise with the dock as well.

The next step brought us back to the studio, to photograph the couple and the sales agent, together and separately, in various poses. The key was to show the couple standing alone on the dock, with a secondary view of them together with the agent in reflection on the water.

These studio shots were made against white seamless, to make it easy to silhouette them out and strip them into the final composite. In formulating my lighting, I had to emulate the morning light. So we began with a 6-foot Elinchrom disc softbox on a boom off a Profoto Acute 2400 W/S pack, up at the top right, and I added a couple of foamcore reflectors way over to the left side, just to open the shadows a

little bit. I also had two heads sharing a 1200 W/S pack to throw a clean wash of light on the background and give us the needed separation to make the next step of extracting them easier. These heads were positioned so that none of this light hit the people, thereby preserving the integrity of this element.

One component was missing: the "For Sale" sign. We could have generated it in Photoshop, but the art director wanted verisimilitude: he wanted the sign to look a little weather-worn and illuminated by mottled light, as from light filtered through tree branches. So we fabricated an actual sign in the studio and photographed it on a Nikon D2x with 105mm Micro lens, outside behind the studio, under natural light, and dropped that element into the final composite.

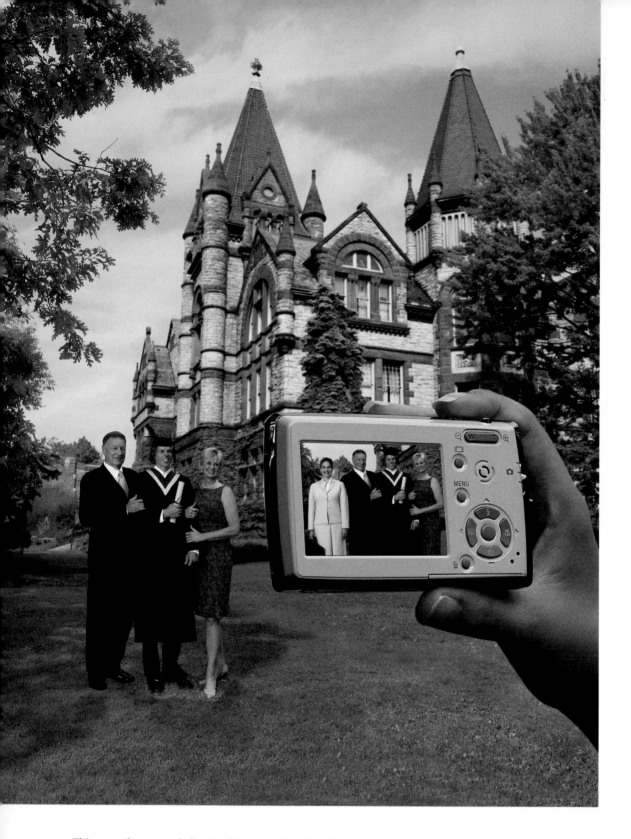

This was the second shot in this campaign. Briefly, this picture pretty much followed the approach outlined above, with elements shot outdoors and in the studio, and then composited. In this instance, the agent was added in the camera's external LCD monitor display.

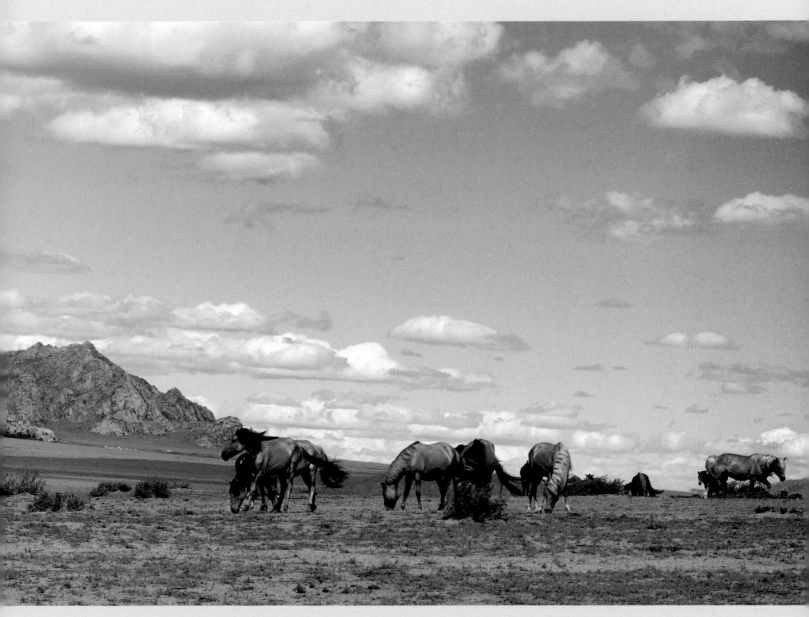

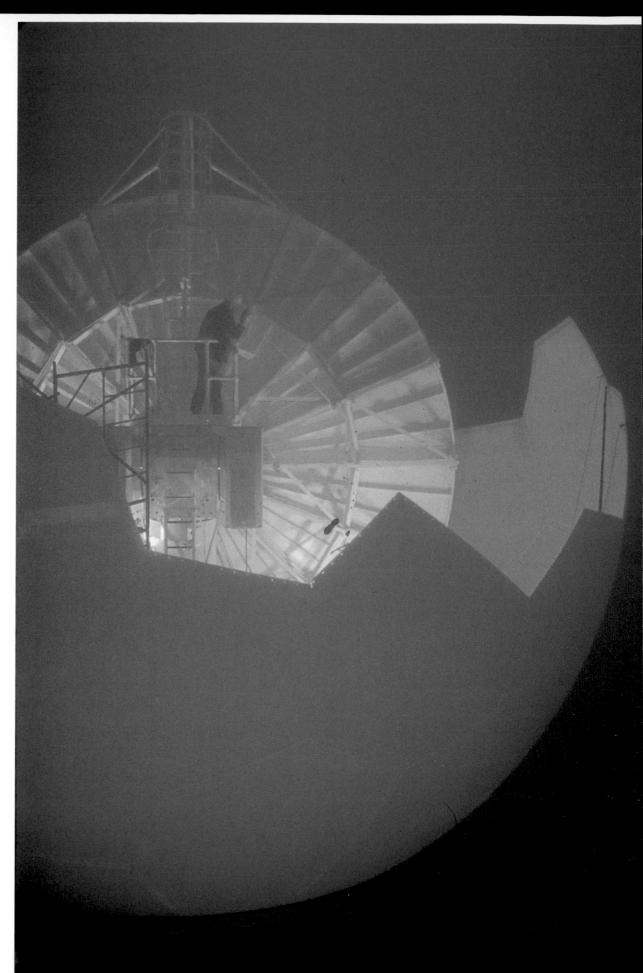

JOB SHEET

CLIENT: **Raytheon**

USAGE: **Collateral**

FIRST ASSISTANT: **Charles Sanson**

LIGHTING: **Strobe plus existing light**

CAPTURE: **Analog**

PHOTOGRAPH COPYRIGHT ©**Jeff Smith**

PRO TIP When at a work site, you have to think fast on your feet. Wanting to imbue the egg yolk section of our eggshell with a warm glow reminiscent of the color of a real egg yolk, I needed warming gels of the right density, seeing as I had a cooling filter over the lens. Trial and error led me to arrive at the equivalent of the requisite double 85B gel for each head. The winning combination turned out to be a Rosco ½ CTO, plus ⅛ CTO, plus ⅛ Minus Green.

This rare view of a Doppler dish in progress gives us a glimpse into the considerable difficulties an industrial photographer faces on location. One could argue which was the greater challenge—the weather or the lighting.

The art director was looking for an egg-yolk-inside-a-broken-eggshell look to represent this Doppler weather radar site in progress for an annual report. He sketched out what the radar dish should look like at this particular stage of construction and at this angle. The only problem was timing. Getting the "eggshell" in this configuration left us only a small window of opportunity in which to get out to the site outside Atlanta, Georgia, and set up, and perhaps three to four hours in which to complete the assignment. We were virtually on call awaiting that window.

To get an accurate assessment of the facility's progress, I decided to talk directly to the site managers rather than go through the corporate offices, and kept in close contact with them from that day on. When they told us they were starting to assemble the fiberglass shell panels, my assistant and I hopped on a plane. This gave us one day to set up and one day to shoot, assuming the weather held—

which was ironic, considering we were there to photograph a weather dish.

When we arrived, we saw that construction on the project had continued despite—you guessed it—bad weather. Because of heavy rains, the "eggshell" was in a sea of red Georgia clay that stuck to everything and created further logistical problems. Because the radar site was on a tower about 100 feet up in the air, we'd rented a crane in advance to give the art director and me a direct line of sight. Unfortunately, the crane didn't get there until way after dark that day, and the muddy clay made positioning it a nightmare. The mud refused to provide a firm foothold, and the crane kept sliding down an embankment. If we couldn't maneuver the crane into position in time, I'd be photographing the completed project—and that would look like a huge golf ball instead of the "broken eggshell" in progress that we needed to capture.

Some shots were done with the work crew, but when they left, I recruited a replacement, giving him one of my walkie-talkies so I could direct him from where I stood, in the crane basket. To add a color accent, I provided a red jacket from my wardrobe kit.

Just when the situation looked hopeless, the crane operator managed to anchor the machine in place. At this late hour, all we could do was position our lights. We used the crane to deposit the lights on the radar dish platform.

Since I'd planned to use strobes both inside the eggshell and from the crane basket that I'd be standing in, I needed electricity. Running wires to the basket and to the radar tower for our lights gave me more amps than two separate generators ever could.

We went out to the local Home Depot and bought about 600 feet of electrician's wire. The electrician wired two grounded lines for 110V at 15 amps up into the dome itself, and then another wire up into the crane basket. The line to the crane enabled me to use a hair dryer to keep the Polaroid back on my Nikon F4 warm, which was important on this very cold December morning. I alternated that wire connection between the hair dryer and the 1200 W/S Comet powerpack in the basket. There was no need to dedicate a connection for each device.

We had two circuits going into the radar dish, and each of these was attached to two Comet packs, for a total of 4800 W/S up in the dish. Each pack was set to slow recycling, so I could run two units off one 15 amp circuit without fear of blowing any circuits. That gave me a recycling time of about six seconds.

We hooked one strobe head to each pack, for a total of four lights in the eggshell. These provided the main lighting for the radar dish. The crane light was a fill, to pop the eggshell on the outside and make sure I got enough detail to separate it from the background. Once all this was done, we waited until morning to test the setup.

At first light, we arrived to find the site socked in by fog, which worked in our favor by obliterating unwanted background clutter. It also let me do a little more with my lighting and made the shot more abstract. I had planned to shoot around 20 to 30 yards from the dish, so the fog wouldn't present any problems in capturing the necessary detail.

To give the center of the eggshell the color of an egg yolk, I gelled the lights on the warm side. On the camera lens I had an 80A blue filter, thereby producing the overall blue cast and creating the illusion of dusk. All of this resulted in a considerable loss of light, so I had to shoot wide open, at f/2.8. This was enough to pull in the ambient light. I started out at between a half- and a quarter-second, and as the sun came up and the fog burned off, the exposure went down to 1/30. I probably made some exposure at a full second as well early on. I bracketed for the shutter time using the Nikon auto-bracketing multifunction back.

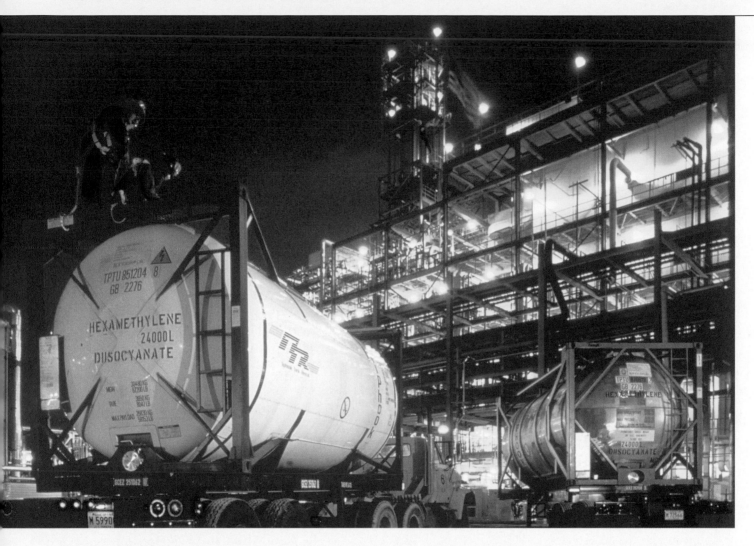

JOB SHEET

CLIENT: **Olin Corporation**
USAGE: **Collateral**
LIGHTING: **Strobe (plus existing light)**
CAPTURE: **Analog**
PHOTOGRAPH COPYRIGHT ©**Jeff Smith**

I scouted the plant site for this annual report shoot the day before. As I did so, I realized immediately that the juxtaposition of chemical transport trucks and plant was the shot I needed.

I decided on a night shot with a 28mm PC lens on my Nikon, letting the lighting eliminate any ugly details while providing drama at the same time. I arrived on site in the morning and moved the trucks and workers into position. I particularly liked the fluorescent red jumpsuits the workers wore.

The lighting took in the existing sodium vapors in the plant and dusky skylight. I then directed various strobes at the trucks and workers. All the pieces fell into place, with one exception: The smaller vehicle didn't sit right with me. To give the truck the small splash of industrial-style lighting that it needed, I aimed a blue-green-gelled strobe at it from behind the cab of the white truck. I bracketed shutter speeds from 1/15 to 6 seconds or longer, as dusk turned into evening. The longer exposures worked best.

It's one thing to photograph a network of pipes outdoors—quite another in a very confining space. The tight quarters in this facility, as much as anything else, dictated the lighting.

For an annual report, the agency wanted a series of pictures that illustrated the relationship between their client and other companies that either produce or use electricity. In this case, it was the then new Cogen Technologies natural gas—fired plant in New Jersey.

We tech-scouted the facility beforehand, but heavy rains limited us to an interior shot the day of the shoot. This room was actually the business end of the plant's operation—where it all happens. The room was huge: we saw that capturing it would require a very wide-angle perspective, specifically with a 20mm lens on a Nikon F3.

We picked this room not only because it was pivotal but also because of the shapes. Because of all the pipes sur-

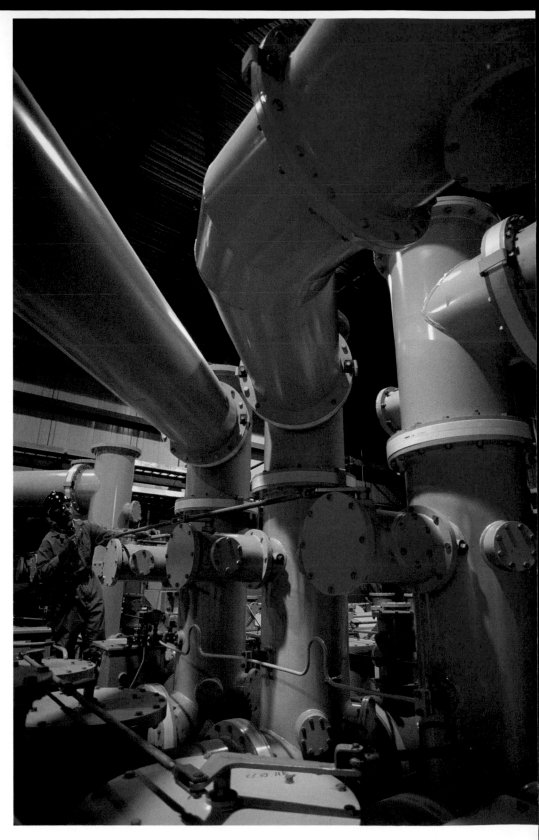

Power-pack and battery-powered strobes add to the ambient lighting to define this network of pipes. Gels and an on-camera filter help color the atmosphere and make it more inviting.

JOB SHEET

CLIENT: **Con Edison**

USAGE: **Collateral**

AGENCY: **Beau Gardner Associates**

ART DIRECTOR: **Allyn Bacher**

LIGHTING: **Strobe (plus existing light)**

CAPTURE: **Analog**

PHOTOGRAPH COPYRIGHT ©**Vickers & Beechler-cvgb.com**

PRO TIP Even in a power plant, the necessary electrical outlets may be unavailable for photographic purposes. It wasn't enough that this place was awfully noisy: it was an electricity-generating facility and yet there was only one outlet in the entire room. And the coffeemaker had dibs on that. After unplugging the coffee machine, we ran both packs off the outlet.

rounding us and the narrow catwalk on which we stood, we didn't have much leeway to move around and were scrunched into one little corner with our tripod-mounted camera. This walkway was maybe seven or eight feet above floor level, and because it didn't stretch completely around and through the room, we had to improvise with placement of lights and our model (a plant-worker, for whom we provided the orange jumpsuit). We also had to build a separate platform for him to stand very still on, because the catwalk didn't reach into that part of the room.

We decided early on not to light the ceiling, because that would have made the shot too busy and stretched our lighting resources to the limit. As is, we came prepared not to overpower the existing overhead sodium vapor lights but to work them into the shot. One immediate challenge was to make the drab and lifeless pipes come to life. The existing lighting would help partially, but we also knew we'd have to gel our lights to make the scene more colorful.

We began our lighting setup with the foreground. We used two shoot-through umbrellas, both running off one Dyna-Lite pack. To further soften the light in an effort to prevent recognizable catch-lights in the glossy pipe surfaces, we hid these lights behind a diffusion screen. Because the space was so tight, these lights were behind and on either side of the camera, with the diffusion screen in between. We gelled the heads blue with double-strength CTBs. The blue highlight on the end cap of the foreground pipe came from another blue-gelled shoot-through umbrella, on a separate pack. We tried to produce a blue glow that was as even as possible.

We lit the worker with a Comet PMT battery-powered strobe, with a half CTO in a bank. Behind him, in the background, there were two, double-strength CTB Norman 200Bs. These were clamped in place because there was no room for stands. Their blue light helped bring out the background just a bit.

We shot 12 rolls of Fuji Velvia, metering first for the worker and then Polaroiding. We varied the light output on each set of lights to make the sodium vapors more or less dominant. We preferred more yellow in the shot; the client chose one with less.

We also color-temped the room initially and determined that a 20CC magenta on the lens would enhance the scene. The exposures ranged from f/5.6 at $\frac{1}{4}$ to $\frac{1}{2}$ second, with other exposures reaching a full second or more.

An eight-second, three-part exposure captured what looks like a futuristic matter transporter. In reality it's just a wafer-polishing device.

Gelled lighting lends a masterful touch to high-tech gadgetry, giving it immediate visual appeal.

The client wanted dramatic photographs of their silicon wafer processing equipment. Showing this wafer polishing machine in operation, with its key parts in motion, provided a sense of what it did.

Getting data on the machine's surface textures clued me in to how I could light this. They also told me the shooting area was confined, which would affect my lighting approach. And they added that the space would be isolated, which meant I could turn off all the existing lights. I could now plan to create blurring reflections that would show the activity through a long exposure.

The device had a head that carried the wafer and moved from top to bottom, bringing the wafer in contact with a polishing surface. The machine cycled in eight seconds and couldn't be reprogrammed or cycled manually. The wafer pictured in the shot was eight inches across. The diameter

JOB SHEET

CLIENT: **On Trak Systems**

USAGE: **Collateral**

AGENCY: **Heiney & Craig (San Francisco)**

ART DIRECTOR: **Janet Carpinelli**

FIRST ASSISTANT: **Clark Irey**

LIGHTING: **Strobe plus tungsten**

CAPTURE: **Analog**

PHOTOGRAPH COPYRIGHT ©**Jim Karageorge**

PRO TIP I used diffusion material so the shape of the light source wouldn't be visible in the reflections. I used grids because I didn't want light spilling over onto the background, which needed to be as dark as possible.

of the plate it was sitting on was about a foot. The machine was about five feet tall and five feet wide; we focused on the center section of the machine, which was about two feet tall and three feet wide. We shot this dead on, which gave us the simplest view and ensured that all photographic elements would record clearly on film. In order to create a sense of movement, multiple strobe pops (the number arrived at through trial and error) would give us the fairly solid image of the head at its various stages of movement, while hotlights would complete that sense of motion through the blur.

We started with a Chimera softbox with a Dyna-Lite head, with a red gel over one half of the bank and a very warm yellow gel over the other to give us the color we needed. We also set up a sheet of Rosco Tough Rolux diffusion material behind the machine. Then, while I previewed the effect through the camera lens, one of my two assistants backed off the light and lowered it so that the two colors blended at an optimum point, creating that reflection in the wafer. In addition, I had two blue-gelled Dyna-Lite grid spots shooting through the sides of the machine, each with Tough Rolux.

To get that warm glow you see in the head when it's in the top position, I used a 350-watt Arri Fresnel hotlight. I bounced this light from below camera position up into a sheet of white foamcore, four or five inches deep and stretched across the width of the machine.

I felt that we also needed some harder reflections, in order to show the drag, so I added a hard light on a boom, just above the opening in the machine and centered over the polishing head. This was another Arri Fresnel, but snooted, positioned a little bit in front of the foamcore.

So when it comes to the actual exposure, what you've got are three pops on the strobes coinciding with the polishing head's movements at the top, middle, and bottom positions, and an eight-second drag, with the lens set on Bulb. A diffusion filter was added in front of the lens during the portion of the exposure when the head was moving. The Arris were turned on after the first strobe exposure and remained on. Some of the reflections became elongated as the head moved through the cycle, forming those transporter beam-like rays of light. The 50mm lens on my Hasselblad was set to f/16 ½.

LIGHTING A CARGO PLANE ON THE TARMAC

Lighting a frenzy of activity around a cargo plane on an airport tarmac requires considerable diligence. The key in delivering the message for this worldwide courier was to keep the illumination on the aircraft understated.

Cargo loading, rather than the airplane itself, was the focus of the shot from the start. The lighting highlights the activity originating in the plane and on the tarmac.

We shot this DC-10 on the tarmac at Subic Bay, the Philippines, for a lavishly illustrated directory of corporate worldwide services. We used this location partly because we needed a large aircraft, one used in transcontinental routes. But mostly we had to show the Asia-Pacific aspect of the operation, which made it necessary to use local FedEx employees, seen here loading cargo. The client also wanted the shots to have an editorial feel, so all the pictures were handheld, with a Nikon N90S, fitted with a 20-35mm zoom and loaded with Kodak E100SW. The

JOB SHEET

CLIENT: **FedEx**

USAGE: **Collateral**

AGENCY: **Hanley-Wood (Minneapolis)**

CREATIVE DIRECTOR: **Sandy Rumreich**

FIRST ASSISTANT: **George Panagakos**

LIGHTING: **Strobe (plus existing light)**

CAPTURE: **Analog**

PHOTOGRAPH COPYRIGHT ©**Lou Jones**

PRO TIP To power our own strobes, we made use of four huge diesel generators, which were normally used for the landing lights.

exposure was 1/15 second, with the film pushed one-half stop. For this assignment, we rented all our lights out of Calumet, Los Angeles, and had it shipped to the location—via FedEx, of course.

We started setting up around 4 PM and finished at 2 AM. This was the first shot taken right after dusk, which is why there is still some blue in the sky. That "magic blue" was a critical factor for this picture in particular.

When setting up our lights—all of them on huge high-boys—we never intended to light the entire plane, front to back, with flat lighting. Instead, I wanted the light on the plane to be understated, with more of a focus on the setting, the people, and their activities. So the first light up was a Balcar head with a half-sun gel, aimed at the nose of the plane from the opposite side, producing a rimlight. This same light was also hitting the tarmac.

The next light was on the right side and way up high, far to the right of camera, lighting that small, stationary truck, together with the side of the plane. The light was also hitting the tarmac, throwing a shadow, hitting the engine, and just grazing the fuselage to bring out some highlights. The third light was hidden by the engine itself. It was filling in on the lower part of the fuselage just under and behind the wing, helping to define the people against the aircraft. The fourth light was on the ground underneath the plane, backlighting the boxes. The next

light, powered down so it would not overpower the primary lights, was designed to illuminate the platform and workers from the front.

Although there was no light inside the cockpit, there was a light inside the plane illuminating the cargo hold. That light was an umbrella, bouncing up against the interior wall of the plane at the far side. The final light was for the tail, positioned far enough away that it just brought out the logo.

Two lights—the one rimlighting the plane and the one behind the engine—were producing flare in the camera, so we had to feather the engine light and add Cinefoil to both lights. One other problem was that the slaves on the packs were too far away from each other to be effective, so we ran peanut slaves with long synch cords to each pack.

You've heard of surround-sound. Now meet surround-lighting, since that was essentially what helped capture these office high jinks.

Surround lighting, a large soft key light, and a special rig come together to give the impression that this office worker is actually skating around the office.

The headline read "Office X-Games," implying the high-risk shenanigans that go on in the workplace. The tagline followed: "It's okay to take a few risks at the office, just not with your work." That was the concept we had to execute for a company specializing in integrated tax and accounting solutions.

Typically, even when we do get comps to work from, they're pretty loose. Not so in this case. The art director gave me a very tight layout that we had to match

JOB SHEET

CLIENT: **CCH Group**

USAGE: **Advertising**

AGENCY: **HSR Business to Business**

ART DIRECTOR: **John Nagey**

PRODUCTION MANAGER: **Sarah Miller**

FIRST ASSISTANT: **Wilbur Montgomery**

DIGITAL ARTIST: **Jeff Siereveld (Mad Macs) and Tony Arrasmith**

HAIR & MAKEUP: **Jodi Byrne (with Illusions)**

LIGHTING: **Strobe (plus existing light)**

CAPTURE: **Digital**

PHOTOGRAPHS COPYRIGHT ©**Tony Arrasmith /Arrasmith & Associates**

PRO TIP I don't do tons of gelling, because I will take an isolated area and color-shift it as necessary.

almost precisely. He even shot stills to show me what he was looking for. Although we did scout locations, we returned to the first one on our list, which happened to be the agency's offices. And with good reason: The layout the art director had given us matched the office location, with the hallway and cubicles—nothing else would have worked quite as well. Using this location also meant we'd have the flexibility to set up and shoot without the same kind of constraints normally encountered at a location site. Moreover, the offices were brand new at the time.

The overhead fluorescent lights were a factor in determining exposure and our lighting setup. I wanted the feel of a real office. The resulting exposure—⅛ second at f/5.6 (ISO 50)—let me limit depth of field and incorporate the interior lighting while introducing just enough blur in the blades to give it a sense of verisimilitude. To achieve this perspective, camera height was just under two feet, around six feet from the skater.

The first big challenge was figuring out how to suspend our "office worker." I tracked down a company in Hollywood that specializes in rigging and harnesses so we could make him "fly." The rigging consisted of two swivel wires on his hip, which enabled him to spin if he wanted to, attached to a belt at the waist underneath his pants. It also meant we would have to cut holes through the slacks, which we bought specifically as part of our wardrobe (we also bought pants for the scooter shot). We also purchased a child's swing set and used it for the platform to which we'd connect the wires. There were a total of four wires connected to the skater: two to his pants, one per side, and two to his toes hooked through the in-line skates themselves.

The shoot, encompassing both pictures, occupied us for one full day—11 hours, to be precise, even after setting up the day before. I probably brought in nine cases of gear for this shot. The camera was a Digiflex with an Imacon 96 Express digital back, with a Nikon 17-35mm lens at 19mm. Our talent was a mix of professional models and people who actually were employed in these offices. I had two assistants on this job with me.

We figured the office fluorescents would burn in sufficiently so that no gels would be needed, and we were right. On the other hand, we did have to be careful: the exposure was based on not letting the existing lights blow out too much, so we could capture just the least bit of detail in these fixtures. We then bounced most of our lights—seven in all—off the ceiling. These lights essentially enveloped our players: four on the right, three on the left, and one

SOFT

032 042 048 049 051

054 058 059 064

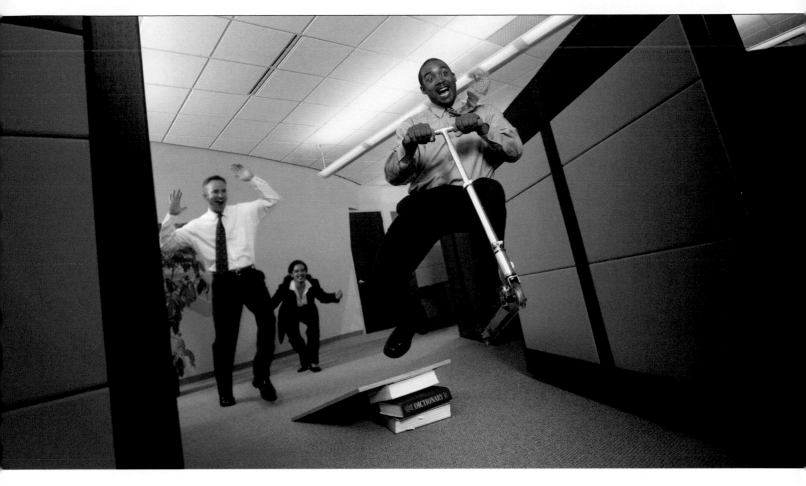

In the second shot, we took a more practical approach. The process started out similarly, but we ended up having the talent sit on a stool with his legs out to the sides, and then we digitally retouched out the stool. Lighting was otherwise very similar to the skater shot, with several lights bounced off the ceiling and one key light on him. We also tilted this shot slightly in camera to give it a different dynamic sensibility. As before, there was considerable work done in post.

in the office in back. But two lights in particular stood out. Most of the lights ran off Profoto packs, with one Broncolor pack at the left rear and one other as noted below.

Our key light was specifically aimed at the skater from the front, which was a Halo Britedome on a boom, coming in from camera right and running off a Profoto Pro 6 Freeze 1200 W/S pack.

The doorway to the office on the left, adjacent to the skater, admitted one more light to our scenario. As fill we had one Lumedyne pack with diffused head in here, at 50 W/S so it wouldn't overpower the key light. It was aimed straight at the skater.

In post we added vignetting and removed the wires and blurred the skates, the fingers on one hand, and shoulder blade just a bit. Directing the talent was a simple matter of just saying, "One, two, three: let's go," and we had the assistants doing a lot of cheering. We shot this numerous times just to get the head right. We took the head off one shot and blended it into the final image. We should add that the tie was tethered to a wire, which was connected to a boom, then blurred slightly in post.

LIGHTING A MUSEUM DISPLAY

Museum displays are something to marvel at. But try lighting one and you suddenly find yourself encountering any number of challenges. Here's one approach to tackling this bear—well, panda and tiger and, oh my!

This shot of the biodiversity exhibit at the American Museum of Natural History, in New York City, was for a calendar published by the Museum. Stray reflections proved especially troublesome when it came time to shoot because a key part of the exhibit was surrounded on all sides by light sources. This called

Although the tiger clearly stands out, his supporting cast is by no means tossed to the shadows—thanks to some deft lighting from either side of this display, mixed in with some of the existing lights.

CORPORATE AND INDUSTRIAL

JOB SHEET

CLIENT: **American Museum of Natural History Special Publications**

USAGE: **Collateral**

LIGHTING: **Tungsten (plus existing light)**

CAPTURE: **Analog**

PHOTOGRAPH COPYRIGHT ©**Denis Finnin/
American Museum of Natural History**

PRO TIP Photographing museum displays requires a diligent eye to prevent any aberrant reflections and distorted colors from intruding on the scene and to capture all the necessary details.

for huge amounts of black cloth and the help of staff electricians to control the existing lights. Lights left on included those in the central endangered/extinct species display and select fluorescent tubes—unfiltered, for added color—in the background case, because we wanted to capture some of the depth and variety of that display. As is often the case in museums, there was no direct access to the exhibits. The endangered species case measured 12 feet wide by 14 feet high.

Aside from reflections, one major problem to contend with were the columns (not visible in the shot) on each side, especially the one on the right. The tiger was a key element of this display and therefore needed to be lit well. The other animals played a subordinate, though certainly not unimportant, role.

We began by piggybacking two 1K Lowel Rifa tungsten banks vertically atop each other to cover the full height of the main display. These skirted the right-hand column, positioned to camera right so that they hit the near corner of the display, where the tiger stood.

That still left some key areas dark, so we added Photogenic MiniSpots—snooted with blackwrap, on the far left, a couple of feet apart, to open up the iguana and the skeleton of the dodo bird. Between these two was a 500-watt Rifa bank, which we used to bring up the shadows on the panda, coming in from a 45-degree sideways angle and very slightly downward relative to the display.

The camera I used on this shot was a Mamiya RZ67, with 65mm lens, loaded with 64T, bracketed (it was a rush job). A CC10M filter was used to compensate for the green tint in the glass. I matched my exposure—30 sec. at f/22—to the light levels in the background exhibit case.

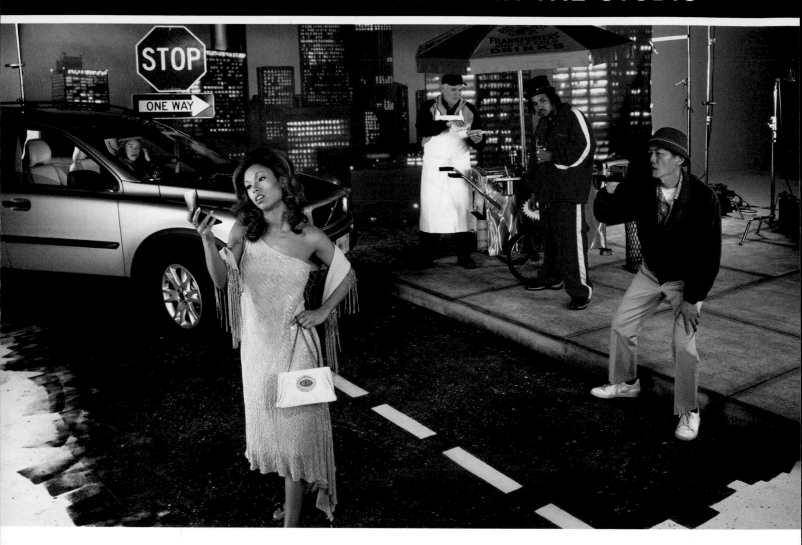

N o, it's not a location shot, but it was made to look like one—to a point. The lighting plays a pivotal role both in trying to fool us and in revealing the truth about this setting.

The idea behind this picture was to extend the scene beyond normal boundaries, which meant including lights and even crew on set as part of the shot.

The introduction to this Engelhard annual report in part read, "More companies are turning to Engelhard . . . Because our company is uniquely equipped to redefine our customers' products and markets . . . Take a look" Then you turn to the first of four two-page spreads that back up this statement: an assortment of products employing this company's technologies. But the images are not the typical fare that generally fills annual reports. These images seem to have a life of their own.

The way we would present this diverse panorama of consumerism was with four different scenarios, each a seeming panoramic perspective, among them this one of a photo shoot on a city street. In each case we would have to allow for the cleverly designed report's spiral binding. Aside from that, it was left to me to plan

JOB SHEET

CLIENT: **Engelhard**

USAGE: **Collateral**

AGENCY: **Addison Design**

CREATIVE DIRECTOR: **David Kohler**

PRODUCER: **Berns Rothchild**

FIRST ASSISTANT: **Kfir Ziv**

SET CONSTRUCTION: **Composition Workshop (Brooklyn, New York)**

WARDROBE STYLIST: **Evelyne Von Gizycki**

PROP STYLIST: **Ariana Salvato**

HAIR & MAKEUP: **Paul Innis**

LIGHTING: **Strobe**

CAPTURE: **Analog**

PHOTOGRAPH COPYRIGHT ©**Rafael Fuchs**

PRO TIP From the outset, I knew this would not be a typical shoot. The creative director wanted the set to extend beyond its normal boundaries, to encompass the lights and grip equipment, and even the surrounding studio and people walking around off set. He wanted to give the shot a kind of quirky, existential feel; I was prepared for that.

each shot. I had the help of three assistants to carry out this assignment.

I brought in my prop stylist, who introduced me to the set builder. We shot at Broadway Stages in Long Island City, New York, with one day for prep and two days for shooting. Generally, we'd be shooting on one set while a second would be breaking down or under construction. The camera for this shot was a Sinar 4x5 with 150mm lens, with Profoto 7 lighting, with each light running off its own 2400 W/S pack. Film was Fuji Velvia. All equipment was rented out of Adorama.

This shot represents the third spread in this annual report. For this one, I not only had to light the set but also had to deal with the car, lighting it almost as if it were an automotive shot. The Volvo, courtesy of the client, represented yet another tie-in to their products, which was also true of the dress and sundry other items. We brought in the hot dog stand, video camera, and remaining wardrobe, as well as the talent. Although the scene was meant to take place at night, Polaroids showed that using subdued lighting in tune with that concept simply did not work, so we pumped up the volume.

The main light was a large Chimera with a bitube head positioned to the right of camera and behind me. I wanted the scene to be on the warm side, so I added a half CTO to this and other lights. I had a white beauty dish on a boom to the left, to open up the young woman's face. There were also two grids with ½ CTO-one for the hot dog customer, a second on the tourist holding the camcorder, both from the right.

For the background, we had two umbrellas—one high, from the left, the second very low, behind the car—to open the driver side of the set. One or both of these lights also reached the hot dog vendor.

We also needed two lights for the cyc, one to cover the area which extended behind the backdrop to the right and one more from the left side, for separation. Then we had one medium Chimera with a half CTO for the sidewalk behind the tourist. And there were also two umbrellas—one at a height of five feet (visible in the picture), the other at 12 feet, to open the backdrop from the right side.

To light the vehicle, we had a 12x12-foot silk positioned 10 feet from the automobile, with two lights five feet behind the silk, to open up the side of the car facing us. We also needed to show the interior, so we added two bare bulb lights inside the car—one in the front seat, the other on the backseat—each with a yellow gel and powered down. The cables to these lights came from a pack in the trunk of the car. We left the car lights on.

GLOSSARY

A glossary of terms employed in professional photography; specifically, everyday jargon used by commercial shooters.

Acetate overlay A drawing on acetate that is overlaid onto the ground glass (usually on a view camera) to help define camera positioning for the shot.

AD Art director.

Advertising usage Encompasses print media, including posters and billboards, but obviously extends to any media where products and services are marketed or sold, and may include POP, package design, and direct mail. Ads are usually shot to a layout.

Annual report A corporate financial report that doubles as a capabilities brochure.

Assignment Job Often entails submitting a bid, or estimate.

Bank light Lightbank (also bank). The term is more correctly used to refer to an array of lights banked together to form a singular light source. May also be referred to as box light.

Bare bulb A light head without reflector, or the technique employing such a head. (*See* bare-bulb lighting.)

Bare-bulb lighting A technique in which a light source—specifically, a bare-bulb—head, is employed to throw a very broad but hard, specular light on the subject/scene. Generally designed to simulate sunlight.

Barndoors A set of two or four black metallic or plastic leaves or "doors" (in essence, flags) fitted onto a light head and designed to flag light away from areas of the set or, conversely, to restrict the throw of light to a narrow area.

Beauty dish A relatively large, shallow reflector fitted to a light head and often used in beauty work to give off a specular light largely devoid of harsh shadows on the subject's features.

Beauty shot (1) In product photography, any picture that shows the featured product to advantage. (2) As a genre, beauty work (or simply "beauty") refers to people, not products, with special emphasis on hair and makeup, with the possible addition of various fashion accessories, usually captured in close-up.

Bid An estimate submitted to a prospective client, based on anticipated costs weighed against potential earnings. Day rate, assistants, stylists, modeling fees, rentals, consumables, studio overhead, incidentals, transportation, lodging, travel time, and meals may all enter into it.

Black velvet A black flock fabric that absorbs light and proves useful and very effective as a backdrop.

Blackwrap A heavy-duty, matte black foil used to shape a light and control spill. Cinefoil is a popular brand name.

Boom (or boom arm) An extension arm attached to a heavy-duty, counterbalanced light stand, designed to position a light head so that it overhangs the set without intruding.

Bounce card A reflector added to a set to bounce light back onto the subject in a more or less controlled fashion. Most often used to denote any small reflective surface. Bounce cards are generally rigid and made of white posterboard or foamcore (*see also* flat), but may also be collapsible. Small rectangular or circular mirrors, while not technically bounce cards, give you a harder edge and cover a more defined area.

Bouncing into Jargon among pros for a light head (or lights) aimed into a reflective surface and bouncing off it.

Box light Lightbank.

Campaign A series of ads that run for a period of time (days, weeks, months, or even years) with a common thread or theme running through them.

Capabilities brochure Similar to an annual report, but without the financial mumbo-jumbo, this is a corporate brochure specifically designed to outline and promulgate a company's manufacturing and technological prowess.

Card Bounce card, flag, or gobo. Used as a verb, it refers to flagging a light.

Catalog Promotional brochure designed to sell a variety of products or services. Usually, work shot for catalogs tends to look fairly stylized, but there are exceptions, where the images can get creative, even edgy. Catalog photography generally pays less than national magazine advertising.

Collateral usage Includes catalogs and brochures, circulars and flyers, and online. May generally be thought of as any means used by a business to disseminate information about itself from within (such as annual reports and capabilities brochures) or utilizing company-sponsored media (e.g., corporate Web site).

Comp A sketch or mock-up around which an ad is based. It may be a composite image, hence the name. (The practice of pulling illustrations from copyrighted sources for this purpose is highly questionable.)

Composite A building up of a picture from separately shot elements superimposed on the same frame to form one fully integrated image (film or digital). Also used as a verb.

Cookie cutter (Formally, cukoloris or cucoloris; also cookie or cutter.) Any device with a cutout pattern that is placed in the light path to create dappled light, such as the impression of dappled sunlight through leaves. The degree of focusing on a spotlight used with the cukoloris will produce varying effects, from subtle (defocused) to strong (focused). (*See also* gobo.)

CTB (color temperature blue) Designation for cooling (blue) gel used in lighting.

CTO (color temperature orange) Designation for warming (amber/orange) gel used in lighting.

Cutter Used to refer to a flag or cookie cutter (intent determined by context).

Cyc Short for cyclorama. An often permanent sweeping backdrop built into a studio. Put it in a corner incorporating the ceiling and you've got an eggshell cove.

Daylight-balanced Refers to color balance of film or lighting referenced to a standard daylight color temperature (5500K for film; varies slightly for lighting, as high as 6000K or thereabouts). Typical daylight-balanced light sources include electronic flash (strobe) and HMI.

Dish Parabolic reflector, or simply reflector.

Dragging the shutter A technique employing a longer than otherwise necessary shutter speed in a shot so that the exposure is long enough to include the ambient light with flash; often used to show some motion blur.

Duvateen Variously spelled, this is a flame-retardant, nonreflective black fabric used to block out extraneous light and reflections around a set.

Editorial usage Use of photographs in any noncommercial published content, usually in print, such as magazines and newspapers. Generally pays less than advertising, and is done to a tighter budget. However, the photographer may have more creative freedom here.

EI Exposure index. The film speed or digital gain actually used for the exposure, other than the manufacturer's rated or recommended ISO (ASA) setting.

Feathering the light A technique in which the light just skims or brushes the subject, thereby producing a softer light.

Fill Also called fill light or fill lighting. Any light used to reduce contrast by softening shadows. A fill can be a physical light, bounced light, or even spill.

Flag Any nonreflective black-toned / black-surfaced device used to control or block the throw or spread of light. Most often used with reference to flagging light off a subject or away from the camera. Often used interchangeably with gobo; may also be referred to as a cutter. (*See also* barndoors.)

Flat Any reflective surface added to a set that is of considerable proportions—generally too big to fit on a tabletop—often 4x6 feet or larger in size, and usually made of white foamcore or fabric stretched over board. Flats may be stacked on top of each other or edge to edge. They may also be white on one side to reflect light, black on the reverse side to hold back light. Flats may also be used as walls around a set. (*See also* L-flat; V-flat.)

Flying flat (*See* hanging flat.)

Foamcore Lightweight board available in sheets of varying size and used as bounce cards or flats, especially when white. Foamcore ages with time and use, and should be replaced regularly.

Fresnel (or **Fresnel spot**) Any spotlight employing a Fresnel lens to control the beam.

FSI Freestanding insert. An advertising insert generally found in the Sunday papers.

Full flood (1) Refers to the use of barndoors wide open, thereby enabling you to flood the set with light while retaining some control over spill. (2) Alternatively, indicates a Fresnel spot internally positioned for a wide throw of light. (3) Also used in the context of flooding an area with light.

Gaffer's tape (or **Gaffer tape**) A special tape used for anything and everything, on a set or even on equipment, as well as to safely cover wires and cables on location, with the distinct advantage that it holds yet does not leave any damaging residue.

Gel Loosely, gelatin filter. In lighting, a filter made of thin translucent plastic material (such as acetate) and used over a light head to either color-balance the lighting to neutral or add color effects.

Gobo (1) Any cardlike device used to keep light from flaring the lens. In this context, also referred to as a flag. May be used as a noun, or as a verb (to gobo the light away from camera). (2) A metal or glass mask used within a spotlight to modify the beam by projecting patterns on a set. (*See also* cookie cutter.)

Grid A honeycomb-patterned light modifier normally attached to the front of a light head and used to restrict the spread of light. Also used to refer to spotlighting employing a grid, either as grid spot or, more simply, as grid.

Grip equipment A term borrowed from the movie and theater worlds referring to light stands, booms, clamps, and anything else used to hold lights in place during a shoot.

Hanging flat Any flat that is suspended alongside or over a set. Also called a flying flat.

Hero The actual food or product photographed (as opposed to a stand-in that may be used when shooting tests prior to arrival or preparation of the real item on set).

HMI (hydrargyrum medium arc-length iodide) A versatile and powerful daylight-balanced form of continuous lighting.

Holding focus Keeping focus centered on the subject or a key area in the shot. (*Compare with* pulling focus.)

Hotlight Applies solely to any 3200K tungsten- (or quartz-) halogen continuous light source.

Hot spot Any glaring reflection that must be toned down, especially in highly reflective surfaces.

In-camera masking A mechanical method of combining two (or more) images on one sheet of film.

Job Photo assignment.

Joules (*See* W/S.) European unit of measurement for strobe power output.

K Thousand. (1) In this book, primarily used with reference to light output—and usually with whole numbers; for example, a 1K light. (2) Also used with reference to color temperature of a light source or film (e.g., 3200K tungsten-balanced).

Key light Main light. Often the light used to establish a base exposure, the mood of the shot, or the principal lighting direction.

Kicker light A light used to elevate an area from oblivion and direct some attention that way. Usually low-power and possibly snooted. Also known simply as kicker or as accent light.

L-flat (or V-flat) A pair of hinged flats, in an L- (or V-) shape, used as reflectors or to block off the set or part of it (or for both purposes at the same time).

Lightbank Often used interchangeably with softbox and banklight. Any light modifier attached to or encompassing a light head, with a reflective interior and diffusion fabric surface to soften the light. Originally used to simulate window light, hence the rectangular (or square) shape, but today a lightbank can be long and narrow (striplight) or even octagonal. Lightbanks generally require an adapter plate to fit onto the front of a head. A few designs open and attach to the head like an umbrella. Because the head is fully contained in the bank, proper ventilation is required.

Light painting A form of lighting involving a fiber-optic wand (or even a narrow-beam flashlight or penlight) to "paint in" areas of a subject or backdrop for the purpose of selectively highlighting or filling in various areas on a subject in a tightly controlled fashion, or to add lines or squiggles or definable shapes in either white or tinted light.

Lock off (or lock down) the camera To keep the camera on set (possibly for an extended period) in a single position so that different elements of a shot can be photographed or composited in registration with one another.

Mock-up (1) A scale-model replica used for testing before the finished model is produced. (2) A layout.

Modeling light Any incandescent or fluorescent light source used to preview the lighting effect in a studio flash unit. The modeling light should be self-quenching or self-dimming to avoid contaminating the exposure when the flash pops, and preferably proportional to the actual strobe output to better assist you in assessing contrast and the overall effect.

Monolight Also monobloc. A self-contained studio flash that plugs directly into an AC outlet and comes with the flash head and power supply in one integrated housing (in contrast to a powerpack system). A central control panel is found on the side or back. Select units have a battery option. Key advantages: ease of use, fast setup, and modest price.

Optical spot A focusable spotlight, with zooming capability, often used to project patterns onto a set. (*Compare with* Fresnel.)

Parabolic reflector (Often simply reflector.) A parabolic dish fitted to a light head and designed to throw light in a preconfigured pattern.

Personal work Any work generated as tests or not specifically shot for clients. This may involve trying out new styles, novel techniques, experimental lighting, or new gear in an attempt to carve a new niche for oneself.

Photographic umbrella Often simply called an umbrella. A light modifier that usually features a white or silver underside to reflect back light. The fabric is somewhat opaque, with the light head aimed into it and the parabolic interior-reflecting surface aimed at the subject. The central shaft is supported on the head's dish or clamped elsewhere at the base of the head. White umbrellas produce a softer, more neutral light, whereas silver umbrellas output a slightly harsher and cooler light that might have to be gelled to bring it to neutral balance. "Shoot-through" umbrellas use a translucent fabric, with the head aimed through them and at the subject. Select umbrellas have a diffusion baffle that further softens the light, similar to what you can get with a softbox. The spread of light from umbrellas results in considerable spill outside the subject area, in contrast to what might be achieved with a softbox, which provides tighter control. Key advantages of the umbrella: inexpensive, compact, easy to use, and sets up quickly.

Plexi Short for Plexiglas, a proprietary name for acrylic plastic sheets. In translucent milk-white form, one of the most useful surfaces in tabletop photography. Also used to diffuse lights.

POP Point-of-purchase, or place where purchase decisions are made. In this context, refers to promotional displays and flyers in retail outlets.

Post Short for postproduction. The phase following capture (whether analog or digital) during which the shot is retouched, corrected, manipulated, or otherwise worked on to get it to a usable stage or prepare it for final publication.

Powerpack Also called generator. The central power supply to which flash heads are attached and through which they are controlled and monitored. Because the power supply is located apart from them, flash heads for this system are smaller, lighter, and less expensive than comparable-output monolights. Key advantages: Powerpacks tend to be more robust than monolights, with perhaps shorter recycling times and possibly shorter flash durations. But they may be pricey, and require a longer learning curve.

Pull Using lower ISO film speeds or reduced digital gain. With film, it further involves compensating in the processing times. Pulling the film would be used to reduce contrast, either for effect or where it is excessive, and possibly for tighter grain structure. (*Compare with* push.)

Pulling focus Setting focus and *f*-stop to ensure as much depth of field as possible. (*Compare with* holding focus.)

Push Using higher ISO film speeds or increased digital gain. With film, it further involves compensating in the processing times. Pushing the film would be used to enhance contrast, either for effect or where the scene is too flat, with possibly an increase in grain texture. (*Compare with* pull.)

Reflector (1) A reflective (generally white or silver-toned, or metallic or mirrored) surface used to bounce light from its source onto a set or subject. May also take the form of a collapsible disc or panel. (2) Parabolic reflector. (*See also* bounce card; flat; parabolic reflector.)

Ringlight A circular light that fits over the camera lens, with the overall effect of a beauty dish, but more specular. Called a ringflash when a flashtube is used.

Seamless Paper backdrop, available in rolls, that is very versatile and often economical. A bar suspended between two poles holds the roll, with the paper sweeping forward onto the floor of the set or just hanging, weighed down with heavy clips.

Scrim While it may have more esoteric uses in the theater and movies, in still photography this term generally (if not entirely correctly) refers to a finely woven or mesh fabric used in front of a light source to hold back light, much like a neutral-density (ND) filter on a lens. May also be referred to as a net. Also used as a verb, such as to scrim light off the subject.

Shoot A photo session. It could be an actual job or simply revolve around tests.

Shooting table Also called a sweep table. A tabletop surface with a milk-white Plexiglas or Plexi-like surface that sweeps up toward the back. Provided the lighting is used appropriately, the sweep produces a graduated backdrop resulting from light falloff. The translucent nature of the shooting table means that subjects can also be lit through the plastic, notably from underneath, when needed.

Shot A picture, but specifically the one you're hired to capture or that you do as a test. One assignment or shoot may involve one shot (or many) focusing on one aspect (or more). Each shot may consist of numerous takes.

Silk A mesh fabric, usually white, primarily used to soften and diffuse the light, or maybe to hold back light (in effect, a scrim or net).

Snoot A cone-shaped device that attaches to a light head, with the narrow, open end directed at the subject, providing an economical way to restrict the light into a tight beam. Blackwrap may be used in its place, or in combination.

Softbox Lightbank. A device designed to produce a soft, even light, usually with one light head positioned inside and behind a diffusion baffle. Softboxes are often time-consuming and sometimes troublesome to set up. A few open much like an umbrella, with a central shaft. Key advantages of a softbox: Compared to an umbrella, it allows a more controllable spread of light and produces a more pleasing catchlight in a subject's eyes.

Sourcebook Any publication, usually produced annually, in which a photographer advertises his or her services largely by means of pictures representative of a current shooting style. It's not cheap.

Specular In lighting, a hard light producing an effect similar to sunlight.

Speedrail Any overhead or sidelong rail designed to easily move attached gear to a more advantageous position.

Spill light (May simply be referred to as spill.) Any light that "spills" out from a light source and onto areas of the set where it was not originally intended to go. Sometimes spill light serves as fill, when used judiciously.

Spotlight (May simply be referred to as spot.) Any light head that focuses down to a tighter beam by internal or external means. It may be a Fresnel or optical spot, or it may employ a grid or snoot to achieve the effect. Focusable spots are the most efficient, but grids and snoots provide an economical and expedient alternative.

Subtractive lighting An effect achieved by pulling light off the subject through the use of black cards or black fabric to remove light and reflections and add contrast and depth.

Sweep Any sweeping backdrop.

Sweep table Also shooting table. A self-standing tabletop set with a milk-white Plexiglas sweep. Designed for lighting from any angle, even underneath.

Tabletop photography Any photography of a product or still life subject on a table-like surface, possibly, but not necessarily, involving a sweep table.

Tacky wax Any of various tacky substances used to hold tabletop items in place, preventing them from rolling, sliding, or shifting. These products generally have "tack" or "tac" as part of the brand name.

Test (1) Personal work. (2) A picture (on instant film, conventional film, or digital media) that provides a preview of the set, composition, lighting, exposure, and contrast, possibly involving models (or an assistant standing in) or hero product (or stand-in). During or prior to a shoot, this may be a step carried out for the benefit of the client or art director.

Theatrical lighting A form of lighting used in theatrical and television productions designed to show characters on stage to advantage, often resulting in double shadows.

Tough spun Popular diffusion material for lighting.

Track lighting Lighting that is repositionable along overhead rails; often designed as a grid running over the staging area.

Tungsten lighting Applies to the use of tungsten-halogen and quartz-halogen 3200K lights. Sometimes, if erroneously, more broadly applied to incandescent light sources of a warmer color temperature.

Umbrella (*See* photographic umbrella.)

Umbrella lighting Any lighting employing a photographic umbrella.

V-flat (*See* L-flat.)

W/S Watt-seconds. This is the power rating for studio strobes. (*See also* joules.)

INDEX

Architecture and interior shoots, 97–123
 architectural details, 110–111
 boat interior, 106–109
 corporate cafeteria, 112, 113
 exteriors at magic hour, 118–120, 121
 health center, 102–105
 hospitality, 98–101
 museum interior, 122–123
 residential interiors, 114–117
Arrasmith, Tony, shoot, 162–165

Blue/black color motif shoot, 76–79
Boat interior shoot, 106–109
Boat, shooting from, 146–149
Boggust, Paula, shoot, 94–95
Bounty Hunter shoot, 62–64
Brandt, David Allan
 fashion shoot with smoke, 20–22
 javelin/athlete icon shoot, 142–144
 vintage-feel shoot, 84–87

Camel/car shoot, 132–133
Cargo plane shoot, 160–161
Cars. *See* Vehicle shoots
Chemical transport truck shoot, 155
Circus clown shoot, 60–61
Club scene shoots, 38–39, 48–50, 51
Corporate and industrial shoots,
 141–169
 adding color to industrial setting,
 156–157
 cargo plane on tarmac, 160–161
 chemical transport truck, 155
 Doppler dish in eggshell, 152–154
 financial company promos, 146–151
 high-tech equipment, 156–157
 javelin/athlete icon, 142–144
 museum display, 166–167
 Office X-Games, 162–165
Corporate cafeteria shoot, 112, 113

"Dirtying" lighting, 63, 65, 100
Dixon, Don
 camel/car shoot, 132–133
 fanciful "Umbrella Man" shoot, 55
 financial company promos, 146–151
 glowing firefly/youth shoot, 52–54
Doppler dish/eggshell shoot, 152–154

Electronic flash. *See* Strobe Lighting
Emotion, evoking, 17, 19, 39
Exteriors at magic hour, 118–120, 121

Fairytale themes, 30–31, 40–43
Fashion and beauty lighting, 15–35
 in barber shop, 24–26
 blue-gelled tungsten light for, 18
 combined fashion/war statement,
 20–22
 facial close-ups, 32–34, 35
 fairytale-theme shoot, 30–31
 flags/nets to paint light, 18
 "flying" models without cranes, 18
 flying umbrellas shoot, 19
 funky shoe shoot, 28–29
 gravity-defying shoot, 16–18
 haute couture, 16–18
 for retail outlet, 30–31
 with smoke, 20–22
 in tight quarters, 24–26
Film-noire genre shoot, 72–74
Financial company promos, 146–151
Finnin, Denis, shoot, 166–167
Fuchs, Rafael
 club scene shoot, 38–39
 fairytale-theme fashion shoot, 30–31
 studio-simulated street scene,
 172–173

Gels
 adding color to fashion shots, 30–31,
 33–35
 bringing life to windows, 91
 "dirtying" lighting, 63, 65, 100
 enhancing club feel, 31, 38, 39, 50, 51
 enlivening industrial shots, 157–158,
 161, 162, 165
 fluorescent lights and, 25, 26, 63, 167
 intensifying infrared with, 29
 moonlight (Harry-Potter-like) feel
 with, 80, 81
 pink charm with, 42–43
 for visualizing fashion shots, 18
 warming with, 22, 39, 89, 119, 123,
 153, 154
Giacobetti, Francis, 33
Gordon, Lee
 exteriors at magic hour, 118–120, 121
 hospitality shoot, 98–101
Gravity-defying fashion shoot, 16–18
Green, Jeffrey, residential shoots,
 114–117
Griflon, 17, 19

Harrington, Marshall

circus clown shoot, 60–61
 shaping shadows with light, 68–71
Harry-Potter-feel shoot, 80–83
Haute couture, lighting, 16–18
Health center shoot, 102–105
High-tech equipment shoot, 160–162
HMI lighting
 beer/club scene shoot, 51
 car shoots, 126–130, 134–138, 139
 fashion shoot, 19
Hopkins, Charles, car shoots, 126–130,
 131
Hospitality shoot, 98–101

In-camera masking shoot, 94–95
Incandescent lighting
 dramatic bounty hunter shoot, 62–64
 fairytale rock band shoot, 40–43
 residential interior shoots and, 115,
 116
Industrial. *See* Corporate and industrial
 shoots
Infrared film, 28–29
Interior shoots. *See* Architecture and
 interior shoots

Jacoby, Edward
 architectural details shoot, 110–111
 corporate cafeteria shoot, 112, 113
 health center shoot, 102–105
Javelin/athlete icon shoot, 142–144
Johnston, Don
 three moving vehicles shoot, 134–138
 truck-in-barn shoot, 139
Jones, Lou, 8
 cargo plane shoot, 164–165
 museum interior shoot, 122–123
 rural-America scene, 90–92

Karageorge, Jim, shoot, 160–162
Kino Flo lighting
 dramatic bounty hunter shoot, 62–64
 facial close-up shoots, 32–34, 35
 hospitality shoot, 98–101
Kuhlmann, Brian
 beer product shoot, 51
 club scene shoot, 48–51

Lantern shot, 57, 59
Layering light, 17–18
Lifestyle shoots, 37–65
 circus clown, 60–61

club scenes, 38–39, 48–50, 51
dramatic bounty hunter, 62–64
fairytale rock band, 40–43
fanciful "Umbrella Man," 55
glowing firefly/youth, 52–54
lantern, 57, 59
raw/gritty environment, 65
rugby scrum, 47
wine glass/barrel, 56–58
Light painting, 94–95

Magic hour, exteriors at, 118–120, 121
Maglites, 34, 54
Magnatta, Tammy, fairytale rock band
 shoot, 40–43
Magnum reflectors, 69, 70, 71
McDonald, Jock
 humorous barbershop fashion shoot,
 24–26
 spotlighting Santa dancing shoot,
 88–89
 wine glass/barrel shoot, 56–58
Museum display shoot, 166–167
Museum interior shoot, 122–123

Nuances and nostalgia, 67–95
 blue/black color motif, 76–79
 film-noire genre, 72–74
 in-camera masking shoot, 94–95
 moonlight (Harry-Potter-like) feel,
 80–83
 romantic old-Hollywood, 75
 rural-America scene, 90–92
 shaping shadows with light, 68–71
 spotlighting Santa dancing, 88–89
 vintage feel, 84–87
Nudes on chairs, 68–71

Office X-Games shoot, 162–165

Permits, 8
Portrait, action shot, 44–46

Rebillard, Remi, beauty close-ups, 32–34,
 35
Residential interiors shoots, 114–117
Romantic old-Hollywood shoot, 75
Rugby scrum shoot, 47
Rural-America scene, 90–92

Santa, dancing in spotlight, 88–89
Schafer, F. Scott

dramatic bounty hunter shoot, 62–64
raw/gritty environment shoot, 65
Schlechter, Annie, shoot, 76–79
Scott, Bob
 action portrait shoot, 44–46
 moonlight (Harry-Potter-like) shoot,
 80–83
 rugby scrum shoot, 47
Scouting locations, 8
Shadows, shaping with light, 68–71
Shaolin monk portrait, 44–46
Shooting tests, 18, 28–29, 30, 34, 57
Skylight, 16, 17, 33–34, 35, 77
Smith, Jeff
 boat interior shoot, 106–109
 chemical transport truck shoot, 155
 Doppler dish/eggshell shoot, 152–154
Smoke
 club scene shoot with, 49
 fashion shoot with, 20–22
 film-noire genre shoot with, 73–74
 machine portability, 49
Sokolsky, Melvin
 flying umbrellas shoot, 19
 gravity-defying shoot, 16–18
 haute couture shoot, 16–19
Street scene, simulating, 168–169
Strobe Lighting
 action portrait, 44–46
 blue/black color motif shoot, 76–79
 boat interior shoot, 106–109
 camel/car shoot, 132–133
 cargo plane shoot, 160–161
 car shoots, 126–130, 131
 chemical transport truck shoot, 155
 circus clown shoot, 60–61
 club scene shoots, 38–39, 48–50
 Doppler dish/eggshell shoot, 152–154
 dramatic bounty hunter shoot, 62–64
 exteriors at magic hour, 118–120
 fanciful "Umbrella Man" shoot, 55
 fashion shoots, 17–18, 20–22, 24–26,
 28–29, 30–31
 glowing firefly/youth shoot, 52–54
 high-tech equipment shoot, 160–162
 in-camera masking shoot, 94–95
 industrial shoot, 156–158
 javelin/athlete icon shoot, 142–144
 light painting with, 94–95
 mixing fluorescents with, 26, 29
 moonlight (Harry-Potter-like) feel,
 80–83

museum interior shoot, 122–123
Office X-Games shoot, 162–165
raw/gritty environment shoot, 65
residential interiors shoot, 117
rugby scrum shoot, 47
rural-America scene, 90–92
shaping shadows with light, 68–71
spotlighting Santa dancing shoot,
 88–89
in TTL mode, 29
vintage-feel shoot, 84–87
wine glass/barrel shoot, 56–58

Tests, 18, 28–29, 30, 34, 57
Tremblay, Pierre, funky shoe shoot,
 28–29
Tungsten lighting
 architectural details shoot, 110–111
 beer/club scene, 51
 blue/black color motif, 76–79
 blue gel over, for visualizing shot, 18
 car shoots, 134–138, 139
 corporate cafeteria shoot, 112, 113
 exteriors at magic hour, 118–120, 121
 film-noire genre feel, 72–74
 health center shoot, 102–105
 high-tech equipment shoot, 160–162
 hospitality shoot, 98–101
 museum display shoot, 170–171
 residential interiors shoots, 114–115,
 116
 romantic old-Hollywood feel, 75

Umbrella (flying) couture shoot, 19
"Umbrella Man" shoot, 55

Vehicle shoots, 125–139
 camel/car, 132–133
 cargo plane, 160–161
 chemical transport truck, 155
 classic look, 126–130
 with sun in shot, 131
 three moving vehicles, 134–138
 truck in barn, 139
V-flat, 18
Vickers & Beechler shoot, 156–158
Vintage-photograph feel, 84–87
Voltage-stabilized generator, 26
Vracin, Andrew
 film-noire genre shoot, 72–74
 romantic old-Hollywood shoot, 75

Wine glass/barrel shoot, 56–58

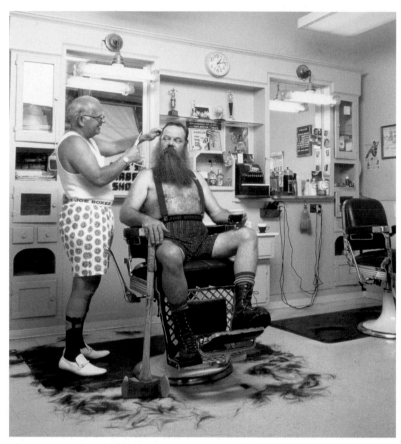